GLORIOUS TECHNICOLOR

THE MOVIES' MAGIC RAINBOW

BY FRED E. BASTEN

GLORIOUS TECHNICOLOR
The Movies' Magic Rainbow
Fred. E. Basten

© 2005 by Technicolor, Inc.

Library of Congress Cataloging in Publication Data

Basten, Fred E
 Glorious Technicolor: The Movies' Magic Rainbow

 Filmography: p.183
 Bibliography: p.272
 Includes index.
 1. Moving-pictures—United States—History
2. Color Cinematography. 3. Moving-pictures—Catalogs.
1. Title.

ISBN 978-0-9647065-0-7
ISBN 0-9647065-0-4

Design: Les Sechler and Dana Levy

DEDICATION

This book is dedicated to the millions of people who first had their eyes dazzled by

Technicolor in the 1930s and 1940s, and to the future millions who may never see that

glorious color on the motion picture screen.

—And to the unsung Technicolor consultants and associates...

> *Joan Bridge*
> *Robert Brower*
> *Monroe W. Burbank*
> *Francis Cugat*
> *Leonard Doss*
> *Alvord Eiseman*
> *William Fritsche*
> *James Gooch*
> *Charles K. Hagedon*
> *Henri Jaffa*
> *Mitchell Kovaleski*
> *Richard Mueller*
> *Morgan Padelford*

> *...who worked in the shadow of the rainbow.*

CONTENTS

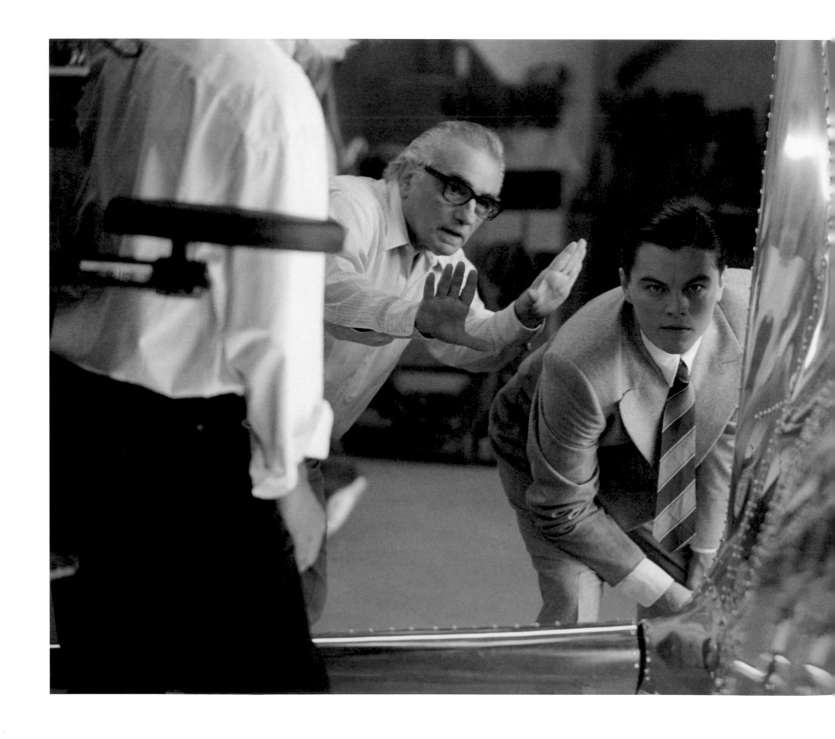

Martin Scorsese directs Leonardo DiCaprio in 2004's *The Aviator.*

FOREWORD by Martin Scorsese

My first memories of movies are in Technicolor. *Duel in the Sun* was the first picture I ever saw, and it's never left me—reds, blues, greens, yellows, deep blacks, lustrous golds. There doesn't appear to be any blending of color in that picture—everything is primary, and everything is alive. It may be garish, it's certainly unreal and it's far from subtle, but it's alive. Alive... To me, that's Technicolor.

I was recently asked to name my favorite color films, and I quickly realized that most of them were in Technicolor. I don't want to slight the efforts that have been made over the years to bring color in movies closer to the way we experience reality—many of my own pictures wouldn't have looked right in true Technicolor. On the other hand, there have been many times when I've had to find different means of reaching that same effect of pulsing, glowing, vibrant life that can only be found in Technicolor—the fiery orange of Moira Shearer's hair in *The Red Shoes*, the troublingly deep blues of *Vertigo*, the multi-colored flowering tree in Renoir's *The River*. I remember when we were shooting *The Age of Innocence* in Troy, and we came to the scene where Daniel Day-Lewis goes to the flower shop in search of yellow roses for Michelle Pfeiffer. I kept asking for more colorful flowers, so we could try and achieve the feeling of the flower shop scene in *Vertigo*, with its striking use of Technicolor.

I must say that with the advent of digital technology, we've come full circle. I see many filmmakers trying to achieve the Technicolor look. However, it's simply not the same. I'm not being nostalgic—that's just the way it is. Digital technology can replicate the glow and the vibrance, but it can't quite achieve the warmth—at least not the same kind of warmth. I don't regard this as a failing—it's just a technology that behaves differently.

Did we lose something when we stopped working in Technicolor? Of course, but we also gained in mobility, speed and versatility. Whenever we gain something, we lose something else.

This wonderful book takes us on a quick tour through the historical evolution of Technicolor. It also serves as a tribute to what can now be understood as a unique moment, when moving pictures were ushered violently into a new life through the power of color. Technicolor.

Martin Scorsese
July 8, 2005

PREFACE

On November 15th, 2005 Technicolor celebrated its 90th Anniversary. In 1915, Dr. Herbert Kalmus, along with an intrepid group of scientists, chemical engineers and investors gambled on the future of color in motion pictures. His prescient gamble was well received—a story documented by writer Fred Basten originally in the late 1970s in the first edition of this book. In 1994 we felt that an updated version would be fitting—little did we know that in the ensuing decade vast changes would sweep over the American and international entertainment industries.

What a difference a decade made. In the early 90s the industry moved into the digital age. Concurrently, the global demand for American films exploded. As the international marketplace and hunger for U.S.-based filmed entertainment was burgeoning so too was the domestic home entertainment video market. These forces, and others, were immediately embraced by Technicolor through strategic investments in facilities and new technologies. The acquisition of Technicolor in 2001 by Thomson allowed us to continue to help the industry through its next big transition, as we benefited from the group's strong digital and video technology focus. Over the last four years, Thomson has transformed itself into the preferred partner to the media and entertainment industries. In the process, Thomson has grown Technicolor's business and helped us build the talents and technologies we need to provide our customers with end-to-end services on a global basis.

Today, it's not unusual for Technicolor to create ten thousand theatrical release prints for a single title, provide digital copies to the great majority of digital cinema venues in North America, followed by millions of DVD copies of the same title a few months later. As the entertainment industry has changed, so has Technicolor. This latest edition of this book celebrates not only our glorious past but embraces the glorious future that we envision.

In the intervening years since the 2nd edition of *Glorious Technicolor*, digital production, editorial, sound and postproduction have become as ubiquitous as the color photography and processes that Technicolor invented and perfected over the company's first 80 years of existence. Driven by industry demand, Technicolor has re-imagined and re-invented itself to serve a new generation of filmmakers who are as comfortable with a computer as a camera. The changes we've experienced in film and digital postproduction are embodied in the films of the last ten years that have incorporated digital visual effects, for example, as a staple alongside the other traditional film crafts of camera, sound, editorial, and production design —all of which have been impacted by the new digital tool set. Today, even the notion of postproduction is almost a misnomer as filmmakers use the various processes of "pre-visualiza-

tion" to imagine the final execution of their stories—a paradigm shift that impacts nearly all the "traditional" crafts of filmmaking.

And yet, as vast as the technological changes are that we've witnessed, Technicolor stays true to two core values that have underscored our existence for 90 years—quality and service. We have endeavored to maintain a level of performance for the creative community and content owners alike, for we are ever mindful of our role in the media and entertainment industries to serve the creative process. Never was this more evident than in 2004 when we had the privilege of working with director Martin Scorsese on his ode to Howard Hughes, "The Aviator." The project was the perfect embodiment of the new digital tool set in the service of one of the world's great "traditional" filmmakers—someone not known for embracing digital postproduction. Part of the pleasure of working on "The Aviator" was Mr. Scorsese's desire to recreate the vintage Technicolor looks of the 1920s and 1940s using new digital technologies. We were given the opportunity to bring what we hold most sacred from our past into the future.

From visual effects, to sound services to our traditional film processing and postproduction capabilities, Thomson continues to invest to support the needs of Technicolor's customers and help drive creativity and innovation in the entertainment industry. Thomson, together with its more than 22,000 Technicolor employees, embraces a future that is the embodiment of our brand position—the world's leading partner to the media and entertainment industries and a company that is "Moving Entertainment".

Lanny Raimondo
Chief Executive Officer, Technicolor

ACKNOWLEDGMENTS

A book, like a movie, is never the work of one individual. It takes a cast of specialists to assemble the photographs, dig for research, check facts, and document history for such a work. And then to make it sound and look as good as it can is yet another challenge. That's why I'd especially like to send a heartfelt thanks to Martin Scorsese for his beautifully written foreword, and to his assistants Emma Tillinger and Meg McCarthy. I'd also like to say a special thanks to the studio archivists at Universal, Miramax, Lucasfilm LTD., Warner Bros., Disney, Paramount, Granada International, Twentieth Century Fox and Sony Pictures who helped bring *Glorious Technicolor* to life by providing many of the treasured photographs that illustrate Technicolor's 90 years of history.

Margaret Adamic	Melissa Hendricks
Andy Bandit	Christopher Holm
Jeff Briggs	Ivy Kwong
Robert Buckley	Roni Lubliner
Monique Diaz	Fiona Maxwell
Robert Easterla	Larry McCallister
Marlene Eastman	Lori Shamah
Robert Fellowes	Anne McGrath
Jordan P. Foley	Deidre Thieman
Sarah Garcia	

Thanks also to the Technicolor and Thomson management team for all its generous support and encouragement, especially Lanny Raimondo, Tom Bracken, Jean-Georges Micol and John Oliphant.

Most of all, thanks to the Technicolor marketing communications team without whom this book would not be possible:
Susan Haggin
Bob Hoffman
Kris Larson
Tiffany Lepard
Julie Purcell

INTRODUCTION

Color has fascinated mankind since Adam and Eve first spotted the brilliant red apple among the lush greens of the Garden of Eden. Despite that fascination, and influence over untold civilizations, the science of color, particularly in the field of photography, remained a mystery for centuries.

It wasn't until the release of a publication in 1704 that the foundations were established. In that year Sir Isaac Newton, credited with the theory of color, discovered the components of light and color by means of a prism held up to sunlight. Through the prism he passed a narrow beam of light onto a screen and produced a colored band or spectrum.

In 1801, Professor Thomas Young, English physician and physicist, proposed his theory that the retina of the human eye has three sets of nerve fibers, one giving the sensation of red, one of green, and one of blue-violet. In 1839, the science of photography was created by the French painter and inventor, Louis Jacques Daguerre.

New developments followed. In 1855, the basic principles underlying color photography were established when an English physicist named James Clerk Maxwell demonstrated his classic experiment before London's Royal Institute. He simply made three still photographs of an object—one through a blue filter, one through a green filter, and one through a red filter—then projected lantern-slide positives of the three on top of the other, each screened by its appropriate filter, and recreated (or "rebuilt") the original colors of the object. Basic as the experiment was, it was hailed as creating a new era in the history of photography.

Movies in color had been the ultimate dream of filmmakers. In 1873, by a happy accident, H. W. Vogel discovered the color sensitizing of photographic emulsions by means of dyes. Four years later, in 1877, Emile Reynaud patented an apparatus for projecting a strip of hand-painted pictures in apparent movement.

Although the earliest patent for color films was recorded in 1897 by Germany's H. Isensee, whose invention used a disc of colored glass which rotated before a projector lens, the first film made for screen projection (by C. Francis Jenkins) was shown three years earlier. The film, in color, contained individual hand-tinted frames.

That same year, Thomas A. Edison, the pioneer of the motion picture in America, produced a color film of a stage success, *Annabell's Butterfly Dance*, using a system he called the Kinetoscope (actually a "peep show" machine). The Edison exhibition, the first public showing of motion pictures for a fee, took place on April 14, 1894, at the Holland Brothers

Kinetoscope Parlor, 1155 Broadway in New York City. The entire thirty-five foot length of the Edison Company release was also colored by hand, frame by frame, so that the white material of the dancer's flowing costume changed hue during the sequence.

The following year, the brothers Lumiere projected motion pictures on a large screen for the first time. And Robert Paul, the pioneer English producer and manufacturer of cinema equipment, exhibited a seven-reel production of *The Miracle*. Each of his film's 112,000 frames was hand-colored.

Audiences for these exhibitions were limited, however. The first public projection of film on a large screen was shown in Edison Vitascope at Koster & Bial's Music Hall, an auditorium on 34th Street west of Broadway, Herald Square, in New York City on April 23, 1896. The screen measured twenty feet and was enclosed in a gilded frame.

In the late 1890's, several short French films were released in color versions, hand-tinted by an assembly line of workers employed to paint the individual frames of film one color at a time. George Melies, noted for his "trick" productions, used this process on such turn-of-the-century films as *An Astronomer's Dream, A Trip to the Moon, Transformation,* and *The Flower Fairy.*

Beginning in 1905, a technique of hand-stenciling color directly onto film was first used by Charles Pathe in short subjects (*Aloha Land, Land O'Lea*). The method was tedious but the results were often stunning. Pathe's process, called Pathecolor, was one of the first to be identified commercially and was used, starting in 1914, in a series of colorful full-length productions. Among them were *A Rose Among the Briars, The Life of Our Savior, The Three Masks,* and *Cyrano de Bergerac.* Of *Cyrano,* one New York critic noted: "The characters appear in eye-smashing creations, consisting of purple trousers, pink shirts and green capes or blue gowns, yellow hats and indigo hose." The reviewer added that the film possesses "all the artistic effectiveness of a succession of penny postal cards."

The truly photographic color process received its initial praise as early as November, 1910, when a British firm, Kinemacolor, startled the world with its first film, *Birth of a Flower.* The company followed with a string of major productions: *The Durbar at Delhi, By Order of Napoleon* and *The Coronation of George V.* While Kinemacolor was hailed in Europe, its future was limited. The process utilized alternating frames of red and green which were projected through a rotating color filter on the projector to a special "color fixed" screen. The equipment was cumbersome, and the continual flickering of the projected images, which gave rise to the expression "flickers," proved tiresome to audiences' eyes.

Another process was developed by Max Handschiegl, a noted St. Louis engraver, who adapted the principles of his trade to motion pictures. Finished productions were brought to Handschiegl; he would then etch, print, or hand block a "register print" of the portions of the

film selected for color treatment. The result of his work became the "color plate," similar to the plates used in lithography. Examples of the Handschiegl process can be seen in sequences within D. W. Griffith's *The Birth of a Nation* (1915) and *Intolerance* (1916), Cecil B. DeMille's *Joan the Woman* (1917), Douglas Fairbanks' *The Three Musketeers* (1921), and *When Knighthood Was In Flower* (1922), starring Marion Davies.

The existing methods, to date, of applying color to film were not only time-consuming and laborious, they were expensive. A faster, more practical system had to be found to make color available. The answers were found in "tinting" (a process that had already seen limited use as early as 1907 in Edison's tinted short subject *The Teddy Bears*) and "toning."

The tinting process involved the dyeing of the black-and-white film so that the entire image would be colored by any one of the eleven standard dye colors. Toning employed a chemical treatment to black-and-white film to give it a brown-and-white (sepia) look, or other single-hued tone.

During the 1920s, more than one hundred and fifty feature films were released in either tinted or toned color. While the two processes achieved roughly the same effect as placing a piece of colored cellophane over a black-and-white television screen, they did create a mood, particularly in sequences within films. For example, the fire segments in *Dante's Inferno* (1924) were appropriately red, the water scenes in *The River Pirate* (1928) projected in blue, and *The Play Girl* (1928) had scenes in lavender. The treatment proved so successful that the practice continued, in selected instances, for many years, particularly in sepia-tinted western films. Among the more notable latterday achievements using these techniques were the sepia tones of Twentieth Century-Fox's *The Rains Came* (1939), United Artists' *Of Mice and Men* (1940), Metro-Goldwyn-Mayer's *Ziegfeld Girl* (1941) and *Tortilla Flat* (1942), the green-tinted storm sequences in David O. Selznick's *Portrait of Jennie* (1948), and the multiple tints in RKO's *Mighty Joe Young* (1949).

Color in motion pictures, in one form or another, seemed certain. Technicians both in the United States and in Europe were announcing new discoveries at a rapid rate. Frederick Marshall Lee and Raymond Turner of England developed the first practical color projector and film. William Friese-Green made news with his Biocolor. The Sanger-Shepherd process was unveiled, as were the processes of McDonough, Lippman, Gaumont, Brewster, Douglas and Keller-Dorian. Coined names were in vogue: Kromoscope, Cinechrome, Chronochrome, Prizma, Zoechrome, Kelleycolor, Colorcraft, Polychromide, Kodachrome and others.

While many of the systems were praised, in one aspect or another, they all had their problems. Registration or focusing was sometimes faulty; one color was often harsh or crude and not natural, therefore distracting and visually fatiguing. Too, equipment and/or projection occasionally proved difficult. But perhaps the biggest drawback of all was that not

one of the multi-color processes could be made available on a commercial basis. Some of the developers had no trouble making small lengths of high quality color film. Producing a number of multiple-reel prints for mass distribution was another story. And so, despite their noble efforts, not one of them fully realized the dream of creating totally acceptable motion pictures in natural color. It remained for a determined and dedicated chemical engineer from Massachusetts, and his associates, to bring that dream to life.

GLORIOUS TECHNICOLOR

One
HOW IT ALL BEGAN

Herbert Thomas Kalmus was born in the town of Chelsea, Massachusetts, on November 9, 1881. His father, Benjamin, and mother, the former Ada Isabelle Gurney, had strong musical interests and wanted their son to become a great pianist. That ambition came to a halt when young Herbert stopped a baseball with the end of his finger.

With his hoped-for career in music finished, Herbert Kalmus concentrated on his studies at school. But even that was interrupted with the death of both his parents. When Herbert was only eight his mother died of acute appendicitis. Three years later his father was gone from Bright's disease. Because Benjamin Kalmus had remarried after his wife's death, Herbert was given the choice of living with his grandfather or his stepmother's family in nearby Dorchester. He chose the latter primarily because there were children his own age in the household. The move meant transferring out of Boston Latin School into English High School. It was a decision he would regret within the next few years.

Herbert lived with his new family until he was sixteen, when he was told there was no reason for him to attend school any longer. "Get a job," he was advised. If he didn't, one would be found for him. The teenager left the next morning for Boston. He found a three-dollar-a-week job in a local carpet store, and later supplemented his earnings with bookkeeping assignments.

By his eighteenth birthday, he had managed to save five hundred dollars, which he decided to spend on a college education. Because of his earlier change in high schools he lacked the necessary requirements in Latin, making him ineligible to enter Harvard, Yale, or any other liberal arts college. His interests were not scientific, but he applied for admittance to the Massachusetts Institute of Technology anyway—and he was accepted.

The young man had a flair for figures, which was one reason why so many of the intricate musical compositions he once mastered had captured his interests. Now he found a substitute in physics and chemistry, and the creativeness of experimentation and invention was unchallenged. Outside his studies, he made many new friends, not only with classmates and faculty members but "outsiders" as well. One of these acquaintances worked as a sales clerk and model in Boston, an attractive

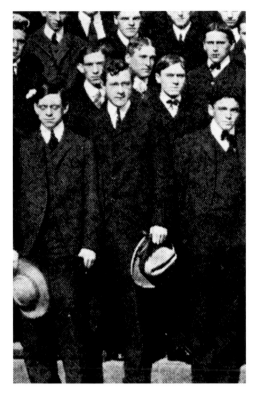

Dr. Herbert T. Kalmus (center front) stands with members of his 1904 M.I.T. graduating class.

redhead named Natalie Dunfee, whom he met at a school dance. She was assertive and opinionated, a free-thinking spirit who kept the studious and rather sober Herbert on his toes. He had never met anyone like her. Herbert and Natalie were married during his senior year at M.I.T. in 1903. He was 22, she was 26. The new Mrs. Kalmus, along with a number of other associations made while in college, would become instrumental in his ultimate corporate success. If ever there was a person he regretted having met, however, it was Natalie. She would make his life miserable for nearly 50 years.

Soon after receiving his Bachelor of Science degree from M.I.T., Herbert and Natalie left for California where he served as principal of University School, a boys' school, in San Francisco. But the students thought his Boston accent was comic and he stayed less than two years. Probably just as well, for a short time later the infamous earthquake and fire destroyed the property.

With Daniel Frost Comstock, a member of his class at M.I.T., he went to Europe on a graduate fellowship. (Natalie tagged along to study art, though not formally.) Herbert received his doctorate from the University of Zurich, while Comstock received his from Basel. After returning to the United States, they both held posts at their alma mater. Dr. Kalmus served as a research associate (1907), an instructor (1907-10), and an Assistant Professor of Physics (1910-12). For three years, starting in 1913, he held dual positions: Professor of Electro-Chemistry and Metallurgy at Queen's University in Ontario, Canada, and Director of the Research Laboratory of Electro-Chemistry and Metallurgy for the Canadian Government. He also had a side interest. It was that enterprise that changed the course of his life.

In 1912, Dr. Kalmus formed the firm of Kalmus, Comstock & Wescott in partnership with Daniel Comstock and W. Burton Wescott. Mr. Wescott was not a classmate at M.I.T., nor even a college graduate, but he was a mechanical genius. The company functioned as an industrial research and development council, offering services on any problem of a scientific nature. One of its first clients was an independent group of manufacturers of abrasives who felt threatened because they could not compete with the process being used by the giant Carborundum Company. Kalmus, Comstock & Wescott saved the group by developing a similar process which, like Carborundum's, produced silicon carbide, yet did not infringe on existing patents. For their reward, the consulting firm took a share of the business. Other clients soon followed. Before long, the young company had an outstanding reputation and enviable earnings.

One day, toward the end of 1912, William H. Coolidge, a Boston corporation lawyer and investor, arrived at the office of Kalmus, Comstock & Wescott with a new movie projector called a Vanoscope. The inventor had brought it to Mr. Coolidge saying that the discovery, with its rotating mirrors, would revolutionize motion pictures by taking the flicker out of "the flickers." The lawyer and his associates were willing to invest one million dollars in the invention if it would indeed do the job. Kalmus, Comstock & Wescott made some tests on the gadget and reported that it was not practical. Undaunted, the inventor made refinements on the Vanoscope and returned to Mr. Coolidge for backing. Again, tests were run—this time more exhaustive—and the same conclusion was reached.

By now, Dr. Kalmus and his partners, having become intrigued with motion pictures, had begun work on a new type of camera. They were not interested in taking something out of movies, however. They wanted to put something in: color. If Mr. Coolidge wanted to invest a large sum of money, Dr. Kalmus reasoned, why not use it to finance his firm in the development of color moving pictures? After all, there were no practical color films in American theaters.

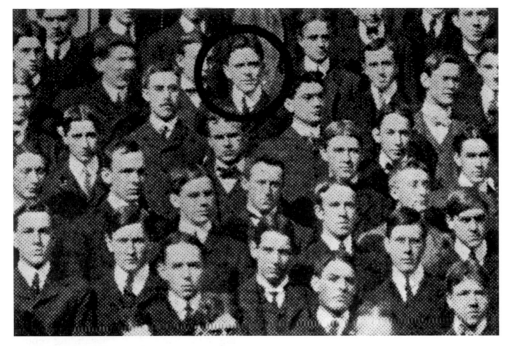

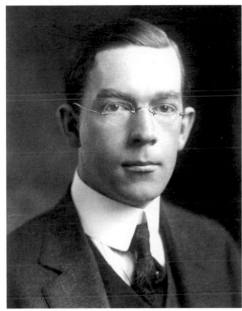

TOP: **Dr. Daniel Frost Comstock (circled) is surrounded by fellow classmates in 1904 M.I.T. graduation photo.**

ABOVE: **Leonard Troland had been a student of Dr. Comstock before joining Technicolor.**

The Kinemacolor Company had a process, but it could only photograph slow-moving objects without annoying flashes of color appearing on the screen. And, as with all other systems that had been tried and failed, the pictures caused pronounced eyestrain.

To Mr. Coolidge, the idea was tempting. The new camera, designed by Daniel Comstock, could photograph a scene in two colors, red and green, simultaneously. A short test run projected on a screen was all that the lawyer needed to be sufficiently impressed. He advanced the trio of scientists ten thousand dollars and told them to move ahead. And so, in 1915, the firm of Kalmus, Comstock & Wescott found itself with a new client: the Technicolor Motion Picture Corporation.

The name Technicolor was selected by Drs. Kalmus and Comstock as a tribute to "Tech," their alma mater. It was Dr. Kalmus, however, who conceived the word. In his search for a name for the new corporation, the word "Technique" on the cover of his 1904 M.I.T. yearbook struck him as being "impressive, meaningful, beautiful, and smooth." As Dr. Kalmus recalled years later: "The more I studied it, the more I pronounced the word to myself, the more fascinated I became with the combination of its significance to the mind and its agreeableness to the ear."

The word "Technique" stayed with him. He was on the right track, he knew, but something was missing to make it perfect for his purpose. He spent an afternoon walking and thinking. Then, suddenly, the most obvious of words came to him: color. He replaced the last three letters of "technique" with "color" and repeated over and over to himself, "Technicolor . . . Technicolor." It was more than the right sound. Said Dr. Kalmus: "Technicolor . . . a beautiful name, a meaningful word, easy to remember, hard to forget, and possessing a full measure of significance for a company aiming to revolutionize the motion picture world." It would be some time, however, before the general public would become aware of it. Not so with the young company's early troubles.

The problem of developing a natural-looking color process, and of ultimately projecting it with standardized equipment, was clear from the fact that the principles of color had been known for so many years without ever having been solved. There was also the obvious point that so many individuals and groups had been unsuccessful in their attempts.

Technical problems were only part of the difficulty. In later years, one of Comstock's favorite quotes was itself a quote from one of America's early photographic color experts: "No independent group will ever develop practical motion pictures in natural color, the problem is too hard and will require too much money; the job will have to be done in the laboratories of a large company where large sums can be spent slowly."

Technicolor was a small company with not unlimited resources, and so the task was like a very complicated picture puzzle where the pieces were technical, financial and human. "Throughout the industry," Dr. Comstock recalled, "the 'it can't be done' atmosphere was general. It even extended to the actors who appeared in our first picture. Their attitude was 'This picture will never reach the screen. No color ever does'."

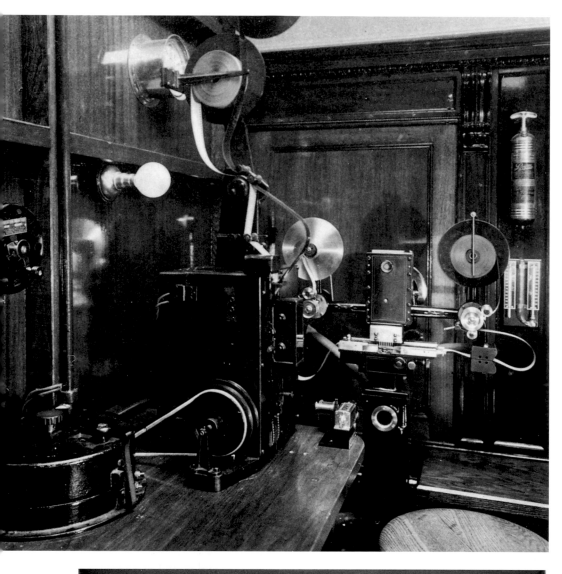

TOP: **The printing room aboard Technicolor's laboratory on wheels.**

ABOVE: **Bronze plaque commemorating the founding of the Technicolor Corporation in 1915. Years later, it was mounted at the entrance of the sprawling Hollywood plant.**

Working within this atmosphere became even more of a challenge, forcing Technicolor into a series of strategic moves that might never have been considered under more positive conditions. A plan called "progressive step development" was initiated. "The essence of this strategy," according to Dr. Comstock, "was to plan, as far as could be seen ahead, in a series of steps, each move—not requiring too much money or time and, at the end of each step, to show convincing pictures on the screen."

It was characteristic of this scheme that in moving ahead much of the equipment and technique of the previous step be utilized, eliminating, as much as possible, back-tracking or wasted time and money. The program also minimized the risk to the investors and made continuous progress possible. (It should be noted that from the very beginning Technicolor's main goal was the development of the ultimate three-color-component process, which was theoretically capable of perfect color rendering. Dr. Comstock later remarked, however, that there was not the slightest chance of achieving color pictures as we know them today in a single development.)

Two other factors had a profound bearing on Technicolor's progress during its first days. Dr. Comstock credited "the rare wisdom of Dr. Kalmus . . ." who gave uniform encouragement to the technical staff.

"We had a number of bad technical emergencies," he related, "and some fiascos, and nearly any executive leader would have felt it necessary to be extremely critical at times. Dr. Kalmus acted as if he thought, 'If you can't do it, it can't be done.' This attitude was very inspiring to the technical group and must have been a unique executive attitude in the history of a large new enterprise."

Technicolor was also fortunate in being able to acquire the services of three of Dr. Comstock's most brilliant students in the Physics Department at M.I.T. These men, Leonard Troland, Joseph Arthur Ball and Eastman Weaver, all made notable and

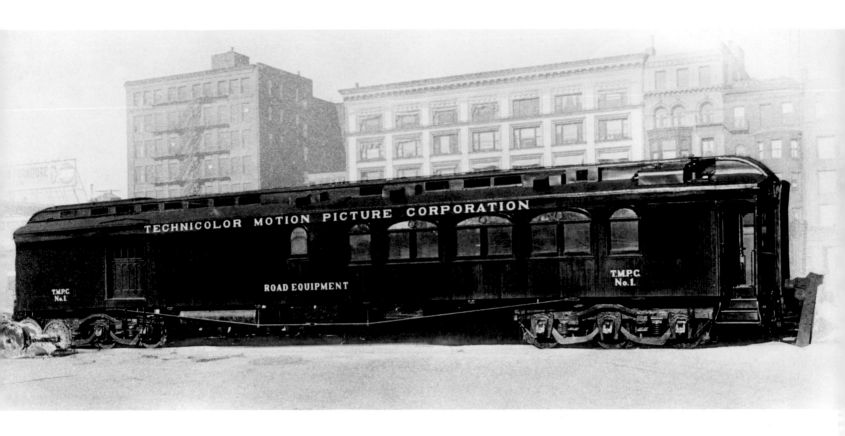

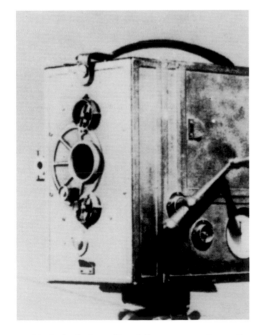

TOP: **Technicolor's earliest laboratory was housed inside a railway car. It contained all the necessary machinery to carry on a number of processes on a small commercial scale.**

ABOVE: **One of the first Technicolor cameras, ca. 1916. This historic model exposed two frames of film at the same time, one sensitive to red, the other to green.**

original technical contributions to the development of the process.

The work on "Technicolor Process Number One" took place in Boston in the company's first laboratory, a railway car. The facility was completely equipped with a photo-chemical laboratory, darkrooms, fire-proof safes, power plant, offices, and all the machinery and apparatus necessary for carrying on a number of processes on a small commercial scale. Considering the space, the scope of operations was impressive: sensitizing, testing, perforating, developing, washing, fixing and drying negative; printing, developing, washing, fixing and drying positive; washing and conditioning air; filtering and cooling water; examining and splicing film; and making control measurement tests.

The enlarged staff and new laboratory with its costly equipment put added pressures on Mr. Coolidge and the other investors. Their initial ten thousand dollar investment had increased considerably and the hoped-for commercial breakthrough did not appear to be in the immediate future. It was up to

Dr. Kalmus to pacify the moneymen. His business ability showed itself time and again, not only in stretching the existing funds but in drawing new cash to the company. Dr. Comstock and Mr. Wescott were credited with the bulk of early patents, but Herbert T. Kalmus directed the production.

By late 1916, sufficient progress had been made on "Technicolor Process Number One" that the principals felt confident enough to produce a feature picture. The backers were naturally enthused. Finally they were going to see more than short tests. Hopefully the finished product would recoup at least some of their mounting investment. A script was developed from a seven part story by Anthony J. Kelly. It was called *The Gulf Between* and several players, Grace Darmond, Niles Welch and Herbert Fortier, were signed for the leading roles.

For economical reasons, the one-reel production shaped up as a modest venture. Nevertheless, to everyone associated with the fledgling color concern, it was to be a milestone event.

Two
THE FIRST FILM

*I*n early 1917, Technicolor's portable laboratory was set in motion. The refurbished railroad car was on its way from Boston to Jacksonville, Florida, rolling over hundreds of miles of tracks to an isolated spot where the filming of *The Gulf Between* was to take place. Florida

seemed the ideal location. The filmmakers could take advantage of the bright sunlight, which was necessary for color photography, as well as the semi-tropical vegetation, a key background element for the story.

The production staff included Dr. Kalmus and his wife, Natalie; C. A. "Doc" Willat, formerly of the New York Motion Picture Corporation and Willat Studios and Laboratory, the production supervisor; Dr. Comstock; Mr. Wescott; Mr. Ball; and a new colleague, Professor E. J. Wall, who had done considerable work with color photography at the University of Syracuse. Both the staff and the cast were housed in a pullman car that had been hitched onto the back of the laboratory.

Dr. Comstock did not travel with the original party. He had remained in Boston to continue development of a projection system and was not scheduled to arrive until well into the production. Those plans backfired when he received an urgent call from Florida asking him to come south immediately. When he reached Jacksonville, he found an exhausted staff. A distressing problem had occurred with the film itself. It could not be sensitized. (Sensitizing, or treating, was necessary at that time because of the non-existence of good color negative of fast enough speed. Without it, even in Jacksonville in the cloudless noonday sun, a close-up of a girl wearing a sunbonnet would develop showing her face with a black halo around it.)

The Jacksonville operations were costing six thousand dollars a week. "I remember vividly," Dr. Comstock noted, "when they called me to come down. They said, 'If you can get things going in two weeks to a day, we will go on. Otherwise, we will have to close up.' There was obviously no time to do anything but feed the right kind of chemical 'medicine' to the sensitizing machine."

Dr. Comstock had long sessions with Professor Wall and others. They tried various solutions, almost in desperation, only to find that if they cured one problem, they caused another. Day after day passed without success. The cast and crew were growing restless and the budget was slowly being drained. The crisis didn't end until it was almost too

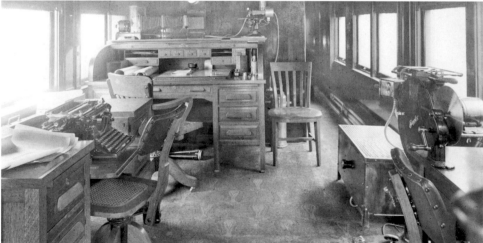

TOP: **Actors, technicians and staff of the original Technicolor Corporation in 1916.**

RIGHT: **The office aboard Technicolor's rolling lab.**

ABOVE: Leading lady Grace Darmond in a rare color still from the first Technicolor film, *The Gulf Between*. "Fringing" was a major problem in early color cinematography.

late. Only thirty-six hours remained when the problem was solved.

The Gulf Between resumed production, and Dr. Comstock and Mr. Wescott returned to Boston to continue work on the projection system. The camera used in "Technicolor Process Number One" made a simultaneous exposure of red and green negatives by means of a prism (an important innovation in the process), which divided the light as it entered the camera. This necessitated the development of a new projector equipped with two apertures for adding color to the film—one with a green filter and the other with a red filter.

The problem of illuminating the two film apertures in the projector equally and continuously at one time seemed insurmountable. Indeed, one of the fundamental difficulties that beset and discouraged numerous investigators in the field of color photography had been the unsteadiness and inadequacy of the contemporary arc lamps, which were used as a source of light for the projection of all motion pictures. At an early stage, the firm of Kalmus, Comstock & Wescott felt it essential that an improved arc be developed to provide brighter light and, of equal importance, steadier light.

Projection of the two apertures onto the screen in register also proved to be troublesome. According to Dr. Comstock; "The register adjustment had to be made from the projection booth and this was relatively far away from the screen. The necessary adjustment in the relative position between the two projector lenses would have been 'going at it' the wrong way. The relative position must be 'massively fixed' or great trouble could be expected."

A set of special register glasses was developed for superimposed fine adjustment. This permitted register correction without trying to change lens position. Register adjustment was still difficult, but it was possible.

The Gulf Between was completed in the summer of 1917 and screened before an invited audience at Aeolian Hall in New York City on September 21. *Motion Picture News*, in its review

of October 6, cited the film as "unquestionably the finest natural color picture ever produced. The process . . . results in the absence of all 'fringe,' absence of eye strain and produces colors that are really natural. The invitation audience . . . was moved time and again to burst into applause of the sort that lasted long. The final shot, showing the sun setting over the water is beautiful—mindful of a Japanese painting."

The October 6 edition of *Motion Picture World* called Technicolor "vastly superior to any of its predecessors. This was quickly comprehended by a large body of spectators that comprised many of the most prominent men in the moving picture industry, and the outbursts of applause were frequent, as different scenes of uncommon beauty were shown. The new process throws upon the screen a continual succession of pictures in natural colors that copy nature with the fidelity of a finely executed oil painting. Many of the landscapes and water scenes are of remarkable coolness."

The critics were not totally complimentary, however. *Motion Picture News* added: "the camera work—the all important angle of production in this case—is all O.K. with the exception that in quite a number of the scenes it lacks definition. There is perceptible haze, ever so slight, but still perceptible . . ."

Motion Picture World went even further.

The interiors and the human element are not so well done, the men and women in particular having a more or less painted or chromo effect. The faces are most successful in the close-ups. When the figures retreat to any distance, it is difficult to distinguish their expression. Another defect is a slight blur of color, as the shift is made from one scene to another.

Briefly, while the process shows great advancement and has much to commend it, perfection has not been reached . . . That all forms of screen drama will ever best be shown in color is more than a doubtful question. The black-and-white animated picture is frankly a photograph and is understood as such by the

spectator . . . *Spectacular production should offer a promising field for this color method . . .* As for drama, that is the product of the playwright. Even the advent of the photoplay has not altered the value of Dumas' recipe for the practice of his art: 'All I want is four scenes, four boards, two actors and a passion.'

Had it not been for the unveiling of the new color process. *The Gulf Between* would have been virtually ignored. Reviewers said the story was "long and drawn out . . . almost without suspense . . . and weak in plot" but praised the work of the cast as "a high order of merit."

Technicolor's first public showing, at Aeolian Hall, left a deep impression on Dr. Kalmus. Years later, he recalled that Friday morning in September.

> *Prior to the running of our film, I was asked to expound on the marvels of the new Technicolor process which was soon to be launched upon the public and which it was alleged by many could hardly do less than revolutionize their favorite form of entertainment.*

The Gulf Between *had been preceded by* The Glorious Adventure, *a feature picture made in England by the Kinemacolor Process. Since Kinemacolor photographed the color components by successive exposure, it was nothing for a horse to have two tails, one red and one green, and color 'fringes' were visible whenever there was rapid motion. The Technicolor slogan was two simultaneous exposures from the same point of view, hence geometrically identical components and no fringes.*

> *We were, of course, introducing color by projecting through two apertures,*

each with a color filter, bringing the two components into register on the screen by means of a thin adjusting glass element During the showing (at Aeolian Hall) something happened to the adjusting element and, in spite of the frantic efforts of the projectionists, it refused to adjust. And so I displayed fringes wider than anybody had ever before seen. Both the audience and the press were very kind but it didn't help my immediate dilemma or afford an explanation to our financial angels.

The final blow occurred not much later. Arrangements had been made with the Klaw and Erlanger Theatre chain to exhibit *The Gulf Between* for one week in each of a group of large American cities. One night in Buffalo, New York, things went from bad to worse, not only on the screen but in the projection booth. Dr. Kalmus, who was in the theater, did not like what he saw and made a snap decision. "I decided that such special attachments on the projector required an operator who was a cross between a college professor and an acrobat . . . Technicolor then and there abandoned 'additive' processes and special attachments on the projector."

Once again, the "it can't be done" forces raised their voices. Technicolor, the upstart, had also failed to field a workable color process. The Technicolor laboratory in Boston, however, was not a scene of depression. Everyone there felt that their accomplishments to date, good or bad, were simply a part of the early strategy. Besides, there was an encouraging note. Progress had already been made on the second project. Hopefully, this one would end the battle cry of the skeptics.

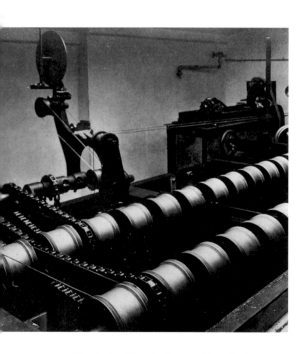

TOP: **The first public viewing of a Technicolor process, an exhibition of *The Gulf Between*, was held at New York's Aeolian Hall on September 21, 1917.**

ABOVE: **Early Technicolor developing machines, probably the only ones ever installed within a railroad car.**

ABOVE: *The Gulf Between*, shot on location outside Jacksonville, Florida, featured Niles Welch, Grace Darmond and Herbert Fortier in leading roles.

RIGHT: Grace Darmond and Niles Welch in a scene from *The Gulf Between*, the first film to use a Technicolor process.

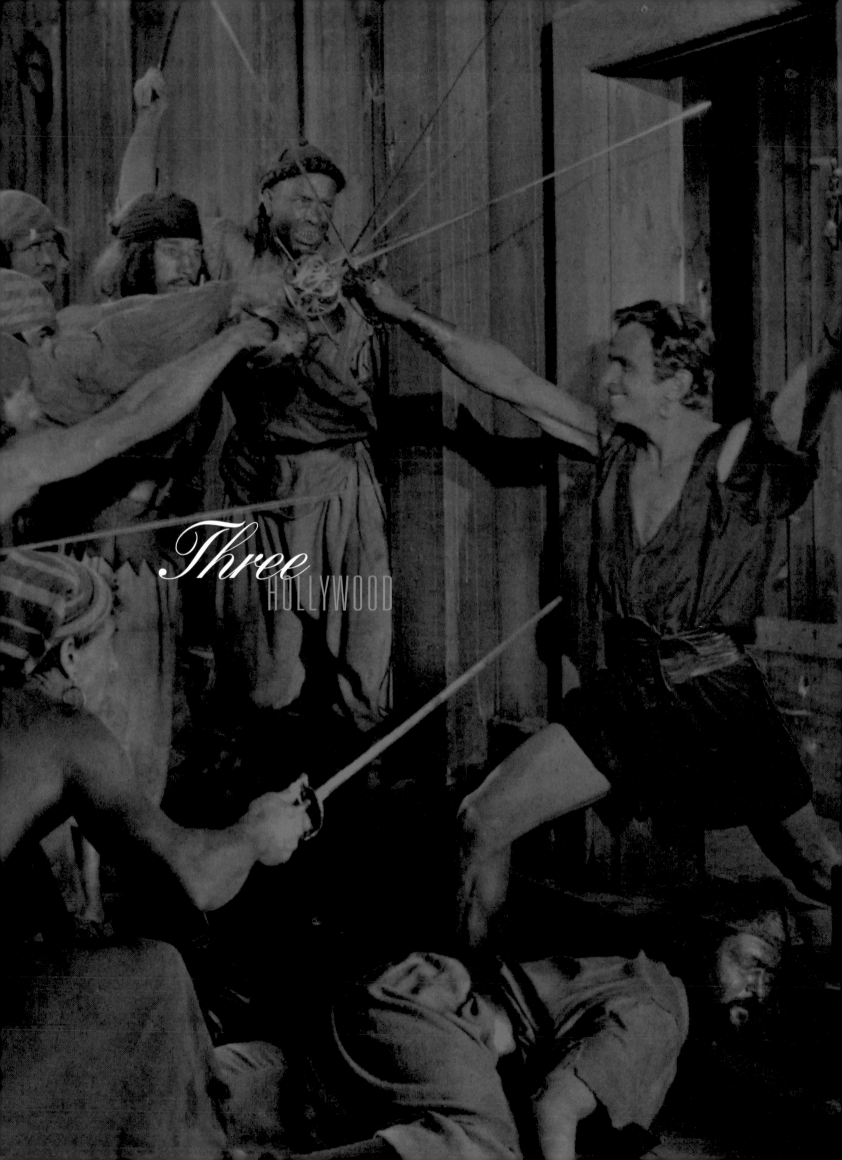

From the standpoint of color, the screen appearance of *The Gulf Between* had been sufficiently impressive to encourage the development of color "on the film" so that an ordinary projector could be used in the theaters. ■ Instead of having two separate

beams of color light going through two separate pictures in the projector, which had to be registered on the screen, the goal was to perfect a process that could contain both components of the picture printed from the negative in register on the positive film.

With increased activity in all departments, the laboratory on wheels became too confining. Additional space for a pilot plant was obtained in the basement of the building occupied by the Technicolor engineers, Kalmus, Comstock & Wescott, on Brookline Avenue in Boston. There, "Technicolor Process Number Two," a two-component subtractive process, was developed. This was largely achieved under the direction of Dr. Leonard T. Troland, who later became Technicolor's research director.

As Dr. Kalmus described it, the new process was accomplished by "making two separate 'relief' images. By a relief image I mean that instead of having silver deposits constituting the image of the picture as printed from the negative, hills and valleys are etched in the gelatin giving a relief image

corresponding with the image of the picture. Two such relief images, one each for the red and green components were welded together back to back in register. Then the two sides, one after the other, were floated over baths of the respective dyes and dried. Thus, we made a double-coated relief image in dyes."

The new process used a specially constructed camera equipped with a split-beam system so that two exposures of the same scene could be made simultaneously through the single lens. The image was relayed from the lens to a prism which split the beam into two portions and filtered the rays to form red and green images on the film.

Research on "Technicolor Process Number Two" was begun in 1918. By 1920, the money that Mr. Coolidge and his associates had invested in developing an acceptable color process had run close to $400,000. Since not a penny had been returned in profits, they withdrew their support.

Dr. Kalmus made a quick trip to New York City, where he managed to intrigue William Travers Jerome, the famed trial

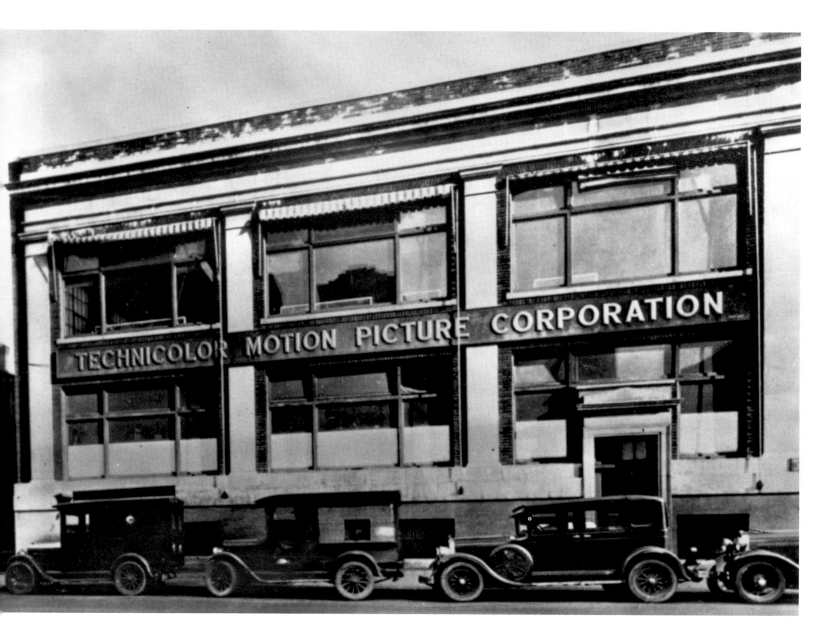

ABOVE: **Early Technicolor headquarters in Boston.**

lawyer who prosecuted Harry Kendall Thaw for the killing of Stanford White. Mr. Jerome, in turn interested two advertising executives, A. W. Erickson and Harrison K. McCann, who each brought in several of their own clients (their agencies did not merge until 1930). The new investors included William Hamlin Childs and Eversley Childs, makers of Bon Ami; Albert W. Hawkes of Congoleum-Nairn; and John McHugh, of (what was at that time) the Chase National Bank.

With substantial backing now guaranteed, the work on Technicolor's new process could proceed without interruption. And progress was being made. A number of tests had been run, problems noted and refined.

Dr. Comstock recorded an interesting episode that took place during this period. He had just privately shown a sample run of film to Edgar Selwyn, the successful Broadway stage producer who, with his brother Archibald, had joined with Samuel Goldfish (later Goldwyn, a contraction of the two family names) in the formation of Goldwyn Pictures in 1916.

"You know what the public wants," Dr. Comstock told him, "and we want to get your comments and advice regarding these pictures."

Mr. Selwyn replied, "I would be glad to help, but if I really knew what the public wanted I would have nearly all the money in the world in a few years. But I know what you mean. Perhaps I know a little more than you

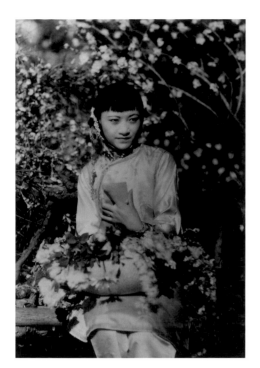

ABOVE: **Anna May Wong in** *The Toll of the Sea*, **the first Technicolor production filmed in Hollywood, 1922.**

do." The producer paused for a moment, then went on. "If you want me to be frank, this is what I think. The drama is the center of human interest, not flower gardens and dresses. The human being is the center of the drama. The face is the center of the human being. And the eyes are the center of the face. If a process is not sharp enough to show clearly the whites of a person's eyes at a reasonable distance, it isn't any good no matter what it is. Your pictures need to be a little sharper."

"All right," Dr. Comstock said, "we'll make them sharper. But what about the color?"

Mr Selwyn smiled. " The color is better than it need be. Your process is a two-color-component process. Some day you will have to add a third color component but not now. Forget about improving the colors for the present. You have troubles enough."

By 1922, the Technicolor process had reached a level that "will surprise many people," as Dr. Comstock put it. The doctor's confidence was bolstered by the fact that, while only two colors (red and green) were being used, they each contributed roughly half of the whole spectrum of color—the precise split arranged so that mixing the two in the right proportions showed a very pleasing flesh tint. Too, he was satisfied that the sharpness problem had been corrected. He no longer worried about seeing "the whites of a person's eyes at a reasonable distance."

Encouragement came from another source as well. Mr. Jerome, the lawyer and investor, had contacted Dr. Kalmus to introduce him to three men who were fascinated with the idea of color. They balked at putting any money into the project but offered their assistance should it ever be needed. The trio included movie magnates Marcus Loew and Nicholas M. Schenck of Loew's, Inc., and Joseph M. Schenck.

The alliance could not have been more timely. Technicolor was making plans to produce its second film, and its first in the new process. The three new associates immediately made good their word. It was decided to film the picture in Hollywood under the general supervision of Joseph M. Schenck. A photoplay called *The Toll of the Sea*, a Chinese version of *Madam Butterfly*, was selected. Thanks to Mr. Schenck, Technicolor was given the use of his studio's facilities, a director (Chester Franklin), and even the star of the picture (Anna May Wong)—without charge.

A young cameraman named Ray Rennahan, who had worked earlier for Mack Sennett and Christie Comedies shorts, reluctantly agreed to photograph *The Toll of the Sea* for the Technicolor company. Rennahan's only experience had been with black-and-white images and, now, he was being asked to work with a new concept, shooting not only exteriors in color but extreme close-ups, as well.

The production was originally intended to be two reels in length, but when Rennahan finished shooting he found the footage too good to cut. Instead, he shipped five reels to Boston for processing. Without knowing it, Technicolor had its first feature film.

The Toll of the Sea was not without its problems. One of the greatest difficulties encountered during production, according to Dr. Comstock, was to get the actors, including Miss Wong and male lead Kenneth Harlan, to treat their work seriously. As on the first production, the players' attitude was, "This picture will never reach the screen."

But reach the screen it did, Nicholas Schenck having arranged for the release through the Metro Film Company. The premier showing was held at the Rialto Theatre in New York during the week of November 26, 1922. (Insufficient laboratory space in Boston, coupled with the great demand for bookings, created a slowdown in quantity prints, delaying the general release in the United States until the following year.)

The Toll of the Sea was shown in thousands of theaters across the country and received high praise from critics everywhere, among them the esteemed artists Maxfield Parrish and Charles Dana Gibson. The general manager of Metro wrote, "I would lay great stress on the fact that *The Toll of the Sea* has been universally accepted as the perfect motion picture in natural colors." (Dr. Comstock, recalling the comment years later, said, "Of course, any really new product is a novelty and the public is far less critical at the start than it is sure to be years later.")

Every phase of the color work in the film was carefully watched by executives of the industry. Adolph Zukor of Famous Players-Lasky Corporation sent a note of congratulations. Producer-director Rex Ingram, who was in the midst of producing *The Prisoner of Zenda* for Metro Pictures, wired Mr. Loew for permission to scrap all the black-and-white scenes already shot on the picture and begin again in Technicolor. D. W. Griffith expressed an interest in color for a proposed version of *Faust*. And Douglas Fairbanks telephoned about producing a feature some day.

The "novelty" proved its earning power, grossing more than $250,000, of which Technicolor received approximately $165,000. "Our first adventure in Hollywood seemed successful," wrote Dr. Kalmus. "Thus far we had made only one feature and several inserts (sequences for Cecil B. DeMille's 1923 version of *The Ten Commandments*, shot by Technicolor's Ray Rennahan, which the director agreed to use only after seeing them). We were told that with prints as good as we were manufacturing, if offered at eight cents per foot, the industry would rush to color."

Cost was a major drawback, however. Technicolor had no adequate means of giving rush print service and the company was charging twenty cents per foot for release prints. But steps were being taken to help correct the situation. Plant Number Two (buildings were designated by number as construct-

ed) was being built in Boston in a building adjoining the Pilot Plant. The new facility would be able to handle approximately one million feet of prints per month. And in April, 1923, a team of Technicolor's top technicians ("Doc" Willat, J. A. Ball and G. A. Cave) was sent to the West Coast to establish a small laboratory and photographic unit. A rented building in Hollywood served as headquarters.

Despite Technicolor's efforts to make its services more available, and marketable at a more realistic rate, other problems began to surface. Theaters around the country began to report on the mounting complaints of their projectionists. Technicolor's film, actually two films cemented back to back to give the combinations of colors, "cupped" as it sped through the projectors—first one way, then the other. The men in the booths tired of the constant adjustments necessary to keep the picture in focus on the screen. Another problem concerned working conditions on the set. Slow-speed film required high-intensity lighting to capture color. Actors not only had to endure the heat and glare of the sun but banks of baking kleig lights, as well.

These objections failed to discourage one major Hollywood producer. In November, 1923, Jesse L. Lasky and Dr. Kalmus agreed on the terms of a contract between Technicolor Motion Picture Corporation and Famous Players-Lasky Corporation for the production of Zane Grey's *Wanderer of the Wasteland*—to be shot out-of-doors without artificial lighting. Dr. Kalmus related:…

We were told by Mr Lasky, that they had appropriated not more for this picture than they would have for the same picture in black-and-white. Also, that the time schedule allowed for photographing was identical with what it would have been in black-and-white. The photography was to be done by our cameras in the hands of our technical staff, following a budget and a time schedule laid out for

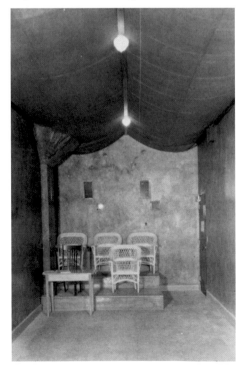

Early Technicolor screening room, ca 1920s.

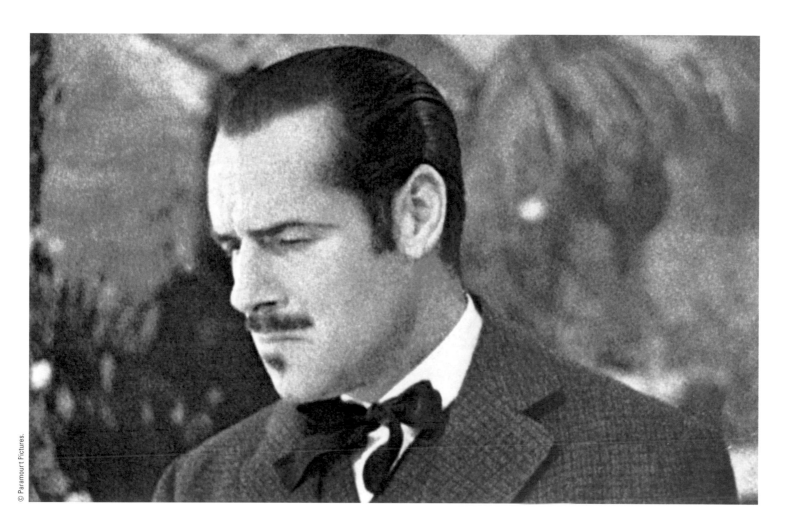

© Paramount Pictures.

ABOVE: Jack Holt in *Wanderer of the Wasteland, 1924.*

RIGHT: Gloria Swanson in *Stage Struck*, 1925.

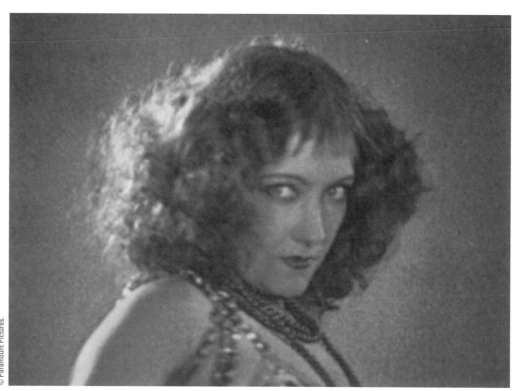

them by Famous Players. Rush prints and the quality of negatives were to be checked by them each day.

During the six weeks of photography our entire staff worked from early morning to late at night, including Sundays and holidays. At one time we were accumulating negatives which we did not dare to develop because of inadequate facilities in our rented laboratory. A few of us in Technicolor carried the terrorizing thought that there was no positive assurance that we would finally obtain commercial negative, and that the entire Famous Players investment might be lost. However, Mr. Lasky was not permitted to share that doubt. His confidence and help during the darkest hours were really marvelous and finally the cut negative emerged satisfactorily. We delivered approximately one hundred and seventy-five prints which were shown in several thousand theaters over the country.

Nevertheless, there were reasons why we could not obtain a volume of business. Every producer in Hollywood knew that the first important production by the Technicolor process under actual motion picture conditions and not controlled by the Technicolor company, had just been completed by Famous Players-Lasky Corporation. A considerable group of producers expressed themselves as interested, but were waiting to see the outcome. Another group believed the process to be practical and might have paid our then price of fifteen cents a foot, but considered it impracticable to send the daily work to Boston for rush prints.

Striving to make the services of his company as convenient as possible, Dr. Kalmus approved construction of a small plant at 1006 North Cole Avenue in Hollywood. The new building served primarily for the purpose of developing negatives, making rush prints, and providing a California headquarters for Technicolor.

Wanderer of the Wasteland, starring Jack Holt, Noah Beery, Richard Neill, and Billie Dove, provided an enormous boost for the Technicolor process with the moviemakers and the general public. Aside from the expense, Mr. Lasky expressed genuine pleasure with the new dimension and all that it brought to his production. "I particularly remember the dramatic use we made of color

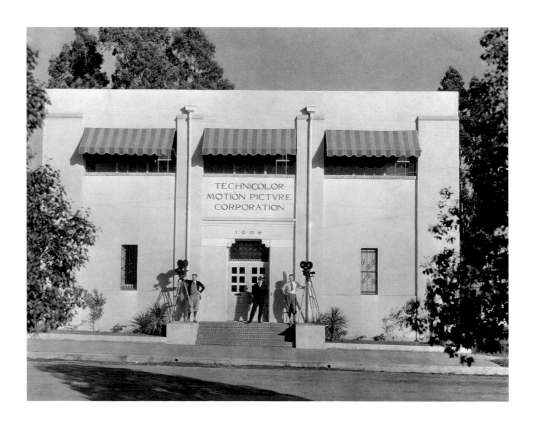

RIGHT: **The Technicolor plant at 1006 North Cole in Hollywood, mid–1920s.**

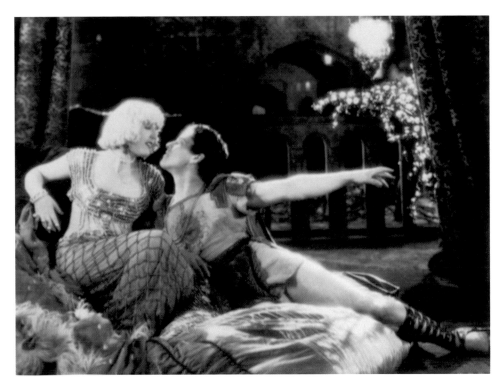

ABOVE: **Technicolor sequences were filmed for** *Ben-Hur*, **one of the early lavish productions, starring Carmel Myers and Ramon Novarro, 1926. The final release print contained little of the color footage, however.**

in one scene where the hero, tracking down the wounded villain who has concealed himself in a gold-mine stamp mill, notices a trickle of muddy water flowing from the mill sluiceway slowly turning red—and it thus led to the hideout of his quarry."

Neither *The Toll of the Sea, Wanderer of the Wasteland*, or any of the sequences made until the middle of 1924, had given the Technicolor people any experience photographing an interior set on an artificially lighted stage. Everything, to date, had been filmed out-of-doors with the aid of natural lighting. The staff was therefore enthusiastic when the company received a contract to shoot two dream sequences for the Samuel Goldwyn feature *Cytherea.*

The film was shot in Hollywood for First National Pictures under the direction of George Fitzmaurice. In its review of May 26, 1924, the *New York Times* said of *Cytherea's* color: "There are some exquisite sequences of color photography in which one enjoys the sight of the varied hues and tints of Cuban costumes and scenery . . . These are not only beautifully photographed, but they are introduced most realistically . . ."

Technicolor's first experience with indoor shooting was termed a success. Still,

the studios continued to be cautious. The company was currently involved in only one production, MGM's original *Ben-Hur*, filming in Rome. Six men and four cameras had been sent overseas. But upon release in 1926 the feature contained little of that footage. To Dr. Kalmus' dismay, *Ben-Hur* drew raves not for its color but for its chariot races.

It was a puzzling situation. Hollywood was churning out hundreds of films, yet few producers were willing to take a chance with color. The movie town was still young. The area was bustling with energetic, bright people filled with fresh ideas. Everyone wanted to be first with a new approach, to build a name and a reputation.

What could be more naturally suited for motion pictures than color? While black-and-white films seemed to satisfy most of the demands of the moviegoers and moviemakers, Dr. Kalmus knew that there was a vast audience that had yet to be exposed to his product—and he leveled part of the blame directly at the studios. "From my own point of view," he stated, 'they have never yet seriously undertaken any color work. By seriously, I mean with adequate preparation by people who are ambitious to do great work and who are at the same time sympathetic."

The doctor also felt that Technicolor needed a major personality to endorse it, one that would lend stature and marquee value. The movies had established a long list of powerful names: Gloria Swanson, Mary Pickford, Douglas Fairbanks, Rudolph Valentino, Colleen Moore, Harold Lloyd, Buster Keaton, Charlie Chaplin, William S. Hart, Tom Mix, John Gilbert, Pola Negri. And more. Trying to lure any one of them into a color production would not be easy, Dr. Kalmus knew. But the fact remained: Technicolor needed a star.

That hurdle was not as awesome as anticipated. In early 1925, Dr. Kalmus received a phone call in Boston from one of the greatest stars of silent films, Douglas Fairbanks. Mr. Fairbanks indicated that he had found a vehicle, *The Black Pirate*, and wanted to make

ABOVE: *The Black Pirate,* 1926.

good his promise of two years earlier. He had the idea, the doctor reported:

> . . . that the screen had never caught and reflected the real spirit of piracy as one finds it in the books of Robert Louis Stevenson, or the paintings of Howard Pyle, and that he could catch it by the use of color. He said, 'This ingredient has been tried and rejected countless times. It has always met overwhelming objections. Not only has the process of color motion picture photography never been perfected, but there has been a grave doubt whether, even if properly developed, it would be applied without detracting more that it added to motion picture technique. The argument has been that it would tire and distract the eye, take attention from acting and facial expression, blur and confuse the action. In short, it has been felt that it would militate against the sim-
>
> plicity and directness which motion pictures derive from unobtrusive black-and-white. These conventional doubts have been entertained, I think, because no one has taken the trouble to dissipate them. A similar objection was raised, no doubt when the innovation of scenery was introduced on the English stage—that it would distract attention from the actors. Personally, I could not imagine piracy without color . . .

The Black Pirate was to cost one million dollars, a staggering sum for the production of a motion picture in 1926. Mr. Fairbanks' attorneys, expressing natural concern, asked for a guarantee that Technicolor could deliver not only prints but satisfactory ones. A mutually satisfying agreement was reached when the engineering firm of Kalmus, Comstock & Wescott, Inc., assented to deliver prints in the event that Technicolor failed.

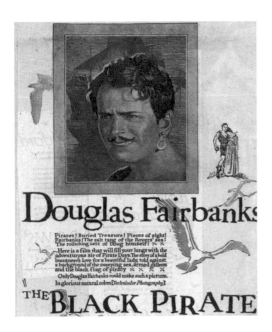

ABOVE: Ad for *The Black Pirate*, 1926. Technicolor's contributions were downplayed in favor of star and story.

BELOW RIGHT: Adventure on the high seas with Douglas Fairbanks in *The Black Pirate*.

As production began, according to Dr. Kalmus, there was "great discussion as to the color key in which this picture would be pitched. We made test prints for Mr. Fairbanks at six different color levels, from a level with slightly more color than black-and-white, to the most garish rendering of which the Technicolor process was then capable. "The star was taking no chances on this production. He spent $125,000 shooting over fifty thousand feet of film, over a four-month period, to test color keys, make-up (his co-star, Billie Dove, was selected because her complexion and coloring photographed so well in *Wanderer of the Wasteland*), fabrics—and even locations.

Douglas Fairbanks originally set to work on the shore of Catalina Island and off the shore on a specially constructed pirate ship (with four of the seven Technicolor cameras then in existence) to capture moods after the manner of impressionistic paintings. But much of that film was rejected because the backgrounds did not photograph to Mr. Fairbanks' satisfaction. Instead, most of

the picture was shot on the United Artists lot, including, as Dr., Kalmus expressed it, "some of the most realistic pirate scenes aboard ship . . . all being done on a tremendous model afloat in an artificial pool which is rocked by mechanically produced waves." Henry Sharp, Mr. Fairbanks' cinematographer, worked closely with Technicolor's own cameraman, George Cave.

During the production, Dr. Kalmus kept in constant touch with his eastern office. "No description which I have had and passed on of *The Black Pirate* pictures," he wrote to Dr. Troland, "has been adequate to express how really remarkable they are. Everybody concerned is just raving about them and my own enthusiasm is beyond anything I can express. Doug and his whole organization think this picture will be epoch making."

With the completion of *The Black Pirate*, all of the key elements Dr. Kalmus felt necessary for a truly exceptional box office attraction had come together. Now, there was nothing left to do but wait for the release of the film.

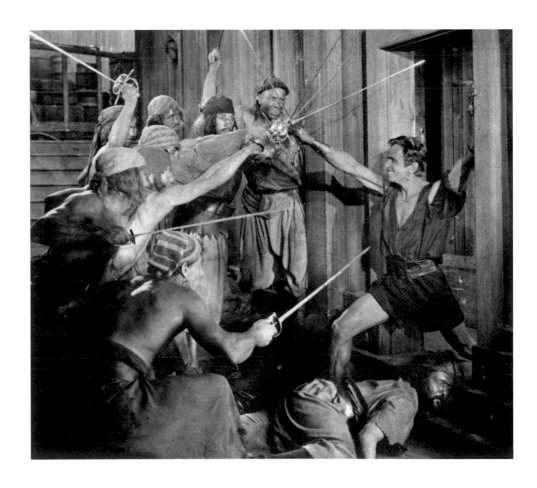

Four
PIRATES, VAGABONDS AND KINGS

*T*he *Black Pirate* was an immediate triumph. Audiences raved, theater receipts soared, and reviewers were unanimous in their praise of Douglas Fairbanks' "glorious chromatic production." Following the film's formal opening on March 8, 1926, at New York's Selwyn Theater,

attended by Mr. Fairbanks, Mary Pickford and other celebrities, the *New York Times* reported: "The unrivaled beauty of the different episodes is mindful of the paintings of the old masters."

More importantly, the still-new Technicolor process was technically applauded. "There is no sudden fringing or sparking of colors," noted the reviewer, "the outlines being always clearly defined without a single instance of the dreaded trembling 'rainbow' impinging itself upon the picture."

From its initial success, *The Black Pirate* was hailed as "another stride forward for the screen." But for Technicolor, as Dr. Kalmus was quick to admit, the film became one of the company's biggest headaches. The New York showing had been supervised by trained technicians in a controlled situation. But once prints of the film were released to outlying theaters, to be projected by virtually untrained operators, trouble mounted. Suddenly, word was out that the film was continually jumping out of focus.

It was the same old problem, "cupping,"

that had plagued the release of *Wanderer of the Wasteland* two years before. Only now, because of the broad distribution of *The Black Pirate*, it appeared to be more serious. Teams of men were sent about the country, rushing new prints to theaters and returning the damaged ones to the laboratory in Boston where they were put through a debuckling process and reshipped. Because these prints were temporarily satisfactory, the popularity of *The Black Pirate* was not diminished. And while, with special attention, executives at Technicolor realized they could operate in this manner for a picture or two, it was clear that their process was not a commercial success. That point reached home even more sharply when both Jesse L. Lasky and Douglas Fairbanks (who was personally upset over the too-dark night scenes in his film) reported to Dr. Kalmus, "We have concluded not to do more Technicolor pictures for the present."

The final blow landed in early 1927. Dr. Kalmus had made a special trip to the West Coast to meet with Louis B. Mayer and

Irving Thalberg at MGM. He memoed back
to Dr. Troland:

> *Metro wants to do* Rose Marie *in
> Technicolor. At the present moment they
> have three writers at work endeavoring
> to make a real subject of it. Dozens of
> questions came up regarding the treat-
> ment which they answer in conferences
> held twice a week, but the final decision
> has not been reached. On our part, var-
> ious technical questions arise, the last of
> which has to do with the amount of snow
> Technicolor scenes can stand in the
> background and foreground. I have just
> been running some snow shots for them
> in their projection rooms. A considerable
> portion of* Rose Marie *will be laid in
> the snow fields and the test snow shots
> we made show up very beautifully. Not
> twenty minutes ago Thalberg told me
> that he definitely had in mind to have
> the picture completed to show at their
> convention on May 1.*

Rose Marie missed the target date but it
was released the following year featuring
Joan Crawford and James Murray—in black-
and-white.

The doctor and his backers were back
where they started, with a multi-million dol-
lar investment and no customers. Clearly,
their existing color system had not been
accepted. It was now imperative for the com-
pany to come up with still another process,
one with both color component layers on
one side of the film instead of one on each
side.

Dr. Kalmus once more found himself
appearing before the directors of the compa-
ny to appeal for more money. This time, how-
ever, he was not after financial aid for new
cameras, printers, and research salaries.
Armed with encouraging word on his labora-
tory's development of the sought-after new
two-color process ("Technicolor Process
Number Three") and advice from Nicholas
Schenck, who felt the company should pro-
duce a picture itself to prove both quality and

costs, Dr. Kalmus urged funds for produc-
tion.

"When they asked me what I knew about
producing a motion picture," he later
recalled, "I frankly told them nothing, but at
least I could start from scratch without some
of the fixed ideas and prejudices concerning
color that some of the Hollywood producers
seemed to have accumulated."

Dr. Kalmus wanted to make short sub-
jects, not primarily to make money but to
prove to the industry that (1) there was noth-
ing mysterious about the operation of
Technicolor cameras (2) cameramen trained
to work with black-and-white film could easi-
ly adapt to color (3) rush prints could be
delivered promptly and (4) the job could be
done efficiently and economically. A series of
historical dramas, the doctor felt, would best
serve this purpose.

Dr. Leonard Troland, his esteemed asso-
ciate, totally disagreed as to the thematic
approach and spelled out his opposition in
detail.

> *It is obvious that we are making sub-
> jects to sell to the public for the purpose of
> amusing them and that our main pur-
> pose is not uplift or education. It, there-
> fore, seems to me that we must not be
> high-brow in our selections and that our
> pictures should appeal in a fairly simple
> way to primitive instincts, such as sex,
> fear, laughter, etc. Becoming acquainted
> with American history is certainly not a
> fundamental motive of this sort,
> although the appeal to patriotic emotion
> may work under certain circumstances.*

> *I am afraid that we are an academic
> or high-brow organization . . . Anything
> which we feel is beautiful is apt to be a
> flop with the public. Isn't it the best busi-
> ness judgement to do the old stuff that
> we know the public will buy, rather than
> try to set new standards in any domain
> except photography?*

> *I should like to see us make a series of
> two-reel comedies of very ordinary type so*

© Turner Entertainment Co.

far as action goes, but Ziegfeldized to the absolute limit that the censorship will stand. Then you will be playing color's highest card so far as box office value is concerned. I am as sure of this as any psychological proposition I would dare to lay down, because I know that the high-brows will buy us well as the low-brows when it comes to sex appeal, and color has a great deal to add here. People want a laugh or a kick and not tears or historical instruction. The latter is what they desire for their children, not themselves.

I should strongly recommend that we experiment with at least one subject which is distinctly of the type which we as a high-brow group would shun and would blush to sign our names to. Such an experiment will, in my opinion, be the best box office success of all.

Dr. Kalmus listened but held firm. The first of the Technicolor two-reelers debuted during 1927. Called *The Flag*, it starred Francis X. Bushman as George Washington and Enid Bennett as Betsy Ross and told the creation of Old Glory. As a companion piece to Charlie Chaplin's successful black-and-

white production of *The Circus*, its favorable reviews surprised no one, least of all Dr. Kalmus, who remarked, "George M. Cohan probably never produced anything more certain of applause than when George Washington unfurled the first American flag in glowing color." Immediately after its release, the doctor received a congratulatory memo from Leonard Troland, to which he replied, "I am so tremendously pleased that you liked the little picture so well and thank you for your earlier encouraging expressions with regard to it."

The Flag was followed by *Buffalo Bill's Last Fight* and *The Lady of Victories* (originally *More Than A Queen*). The latter film, an episode in the life of Napoleon and Josephine, starred Agnes Ayers and Otto Matiesen. It was factually weak but considered the finest example of color to date. In all, Technicolor produced twelve films in its *Great Events* series. The survival of the company has been credited to the experience gained in the making of these pictures.

Despite positive nationwide reaction to the series, the studios continued to be color shy. After all, as friends and associates made clear, the films were only short subjects.

Again, Nicholas Schenck stepped in. Produce a feature film, he suggested, and Metro-Goldwyn-Mayer would distribute it.

Since its release, in 1923, Dr. Kalmus had been impressed with the black-and-white production of *The Covered Wagon,* a story of love, survival, and the conquering of a continent. Why not produce a love story about the Vikings, he reasoned, one with the epic qualities of fighting mutiny and storms while conquering an ocean? Jack Cunningham, who wrote *The Covered Wagon* and a number of the *Great Event* shorts, was hired to write an original screenplay

© Turner Entertainment Co.

for *The Viking* to star Donald Crisp and Pauline Starke. When the final reel was processed, Technicolor had spent $325,000 on the production—and it showed. Irving Thalberg, MGM's wizard, liked the film so much that he decided to buy it for his studio and reimburse Technicolor for its expenses.

With its release of *The Viking* (1928), two major faults plagued the film. Although it was the first Technicolor motion picture to have synchronized music and sound effects, it was one of the last productions without audible dialogue. The second problem, and probably the most serious, was attributed to the very authenticity of the film. True to character, Leif Erickson, the Viking hero, had a long curling mustache. American audiences, at that time, preferred their idols to be smooth shaven. More than once, critics, noted, the entire screen appeared to be filled with Viking whiskers.

The film's faults aside, *The Viking* was heralded as an excellent color job and opened a few influential eyes. Technicolor had again proven itself and, in the process,

demonstrated that decreased costs were possible. Warner Bros. and MGM began planning their own short subjects in Technicolor, to be produced on a regular basis, and scheduled color sequences for two important films, *The Broadway Melody* and *The Desert Song.* The powers at Paramount, more than satisfied with the results they had seen, signed for a feature-length production called *Redskin.* The studios, at last, were becoming color-conscious.

It was up to Jack L. Warner, however, to take the plunge on a grand scale. Warner, whose brilliant experiments with talking pictures turned Warner Bros. from a company that made $30,000 in 1927 into one that earned over $17 million in 1929, was naturally receptive to another new cinema idea. Once he caught sight of the extra profits that color conferred to *The Desert Song,* he signed contracts calling for more than twenty full-color features. The package included *On With The Show,* the first all-talking, all-color picture, and *Gold Diggers of Broadway,* a movie gem which grossed over $3.5 million (the then-reigning box office champion was Warner's *The Singing Fool,* with a top of $5 million).

Just as Jack Warner's success with the "talkies" led other studios to abandon the silent film, his color creations started a new trend. Producers swarmed upon Dr. Kalmus and his facilities, waving cash and demanding footage. "As evidence of the increased color-mindedness throughout the industry," the doctor recorded, "Technicolor had contracts for the ten months beginning March, 1929, covering the photography and delivery of prints of the footage equivalent of approximately seventeen feature-length produc-

If rainbows were black and white

Suppose that, since the world began, rainbows had been black and white! And flowers; and trees; Alpine sunsets; the Grand Canyon and the Bay of Naples; the eyes and lips and hair of pretty girls!

Then suppose that, one day, a new kind of rainbow arched the sky with all the colors of the spectrum—that a hitherto undreamt-of sunset spread a mantle of rich gold over the hills.

In "Song of the West," Warner Brothers present all the magnificent beauty of nature, in Technicolor.

Literally, that is what happened to the motion picture screen. Technicolor has painted for the millions of motion picture "fans" a new world — the world as it really is, in all its natural color.

Yesterday is an old story in the annals of the "movies." For yesterday motion pictures were silent. And...yesterday motion pictures were black-and-white.

Today you hear voices, singing, the playing of great orchestras. Today you see the stars, the costumes, the settings—in natural color — in Technicolor.

DOLORES COSTELLO, lovely Warner Brothers star, is even more charming than ever, in Technicolor.

Technicolor *is* natural color

SOME OF THE TECHNICOLOR PRODUCTIONS

DIXIANA, with Bebe Daniels (Radio); GLORIFYING the AMERICAN GIRL, with Mary Eaton. Eddie Cantor, Helen Morgan, Rudy Vallee in revue (Paramount); GOLDEN DAWN, with Walter Woolf, Vivienne Segal (Warner Bros.); HOLD EVERYTHING, with Winnie Lightner, Georges Carpentier, Joe E. Brown (Warner Bros.); PARAMOUNT on PARADE, all-star revue (Paramount); The ROGUE'S SONG, with Lawrence Tibbett, Catherine Dale Owen (Metro-Goldwyn-Mayer); SON of the GODS, starring Richard Barthelmess (First National); SONG of the FLAME, with Bernice Claire, Alexander Gray (First National); SONG of the WEST, with John Boles, Vivienne Segal (Warner Bros.); The VAGABOND KING, starring Dennis King (Paramount); BRIDE of the REGIMENT, with Vivienne Segal (First National); UNDER A TEXAS MOON, with Frank Fay, Noah Beery, Myrna Loy, Armida (Warner Bros.).

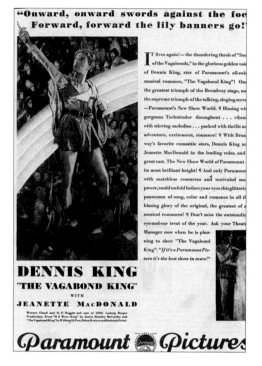

TOP: **A portion of Technicolor's expanding Hollywood facilities, 1930.**

ABOVE: Ad for *The Vagabond King*, 1930.

tions. This required a doubling of the Hollywood capacity which was accomplished in August, 1929. For the year 1930, Technicolor had closed contracts for thirty-six feature-length productions . . ."

During this boom period the company was pressed to such an extent that cameras operated day and night. Laboratory crews, not equipped to handle one-tenth of the volume they actually turned out, worked three eight-hour shifts. At one time, the extremely delicate process of printing the film was carried on amid the debris of falling bricks and the roar of riveters' guns in a building in which one wall had been torn away to permit enlargement. (Because of the highly explosive nitrate film being used, many of the new walls were constructed of massive steel and concrete, eighteen inches thick in spots.) Hundreds of new men were hastily trained to do work which properly required years of training. Many features were made which Dr. Kalmus personally counselled against, despite the fact that Technicolor's crowded schedules called for a deposit of $25,000. During this peak, the company had $1.6 million in cash payments on future contracts.

While Technicolor's facilities were being strained, so were the eyes and pocketbooks of movie fans across the country. America was in the throes of the Great Depression but theater screens offered a few hours of bright entertainment and, for the first time, a chance to see many of the top stars of the day in thrilling color—the beautiful Jeanette MacDonald in *The Vagabond King*, Paul Whiteman in *King of Jazz* (the first Technicolor film to win an Academy Award, and the first film to show a cartoon in Technicolor*), Charles "Buddy" Rogers and Nancy Carroll in *Follow Thru*, Marilyn Miller in *Sally*, John Boles and Vivienne Segal in *Song of the West*, Irene Bordoni in *Paris* and Eddie Cantor in *Whoopee*.

* Created by Walter Lantz and Bill Nolan for five-minute opening sequence.

Technicolor wasted no time in promoting these star-filled productions and, in the process, the wonders of its color. In a series of lavish and colorful multiple-page spreads, highlighted with hand-tinted stills from the newest releases in Technicolor, the color company pulled out all the stops, touting its process as the greatest, the grandest, the most glorious. An early 1930 issue of *Saturday Evening Post* featured this inspired, dramatic copy:

> As the theater slowly darkens . . . you wait, tingling . . . alert for the first stab of light from the projector's lofty eye. Then it comes . . . not the neutral, gray shadows of yesterday. But Technicolor! Can you describe it ,this glorious spectacle? Are there words to match the soft glow of color . . . the bewildering beauty . . . the reality? And this reality is literally breathtaking! The shadow actors of the black-and-white drama are transformed. An authentic bloom rests on the curve of their cheeks. Their lips, their eyes and hair. . . it's all real. They greet you, face to face, just as the cameras caught them. That is Technicolor. As though a great magician had touched the screen . . . the shadows . . . with living color . . . with a vital, natural, overpowering personality! MOVING PICTURES ARE LIVING PICTURES NOW.

The good Technicolor pictures drew curious customers for a time, but soon producers, caught in the race for color, began rushing out releases that ranged from mediocre to bad. Even in normal times and under optimum working conditions, the two-color process had serious weaknesses. Limited to shades of red and green, and their combinations, many compromises had to be made. Blue and various other hues, could not be achieved, therefore, outdoor scenes required camera angles that did not show large areas of sky or water. When it became necessary to photograph those areas, audi-

ABOVE: **Samuel Goldwyn (wearing hat) and Florenz Ziegfeld on the set of *Whoopee*, 1930. Goldwyn's production assistant, Arthur Hornblow, is seated at right with head cameraman, Ray Rennahan, standing cameraside.**

ences saw them at dusk or dawn—or so they imagined—with the available warmer tones prevailing. Trying for added realism, dramatic effects became commonplace and many films took on a mystical quality.

Perhaps one of the most glaring casualties of two-color Technicolor can be seen in a color sequence from the movie *Irene*, starring Colleen Moore. According to producer-director Mervyn LeRoy, who had worked as a gag writer on the film, a major problem was encountered in shooting the *Alice Blue Gown* number. "Everything possible was tried to make the dress appear as blue but there was nothing anyone could do about it. Audiences had to settle for a pale green."

Technicolor alone could not be blamed for the declining quality of color feature films. The producers themselves had very little color sense, either from the standpoint of arranging esthetic compositions or acquiring a tint technique. Hollywood had gone "color mad" but little else had really changed. No one seemed to realize that a color film is simply not a black-and-white film shot in color. Everyone at the studios had grown up in a black-and-white world and did things in a black-and-white way.

There was more than casual concern at Technicolor. At the Boston lab, Dr. Troland memoed George Cave: "We are certainly having the matter of poor quality rubbed into us here. Some critics think we would better shut down on color for a year, until we get it ready for use . . . Metro particularly emphasizes the idea that we are putting out a lot of stuff

ABOVE: **Scene from** *The Show of Shows,* **1929.**
(Ad line: "One hundred shows in one. One hundred
stars. One thousand Hollywood beauties.")

RIGHT: **Jack Oakie and Polly Walker star in** *Hit the*
Deck, **1930.**

which is not doing us any good."

 Audiences were now growing weary of the increasing number of second-rate films with poor stories—a monotony of musicals and period pieces—that were to be saved, hopefully, by (less than perfect) color. Realizing the shortcomings of his two-color process, Dr. Kalmus reported to Technicolor's directors: "The fact that we have signed this large volume of business on the

basis of our present two-color process has not altered, in my opinion, the fact that the quality of this two-color output is not sufficiently good to meet with universal approval, and hence cannot be regarded as ultimate . . . Consequently, I feel urgently that our drive to put our process on a three-color basis as soon as possible should not in the least be abated."

 Dr. Kalmus' remarks couldn't have been more timely. With dwindling theater

ABOVE: **Marilyn Miller** in *Sally*, 1929.

ABOVE RIGHT: **Alice White** in *Showgirl in Hollywood*, 1930.

attendance (receipts for mid-1931 were the lowest in fifteen years), the producers soon realized that Technicolor was not a cure-all for the industry. Contracts were canceled, guarantee money was refunded, and production slowed again to a few short subjects. Color pictures had once more fallen into disfavor. Technicolor, however, was not sit-ting quietly in its newly expanded Hollywood plant. A revolutionary new color process was in the final stages of development. The only question now was, would anyone be receptive to it?

Five
ALL THE COLORS OF THE RAINBOW

B y May, 1932, Technicolor had completed its first three-component camera and had one unit of its main processing plant, shifted the previous year from Boston to Hollywood, equipped to handle a moderate amount of three-color printing. Though the new process

was more expensive (cameras alone cost $30,000 each to build), it reproduced faithfully any shade or hue, indoors or out, and for the first time color movies were true and realistic. "Not only is the accuracy of tone greatly improved," Dr. Kalmus noted, "but definition is markedly better. The difference between the three-component process and the previous two-component processes is truly extraordinary."

Dr. Kalmus was aware that he could not offer his new process to one customer without offering it to all, which required many more cameras and the conversion of a greater portion of the laboratory. Too, he was continually haunted by the fact that the studios were still burning over their recent adventures into color, and wanted no part of any new product, no matter how extraordinary it was.

To allow time to become better equipped—the company had learned its lesson only a few short years before—and to prove the new process beyond any doubt, the doctor sought first to try it out in the cartoon field. No cartoonist, however, wanted color.

The general feeling was that animated features were good enough in black and white and that, of all the departments of production, cartoons could least afford the added expense.

Undaunted, Dr. Kalmus continued making the rounds of artists and animators. His dedication finally paid off. Walt Disney felt that color might make some sense in his *Silly Symphonies*, an umbrella title for a continuing series of light, whimsical fantasies. Although Disney had never used the two-color process in any of his creations, he was so impressed with the new three-color that he openly stated, "I wanted to cheer."

On the day Walt Disney saw his first demonstration of the new Technicolor, he called on master showman Sid Grauman with a film sample. According to Disney, Grauman took one look and fairly erupted with excitement. "Walt," exclaimed Grauman, "if you make *Flowers and Trees* in the Technicolor process, you've got a booking at my Chinese Theater. The picture and Technicolor are made for each other."

"I started on the greatest campaign of persuasion in my life," said Disney. "There were plenty of our associates—including sales and financial—who thought I was crazy. Cartoons sold well in black and white, they argued. Why change?"

One of the dissenters was Walt's brother, Roy. As financial guardian, Roy Disney felt it his duty to point out the likely hazards involved with color animation and even went so far as to try and enlist support from influential associates in an effort to discourage Walt. United Artists, distributor of the Disney shorts, shared that concern. The studio would distribute Disney's product, if he could produce one, but would not advance him any money.

Walt Disney had been working on a cartoon called *Flowers and Trees*, the nonsensical romantic adventures of two young saplings and a cantankerous old stump, when Dr. Kalmus approached him. Although nearly half the film had been completed in black and white, he decided to scrap the footage and have his artists begin again—this time in full color. Roy was appalled, not only at the total waste of good product but at the thought of adding another ten thousand dol-

lars, at least, to the cartoon's cost.

In late 1932, *Flowers and Trees* premiered at Grauman's Chinese Theater in Hollywood as a companion piece to Irving Thalberg's production of Eugene O'Neill's *Strange Interlude*. Despite its fragile storyline and colors that tended to be somewhat washed out by today's standards, the new Technicolor turned the cartoon into a valuable property. *Flowers and Trees* became the first Disney production to win an Oscar (Best Cartoon of 1931-32).* The success of this venture and the even greater success of the all-color *Three Little Pigs*, which earned another Academy Award the following year, told Disney his instincts had been correct. Technicolor was a natural for his cartoons.

It wasn't too long before Walt Disney had signed a contract to operate on a strictly color basis, producing both the *Silly Symphonies* and *Mickey Mouse* cartoons in Technicolor. (The first short Mickey Mouse cartoon in color, made in 1932, was seen only at that year's

The Academy also recognized Technicolor's contribution by honoring the company with a Class II (Technical) Award for its Color Cartoon Process.

RIGHT: **Disney's 1933 Technicolor success,**
Three Little Pigs.

Academy Awards ceremony by a limited audience.) In return for Disney's pioneering with the new process, Dr. Kalmus gave him a three-year exclusive for the cartoon field. What originally appeared to be a smart move turned out to be nearly fatal.

Once the popularity of Disney's color creations had been proved, other producers began to approach Dr. Kalmus for film for their cartoons. Having to turn them down put the Technicolor chief in an awkward position. How, for example, could he refuse MGM the use of Technicolor? Doing so would naturally influence Mr. Mayer's decision to use the process in lengthier productions. Feature films were the real goal of the Technicolor company.

With Walt Disney's consent, the three-year exclusive was reduced to one. In the meantime, the studios and cartoonists would be allowed use of the previous two-color process. Under proper supervision and handling, everyone agreed, the old system would be satisfactory, particularly for animation. The agreement also gave Technicolor's out-

moded equipment a second lease on life. The company had thirty two-color cameras on hand, all standing idle. The deal made with Disney's competition extended their usefulness one extra year.

While the producers willingly admitted they had been wrong about color in cartoons, they were still certain they were right about features. Whenever Dr. Kalmus sought to break the barrier, he was asked, "How much more will it cost to produce a feature in three-color Technicolor than in black and white?"

His reply was simple, "You have all seen Disney's *Funny Bunnies*," he would tell them.* "You remember the huge rainbow circling across the screen to the ground and you remember the funny bunnies drawing the color of the rainbow into their paint pails and splashing the Easter eggs. You will admit that it was marvelous entertainment. Now I will ask you how much more did it cost Mr. Disney

* Actual release title of the *Silly Symphony* cartoon was *Funny Little Bunnies*.

© Disney Enterprises, Inc.

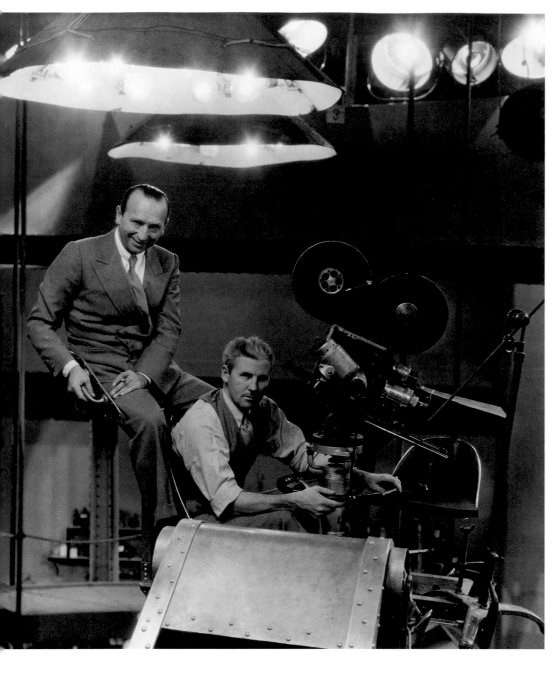

to produce that entertainment in color than it would have in black and white?" The answer was that it could not have been done at any cost in monochrome.

Having made his point, the doctor would then draw a similar analogy with regard to feature production, telling his skeptics:

> *If a script has been conceived, planned and written for black-and-white, it should not be done at all in color. The story should be chosen and the scenario written with color in mind from the start so that by its use effects are obtained, moods created, beauty and personalities emphasized, and the drama enhanced. Color should flow from sequence to sequence, supporting and giving impulse to the drama, becoming an integral part of it and not something super-added. The production cost question should be, what is additional cost for color per unit of entertainment and not per foot of negative? It needn't cost any more, of course.*

The producers listened but they didn't buy.

Another breakthrough came when Merian C. Cooper and John Hay (Jock) Whitney began to show a practical interest in Technicolor. Mr. Cooper was a noted motion picture director (*King Kong*), producer (*Grass, Chang, The Four Feathers*), cinematographer (*Gow, The Head Hunter*) and former production chief at RKO-Radio Pictures. Mr. Whitney was a horse fancier, pilot, Chairman of the Board of Freeport Texas Company (sulphur producers), and the cousin of wealthy Cornelius (Sonny) Vanderbilt Whitney.

It was Merian Cooper's enthusiasm for Technicolor that first attracted Jock Whitney to the picture business. In turn, Jock Whitney interested his cousin Sonny. The result was the formation of Pioneer Pictures, Inc., organized in the spring of 1933, with distribution to be handled through RKO. While there was no corporate connection between Pioneer Pictures and Technicolor,

OPPOSITE PAGE TOP: **Director Michael Curtiz (left) and Ray Rennahan on the set of *The Mystery of the Wax Museum*, 1933.**

OPPOSITE PAGE BOTTOM: **Dr. Kalmus checks a reel of film.**

BELOW: **Early three-color Technicolor camera. (For a detailed description of the three-color process, see Appendix: The Technicolor Technique.)**

a personal one was established when a large block of Technicolor stock was purchased by the two Whitneys. On May 11, 1933, Pioneer signed a contract with Technicolor calling for the production of eight films, "superfeature in character and especially featuring color."

There were still questions to be answered, and to protect the fledgling studio's investment conditional clauses were inserted into the contract, among them a provision requiring extensive preliminary testing prior to production. Would the three-color process indeed capture all shades of blue? Would a leading lady with dark hair photograph against light backgrounds? Conversely, a blonde against dark backgrounds? What about make up? And the visibility of extremely small figures in the background? Technicolor was now moving into "live" production—a far cry from the work, to date, in the cartoon field.

Exhaustive tests under various conditions were made, with the results proving more than satisfactory to Mr. Cooper and the Whitneys. Now began the hunt for a suitable feature-length property, the first story ever to be produced in the newest Technicolor process. No less than two hundred ideas were under consideration.

While the search for a story continued, under Jock Whitney's supervision, Pioneer Pictures' hierarchy decided to "get its feet wet" by shooting a live action two-reeler which, in a sense, would be nothing more than an expanded test of the process under actual production conditions.

A thin-plotted storyline (how a hot-tempered cantina girl maneuvers to recapture her dancer/lover) with an intriguing title, *La Cucaracha*, was chosen. Except for hiring Robert Edmond Jones, the famed stage designer whose use of colored lighting revolutionized Broadway in the 1920s, as art director and the movies' Kenneth Macgowan as producer, the film featured no big names. This was understandable inasmuch as stars

were unwilling to appear not only in the new process but in short subjects as well. For the leading lady, the studio hired Steffi Duna, a fiery young singer-actress from the Tingle-Tangle, an intimate theater in Hollywood. Veteran character actor Paul Porcasi and Don Alvarado were handed the male leads. The project garnered unexpected publicity when John Barrymore, a close friend of Mr. Jones', volunteered to play Hamlet for the lighting tests, which involved experimental placements of various colored filters over the lamps to add splashes of vivid color to the otherwise pastel mood.

Pioneer spared no expense on the production of *La Cucaracha*, spending about $65,000 (the usual short then ran about $15,000). But this initial effort from the studio was in no way intended to be "just a short." Nor was it considered that by the powers at Technicolor. In being the first non-cartoon picture to reach theater screens, one that had been photographed in studio conditions with the new Technicolor, *La Cucaracha* would bring human figures in full color to the general public for the first time. The industry watched its progress with interest.

As expected, when the film was released in 1934, reviewers tended to overlook the principals and plot in favor of the new Technicolor process. Said one:

> . . . *the colors are clear and true; when a gentleman in a close-up turns red with anger you can see the color mounting in his cheeks . . . there are now rich, deep blues and it is no longer necessary to avoid or to regret the existence of blue skies, blue water and blue costumes. The old process presented blurred outlines which were even harder on the eyes than its imperfect colors Color producers today may again mishandle their medium—but at least they will have good colors, well focused, to abuse. There is no question that color has made* La Cucaracha *an outstanding short.*

At the 1934 Oscar ceremonies,

La Cucaracha won the Academy Award for best Comedy Short Subject.

Although Pioneer Pictures' first entry into movie production had created a stir, the studio continued to move cautiously in selecting a property for its first full-length feature. Even so, Technicolor's business was improving. Between *Flowers and Trees* and *La Cucaracha,* the company had completed work on no less than fifty productions, either cartoons, short subjects or sequences within black-and-white films. Among them were a Disney insert, *Hot Chocolate Soldier,* for MGM's *Hollywood Party* starring Jimmy Durante, and a sequence for the closing scene in Twentieth Century Pictures' *The House of Rothschild* with George Arliss, Boris Karloff, Robert Young, and a rising contract player named Loretta Young. Twentieth, like Warner's and MGM, which were also timidly experimenting with Technicolor, appeared to be even less confident than the other major studios. *The House of Rothschild* footage was shot in both color (it was the first test of the new process on a very large set) and black-and-white, the latter to be substituted in all release prints depending on public reaction to the Technicolor version.

Another closing sequence to reach the screen appeared in Samuel Goldwyn's *Kid Millions* on which Daily Variety reported: ". . . an ice cream factory number in Technicolor is one of the finest jobs of tint-work yet turned out by the Kalmus lab, and the joint Seymour Felix-Willy Pogany handling of the colors, mass movements and girls creates a flaming crescendo for the production." The enormous popularity of comedian Eddie Cantor introduced many customers to "living color" via this film.

As Technicolor began hitting the screen in bits and pieces, the news was released that Pioneer Pictures had finally selected a vehicle for the first full-color, full-length motion picture. The property was Thackeray's classic, *Vanity Fair.* Within the year, film audiences would know it as *Becky Sharp.*

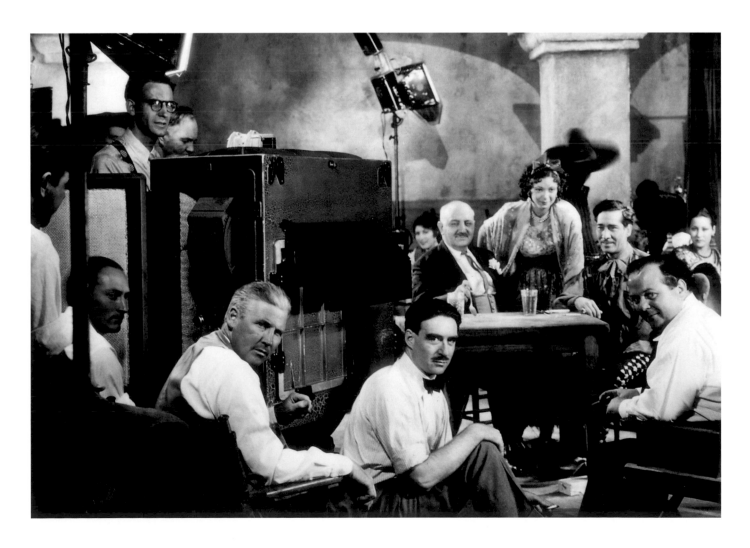

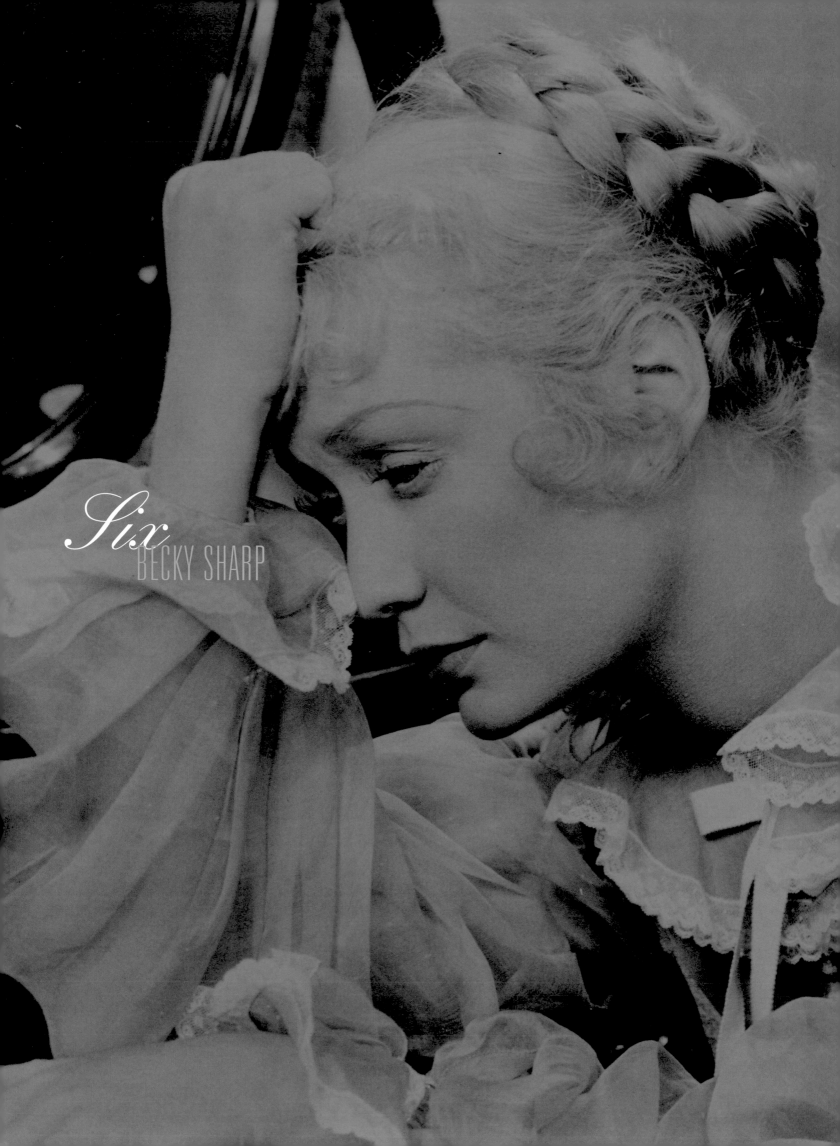

Six
BECKY SHARP

*T*he introduction of Technicolor's new three-color process, based on the release of *La Cucaracha*, had split the film world into two argumentative camps. On the one hand were the cinematographers, directors, art directors, and various executives who felt that natural

color photography would herald an industry revolution as sweeping as the one introduced by sound. The opposition felt that, while color was interesting, it could play no really important part in the dramatic and artistic advancement of the cinema.

The color controversy spread to the general public as well—and had film fans playing a guessing game as to the vehicle for the first full-length feature. Based on reports that had reached the nations press, the odds-on favorite had been *The Three Musketeers*, starring Francis Lederer. The selection of *Vanity Fair* surprised many people.

Becky Sharp went into production on December 3, 1934, at the RKO Pathe studio in Culver City, with Miriam Hopkins in the title role as "a poor girl with expensive tastes who lives by her wits," Frances Dee as Amelia Sedley, Cedric Hardwicke as the Marquis of Steyne, Billie Burke as Lady Bareacres, and Nigel Bruce and Alan Mowbray in featured roles. Robert Edmond Jones, who worked on *La Cucaracha*, was engaged to handle settings and costumes.

Filming began on an optimistic note but a series of events occurred which soon labeled the production, as Dr. Kalmus put it, "a champion for hard luck." The original director, Lowell Sherman, was taken ill only three weeks into shooting. He died before the month ended.

Sherman's directorial credits included *She Done Him Wrong*, the 1933 film that launched Mae West's movie career, and the same year's *Morning Glory* for which Katharine Hepburn won an Academy Award. He was an elegant, witty man with a flair for the high style comedy of manners that attracted audiences during the dim Depression days. It was hoped he could restrain the dynamic Miss Hopkins, whose on-screen presence often overpowered everyone and everything in sight, in favor of the new color process.

Director Rouben Mamoulian (*Dr. Jekyll and Mr. Hyde*, 1932; *Queen Christina*, 1933) was hired to step in where Sherman had left off. But on viewing the scenes already shot, plus Technicolor demonstration film, he was not pleased. Mamoulian said:

BELOW: **Miriam Hopkins as** *Becky Sharp*.

BOTTOM: **Miriam Hopkins and Alan Mowbray in** *Becky Sharp*, 1935.

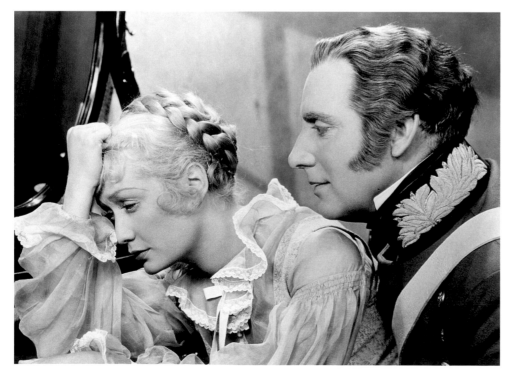

Up to now the moving picture industry has been like an artist who was allowed only to use pencil or charcoal. Now Technicolor has given us paints. Color is an adventure—and a promise. But, at present, it is in about the same stage of development as was sound when the first talkies were made. Color is mechanically well developed but no one has used it enough to be fully conversant with the artistic technique of applying it constructively to production.

Do you remember when the first talkies came out, how carefully we recorded every slightest noise that might be 'natural'— every footstep, every rustle, every door-slam, even to eggs sizzling in a frying pan? Well, until now, color has been in exactly the same stage of development. We have had the means of bringing color to the screen and we have taken pains to see that it gave us plenty of color. But from now on we must be selective, using color intelligently for its dramatic, emotional value as well as for pictorial purposes. The main thing is not to get excited over color to the point where enthusiasm for color overbalances what we have already learned about film craftsmanship.

Before the cameras were to roll again on *Becky Sharp*, Rouben Mamoulian had met with Robert Edmond Jones and associate art director Wiard Ihnen. Together, a decision was reached to completely redesign the look of the film, to use color delicately, yet dramatically, rather than for purely decorative effect.

Mamoulian's linking of color and sound was ironic. No sooner did production resume than problems were encountered in recording the audio portion. As Dr. Kalmus recalled, "Mr. Whitney (of Pioneer Pictures) suddenly found himself in the anomalous position of having to produce the first three-color Technicolor feature, of having to surmount all the hazards of color, yet being in difficulty with an aspect of the work which everyone had naturally taken for granted."

Becky Sharp soon became an expensive workshop and constant experimentation was necessary. As Dr. Kalmus put it, "*Becky's* production extravagance was a demonstration of how not to make a picture for profit."

The picture was set in England during the days of Napoleon so it was only natural that soldiers with red coats of that period be a part of the cast. Yet early in the filming the art and color specialists discovered the dangers of injecting any of the primary colors in heavy doses.

Until the entry of the first red coat, the rushes revealed, there was something very pleasant, almost poetic, in the use of pastels and grays. But the sudden arrival of too much red was a shock. The eye caught it and held on throughout the scene.

Another illustration of the power of red, thought to be a dramatic color accent at the time, became evident in one scene where Miriam Hopkins and several other cast members were seated in the foreground. In back of them was a large vase of red roses. The flowers completely "upstaged" the performers.

Color became a scene-stealer again in a sequence where Becky, dressed in bright blue, confronted a soldier in a red coat. The result

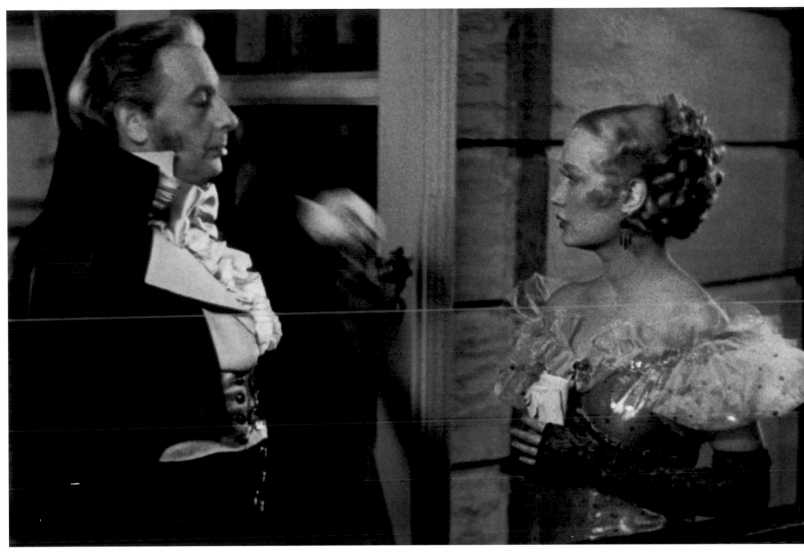

ABOVE: **Miriam Hopkins and Cedric Hardwicke in** *Becky Sharp*.

was a harsh clashing of colors, forcing the viewer to continually shift his attention.

Karl Hale, an early color specialist who followed the filming with interest, offered the film-makers this advice:

"Too much color will tire one very quickly. What you learned about composition in black and white will not mean much in color filming if you do not watch the placement of your colors. Color itself can throw your composition all awry. It will make its own composition in spite of you.

"It seems as though it would be best to lead up into the heavier colors slowly. Attempt the softer shades, learn the value of color and especially the placement of values. Otherwise you are merely going to have a hodgepodge of color without any central interest."

Color designer Robert Edmond Jones

had these thoughts:

"With the new process, the possibilities are unlimited. Rather, they are limited only by the intelligent artistry with which the color is employed . . . Up to now, of course, the industry has been anything but color-conscious. Now that we have color— and very good color—to work with, we must learn to think in terms of color. But color does not mean an abundance of color. This can not be too strongly emphasized."

Basically, *Becky Sharp* was made to prove a point: that color, in all its glory, had at last arrived upon the screen. And while chromatic effects were used with splash at times, the picture also revealed moments of great restraint and inventiveness. One now-famous sequence was superb in the way color was handled to heighten dramatic impact. The scene was the Duchess of Richmond's Ball. Napoleon's can-

nons had sounded at Waterloo and fear was spreading among the dancers. As the scene builds to a climax, through a series of intercut shots, the audience sees the colors shift from the coolness and sobriety of grays, blues, greens, and pale yellows to the excitement and danger of deep oranges and flaming reds. The effect was achieved, according to Director Mamoulian, by the selection of dresses and uniforms worn by the characters and the changing color of backgrounds and lights.

Becky Sharp was completed on March 20, 1935, at a cost of nearly one million dollars. On its release in late spring, the film was generally crucified as dramatic fare, classed as "dull . . . artificial . . . tedious." But *Becky Sharp* was a milestone in screen entertainment. Audiences were more attracted by its color than by its story or its characters and players. And from that standpoint alone, the film received high praise and fair evaluation. Said the *New York Times* its review of June 14, 1935:

> *Science and art, the handmaidens of*
> *the cinema, have joined hands to endow*
> *the screen with a miraculous new element*
> *in* Becky Sharp *. . . Although its faults*
> *are too numerous to earn it distinction as*
> *a screen drama, it produces in the spec-*
> *tator all the excitement of standing on a*
> *peak in Darien and glimpsing a strange,*
> *beautiful and unexpected new world. As*
> *an experiment, it is a momentous event,*
> *and it may be that in a few years it will*
> *be regarded as the equal in historical*
> *importance of the first crude and*
> *wretched talking pictures. Although it is*
> *dramatically tedious, it is a gallant and*
> *distinguished outpost in an almost*
> *uncharted domain, and it is probably the*
> *most significant event of the 1935 cine-*
> *ma.*
>
> *Certainly the photoplay, coloristically*
> *speaking, is the most successful that has*
> *ever reached the screen. Vastly improved*
> *over the gaudy two-color process of four or*
> *five years ago, it possesses an extraordinary*
> *variety of tints, ranging from placid and*
> *lovely grays to hues which are vibrant with*
> *warmth and richness. This is not the col-*
> *oration of natural life but a vividly pig-*
> *mented dream world of artistic imagina-*
> *tion.*
>
> *The major problem, from the spectator's*
> *point of view, is the necessity for accustom-*
> *ing the eye to this new screen element in*
> *much the same way we were obliged to*

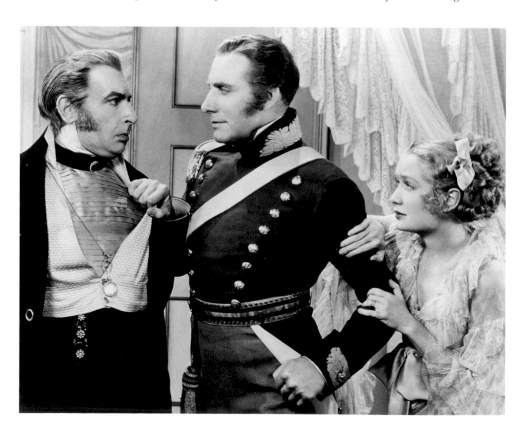

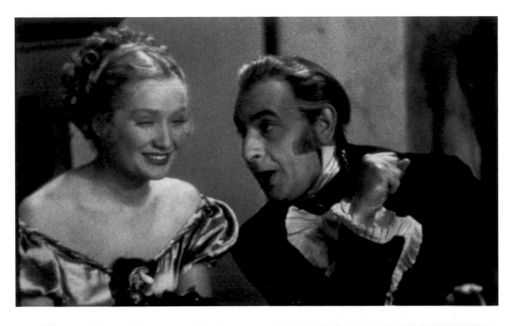

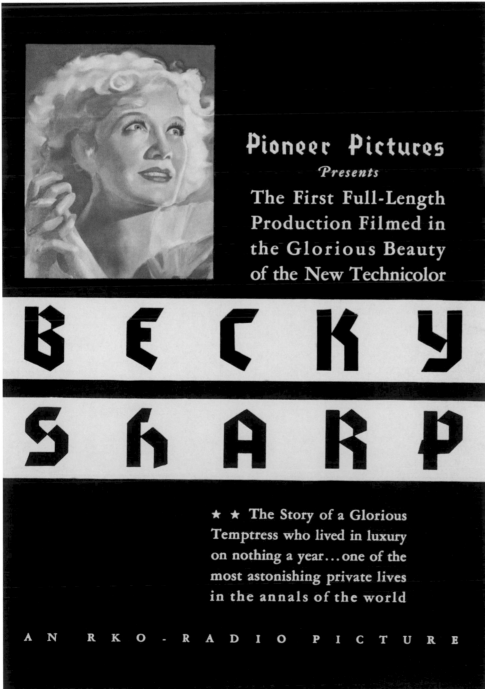

accustom the ear to the first talkies . . . At the moment, it is impossible to view Becky Sharp *without crowding the imagination so completely with color that the photoplay as a whole is almost meaningless. That is partly the fault of the production and partly the inevitable consequence of a phenomenon.*

Said *Variety*: "Technicolor's tints offer magnificent eye entrancement to give added significance to the pre-Victorian comedy-drama for smash entertainment. . . The color is so entrancing that it threatens at times to beguile the appreciation away from the story, and this exhibit suggests that color may have to be fed to audiences a little more moderately while they get inured to the vivid new screen process. Use of the blues especially would seem to call for more care to prevent too sharp contrasts"

Variety's comment regarding "use of the blues" was particularly meaningful. The color-men, obviously overreacting to the old two-color process' inability to record the color blue, became heavy-handed in trying to impress viewers with their new capabilities.

Other critics were brutal in their evaluation of the new film, noting that the skin tones were often "over ripe" and that "there is no sex appeal in a gal who looks as if she is in the last stages of scarlatina." One even remarked that "all the actors look like roast turkeys." Within a few years, such comments would haunt Technicolor.

While the public rushed to see *Becky Sharp* and the color controversy raged, one basic fact emerged: the film did not introduce the hoped-for perfect color. Nor did it prove to the feature field what Disney had proved to the cartoon field—that increased box office returns accompany good pictures, economically made with the additional appeal of color. However, *Becky Sharp* did represent a tremendous advance beyond the previous two-strip process and established the point that a true, natural color system had finally arrived.

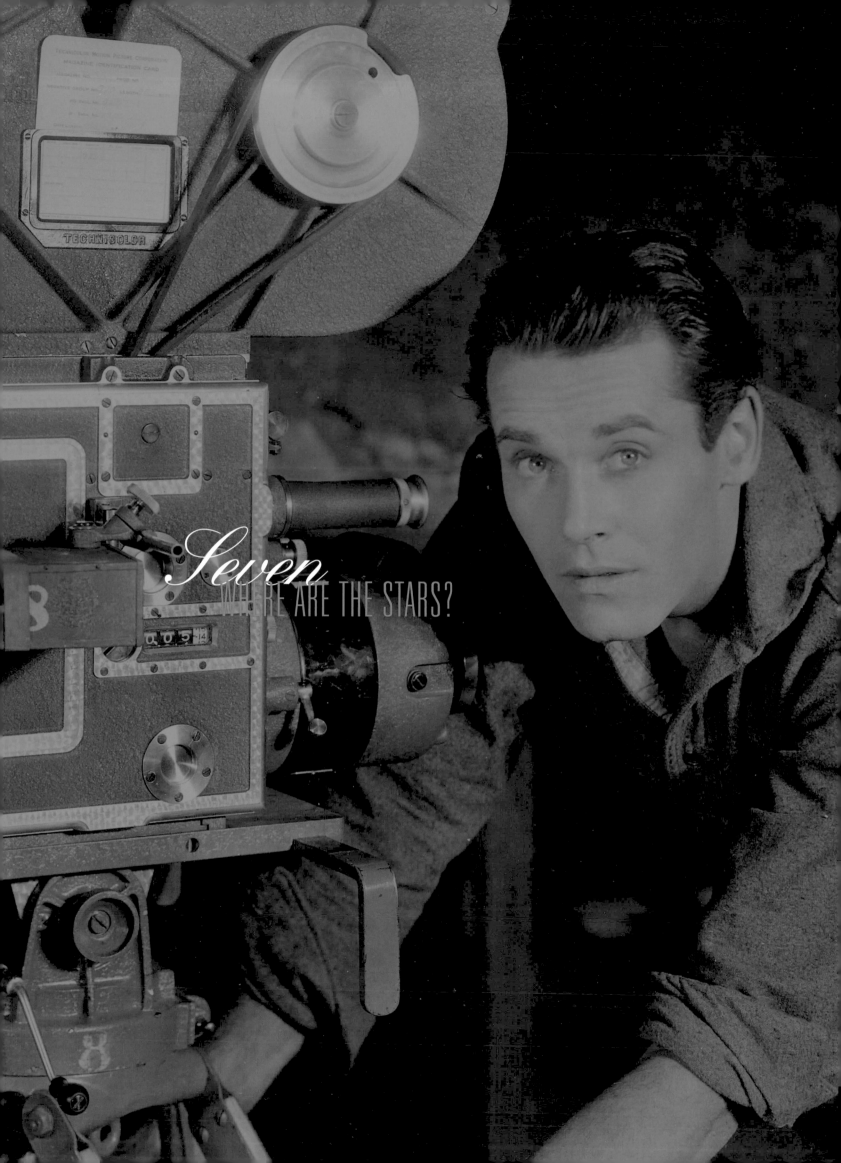

Seven
WHERE ARE THE STARS?

*T*n mid-1936, a Los Angeles newspaper reported that the respected cinematographer Hal Mohr had predicted that *The Green Pastures*, the film he was then currently shooting, would be the last major production to be filmed in black and white. The column further

quoted him as saying he and his fellow cameramen were "storing in mothballs their hard won cinematographic arts in favor of the new chromatic medium which had bloomed overnight to dominate the Hollywood production schedule."

Carl Laemmle, the president and founder of Universal Pictures, was in Paris when he heard about the Hal Mohr item and immediately refuted the prediction. He was described as adamant when he told reporters that "most motion pictures of the future would be in black and white."

The truth was, Mr. Mohr had never made such statements nor did he have any idea as to how they reached the paper and were accredited to him. What made the comments even more incredible was the fact that a notice in *The Hollywood Reporter*, dated August 11, 1936, listed forty-five productions in progress in Hollywood Studios. Only one was shooting in color. Looking even farther ahead, *Motion Picture Herald*, noted for its reliability, reported on four hundred and eighty-five features projected for the coming production season by

the ten largest companies. Of those, only three were to be in color.

To date, three feature films in the new Technicolor process had been released: *Becky Sharp* in June, 1935, *The Trail of the Lonesome Pine* in March, 1936, and *Dancing Pirate* in May, 1936. During this same period, over five hundred black-and-white films were made and released.

The early rush by moviegoers to see *Becky Sharp* generated wild optimism both at Pioneer Pictures and at Technicolor. Initially, it was heralded as a box office smash. Within weeks after the release of the picture, however, audience interest dropped sharply. *Becky Sharp* was not a financial success nor was it highly regarded as a theater attraction by exhibitors.

The *Trail of the Lonesone Pine*, Walter Wanger's outdoor drama with Sylvia Sidney and screen newcomers Fred MacMurray and Henry Fonda, fared much better and became a highly successful and profitable venture. But the question around Hollywood was, to what degree did color influence its popularity?

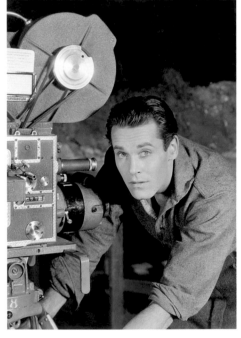

TOP: **Director Henry Hathaway on the set of**
***The Trail of the Lonesome Pine**, 1936, the first*
outdoor drama filmed in full color.

BOTTOM: **Henry Fonda on location for his second**
feature film, *The Trail of the Lonesome Pine*.

*to imprison the rainbow in a series of care-
fully planned canvases that were radi-
antly startling, visually magnificent,
attuned carefully to the mood of the pic-
ture and to the changing tempo of the
action.*

*Trail attempts none of this.
Paradoxically, it improves the case for
color by lessening its importance. It accepts
the spectrum as a complementary attribute
of the picture, not its raison d'etre. In
place of the vivid reds and scarlets, the
brilliant purples and dazzling greens and
yellows of* Becky Sharp, *it employs sober
browns and blacks and deep greens. It
may not be natural color but, at least, it
is used more naturally. The eye, accus-
tomed to the shadings of black and white,
has less difficulty meeting the demands of
the new element; the color is not a distrac-
tion but an attraction—as valuable and
little more obtrusive than the musical
score.*

Motion Picture Herald called it ". . . one of
the most important motion pictures, not sim-
ply because it is a color picture in which the art
of intelligently and expertly applying hues and
tints approaches perfection, rather more
because of the depth and power of its motivat-
ing human interest heart-touching story, the
high quality of acting provided by principals
and support, finesse of direction, and worth of
substantiating production features."

The general consensus seemed to be that
The Trail of the Lonesome Pine could not be
hailed as a monumental color triumph.
Rather, it was a shrewdly handled picture that
made money—and incidentally happened to
be made in color.

Dancing Pirate, which featured Steffi Duna
(of *La Cucaracha* fame), Frank Morgan and
Charles Collins, didn't fare too well at the box
office and proved to be Pioneer Pictures last
feature. Upon release of the film, the studio
was dissolved and Mr. Whitney joined with
David O. Selznick in the formation of Selznick
International Films.

In the screenplay, the producer had a
proven theatrical property, one that had been
filmed earlier (1916) in black and white. The
new version was created with an eye to story,
unfolding of drama and entertainment con-
tent. Unusual precautions were taken to keep
the color subdued and of secondary interest.
"The goal we set at the start of the production
and never deviated from," Mr. Wanger
declared, "was to hew to the storyline and let
color fall where it may."

To a great extent, Mr. Wanger and his
director, Henry Hathaway, succeeded in
achieving their goal. Said the *New York Times* of
the production:

*Color has traveled far since first it
exploded on the screen last June in* Becky
Sharp. *Demonstrating increased mastery
of the new element, Walter Wanger's pro-
ducing unit proves . . . that color need not
shackle the cinema but may give it fuller
expression.*

*Chromatically, Trail is far less
impressive than its pioneer in the field.*
Becky Sharp *employed color as stylistic
accentuation of dramatic effect. It sought*

The production missed with the critics as well, although their evaluations were positive regarding its color. *Dancing Pirate*, said *The Hollywood Reporter*, "belongs to that fantastic school which deems anything is permissible as long as it is played against a musical background. It has gorgeous color, intelligently and sparingly used by Robert Edmond Jones, but little else to recommend it as a potentially great box office attraction. It will have to be sold almost entirely upon the novelty of color."

Many of the writers appeared overly opinionated in their evaluation of the new color technique. "One hour of color," noted one reviewer, "is too much color at one sitting. Eyes are accustomed to reading from black against white."

Wrote another: "Inclusion of color stifles the greatest of audience reactions; it does not stimulate the imagination. Color, of itself, will not impart dramatic punch."

Still another: "Individuals have definite color prejudices. One may have emphatic antipathy for greens in wearing apparel. If the star appears in a gown of green, his sympathy is immediately alienated."

One exhibitor, after a screening of *Dancing Pirate*, offered a more objective view. "The producers missed fire here." he stated. "In making a great picture you must have

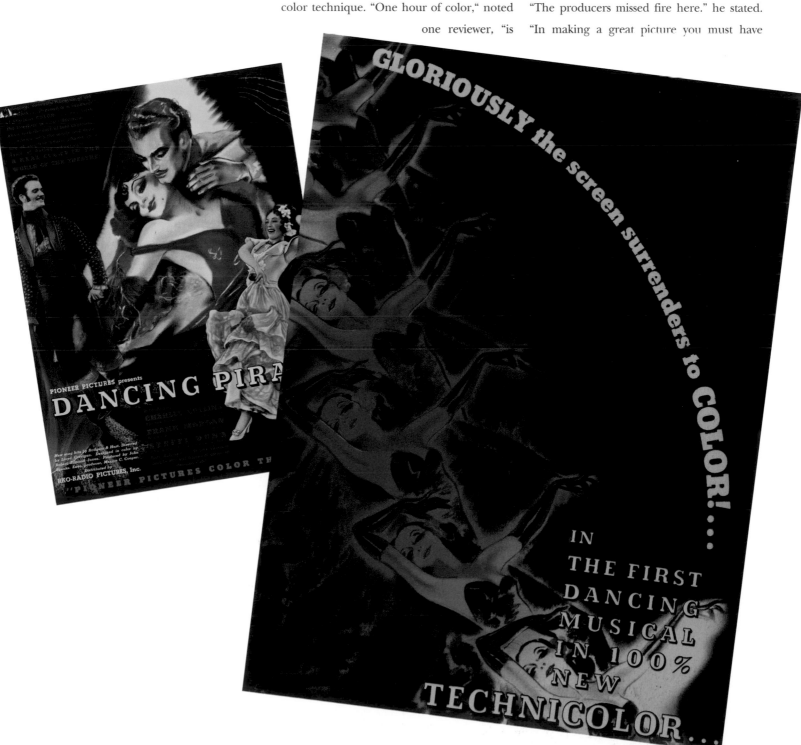

names that sell at the box office." The inference was clear. Color alone could not carry a picture—nor could color lure enough customers to the ticket windows to encourage producers to jump picture costs another third by adding the involved and highly technical new process.

The top stars of the day included Shirley Temple, Clark Gable, Fred Astaire and Ginger Rogers, Dick Powell, Joan Crawford, Claudette Colbert, Jeanette MacDonald and Gary Cooper. These stars, and others, were generally under contract to the major studios, which were hesitant to use their top players in a color production. Color was still a novelty and having them appear, or even be associated with such a production, could jeopardize their futures. The smaller studios rarely had a stellar personality.

Rogers and Astaire were set to face the Technicolor cameras in early 1938. Having the cinema's top dancing duo appear in Technicolor generated great excitement at the color plant's Hollywood offices. Who better than this popular pair to give Technicolor a big boost?

The film, *Carefree*, featured new songs by Irving Berlin. One of the numbers, "The Night Is Filled With Music," was dropped when producer Pandro S. Berman decided to film a Technicolor "dream sequence" within the black-and-white production. In its place, Berlin wrote "I Used to Be Color Blind." The lyric was tailor-made for Technicolor, as it described the "green in the grass . . . gold in the moon . . . blue in the sky," capped with, "you brought the colors out." The lush setting, with a rainbow and oversized flowers and leaves (the dance floor was formed by giant, floating lily pads), looked like a corner of Oz.

Tests were made, then came the bad news. It wasn't that the tests disappointed, only that the already financially strapped studio, RKO, feared the added expense. Eleven years would pass before Fred Astaire and Ginger Rogers appeared together in a Technicolor film (MGM's *The Barkleys of Broadway*).

Ginger Rogers may have been agreeable to appearing in Technicolor, but she was an exception. In fact, most established leading ladies of the mid-1930s wanted to avoid Technicolor. Black-and-white filming had developed to such an art that a variety of subtle lighting techniques were available to establish various effects and moods. Color lighting tended to be brilliant and harsh. To obtain an image for color film, subjects had to be flooded with light from all angles.

The majority of studios opted for a "wait-and-see" approach and let their continuing black-and-white schedules reflect executive opinion. Seldom were the stars allowed to speak their minds, although there were those who let their thoughts be known. In November of 1936, Walter Wanger, whose success with *The Trail of the Lonesome Pine* prompted him to be a color enthusiast, was searching for a leading lady to play the starring role in his production of *Vogues of 1938*. His first choice was Carole Lombard. Miss Lombard had a reputation for frankness and did not hesitate in admitting her fear of color to the press. "Sure, I'll read the story of *Vogues*," she said, "but, you know, color goes a little screwy at times and I'm not just sure I want to make a Technicolor picture."

The fact that *Vogues of 1938* was to be a glamorous "clothes picture" seemed to be a powerful influence in getting Carole Lombard to even consider the role. But she recalled the sometimes "over ripe" tints of *Becky Sharp* and color frightened her. The role was eventually assigned to Mr. Wanger's wife-to-be, Joan Bennett.

Bette Davis, too, was an outspoken holdout. She considered her 1936 black-and-white picture, *Satan Met A Lady*, to be a disaster and pleaded with her studio, Warner Bros., for a good property. Jack L. Warner personally sent her a script of *God's Country and the Woman*, a north woods melodrama the studio had scheduled for the following year's release. To entice Miss Davis, he emphasized that she would be co-starring with matinee idol George Brent in

ABOVE: "Color goes a little screwy at times," said Carole Lombard.

the studio's first three-color Technicolor feature film. The star was not at all interested and called the entire project "tripe." She held firm even after Mr. Warner returned to tell her that he had just taken an option on a then unpublished novel. If she would do *God's Country and the Woman*, the role of the book's heroine, Scarlett O'Hara, was hers. The studio placed Bette Davis on suspension.

In spite of the drawbacks, Technicolor did have one advantage that intrigued actresses: it did not project with pinpoint sharpness on the screen. To get a "soft focus" in black and white meant diffusing the lens. With mid-1930s Technicolor there was no need for diffusion. That point, however, was not enough to induce the likes of Joan Crawford, Greta Garbo or Norma Shearer to desert the security of their monochromatic world. And so, whenever a major studio experimented with color, it preferred to give its newcomers a chance. Far safer, for example, to cast Frances Farmer rather than risk Claudette Colbert's career.

Miss Colbert would not even consider appearing in color films. By 1936, she was a screen veteran and a top money-maker. Her saucy hairstyle and sophisticated looks were

known to millions of moviegoers. Despite her vast appeal, she had always felt that her face, with its wide-set eyes and high cheekbones, was difficult to photograph. Too, her nose was broad at its base. She was, therefore, insistent that she be photographed only from certain more flattering angles.

To further help heighten her appeal, she became a master of make-up, devising such "tricks" as running a tinted line down the center of her nose and around the base of the nostrils to minimize the broadness. With special filters and diffusion lenses on the camera, her technique was highly successful for black and white filming. Color was another story.

In 1939, she surprisingly agreed to appear in *Drums Along the Mohawk*, to be directed by John Ford. Mr. Ford was not one to pamper his stars, and he shot the film and the performers his own way. Claudette Colbert did not appear in another color production for sixteen years (*Texas Lady*, 1955).

Money, of course, was a major determining factor in casting. The top stars commanded large salaries. Why gamble with the added expense of Technicolor when a big name alone could virtually insure the success of a black-and-white picture?

Technicolor was in the throes of another cycle. To Dr. Kalmus, the situation was much too similar to the one that faced his company in 1925. Douglas Fairbanks had given color an important boost in that year but there was no Fairbanks on the horizon now. It was even more frustrating to know that a true, full-color process, one that photographers and moviemakers had dreamed about for over one hundred years, was finally here. People were no longer saying, "It can't be done." It could be done. It had been done.

Whatever criticisms that had been leveled at color in pictures, the doctor knew, were not insurmountable nor basically the fault of his process. The system worked. It simply needed refining—and it was up to Technicolor to prove it.

Eight
REVOLUTION BEHIND THE SCENES

*S*tarting in the mid-1920s, Technicolor had made available a color consulting service to work with the studios and designers prior to and during film production. Now that service was not only available but required—and expanded to include the upgrading of virtually

every facet involved in color photography. A contract with Technicolor was a package that included not only the rental of the three-color camera but a Technicolor cameraman who worked as an advisor to the studio's cinematographer; advice given to art directors, set directors and designers, wardrobe and property departments; use of make-up and assistance to the studio make-up departments; the requirements of special lighting equipment; and laboratory processing up to and including the final release prints. Technicolor had but one goal in mind: that of adapting the Technicolor cameras and equipment, and the user of the Technicolor process, to picture production, with the smoothest possible coordination and the fewest possible special facilities or special equipment.

THE CAMERAMEN. Technicolor's staff of cameramen were drawn from the ranks of black-and-white studio cinematographers and trained in the special requirements of color photography. They were taught to "think

color" at all times, to know its limitations, to become expert in the areas of exposure and lighting, and to be able to handle any assignment, exterior or interior, that required shots ranging from a minute insect to a towering skyscraper.

Originally, the major photography on all three-color features had been handled by one of the company's cinematographers. Dr. Kalmus knew, however, that with increased use of the process, the work had to become the responsibility of the studios' first cameramen. That point was obvious for a number of reasons. These men were familiar with their individual studio's special requirements; they knew the crews and how to get things done in the shortest, best possible way. Too, they were sensitive to the special photographic requirements of the stars on their lots and had the confidence and respect of the studio staffs.

At Technicolor's insistence, it became standard practice for a studio first cameraman to team with a Technicolor first cameraman. The feeling was that during the course

ABOVE (LEFT TO RIGHT): **Technicolor cameramen Ray Rennahan, William Skall and W. Howard (Duke) Greene.**

of production the studio man would gain insight not only into the new color process but the camera and side equipment as well. Eventually, he would be on his own and would not require the assistance of a Technicolor cameraman. Said one cinematic journal: "This policy should be of great benefit to Technicolor for it will not only develop greater variety and individual style in Technicolor productions, but it will also eliminate the divided responsibility, and its inevitable friction, which seemed inseparable from the old arrangements."

Technicolor's camera crew included many of the finest cinematographers in the business. Ray Rennahan, the company's cameraman on *La Cucaracha* and *Becky Sharp*, was ultimately involved in more color productions than any other motion picture photographer and was honored with a number of Academy Awards and nominations for his work on such features as *Gone With the Wind*, *Blood and Sand*, *For Whom the Bell Tolls*, and *Lady In The Dark*. Over the years, others in the department were recognized for their outstanding achievements as well. Among them were: W. Howard (Duke) Greene (*The Private Lives of Elizabeth & Essex, Blossoms In the Dust, Phantom of the Opera*), Allen Davey (*Hello Frisco, Hello, Cover Girl, Life With Father*), William V. Skall

(*Northwest Passage, Reap the Wild Wind, Joan of Arc, Quo Vadis*), Wildred M. Cline (*Aloma of the South Seas*), Charles Boyle (*Anchors Aweigh*), Winton Hoch (*She Wore A Yellow Ribbon, The Quiet Man*), Art Arling (*The Yearling*) and William Snyder (*The Loves of Carmen, Jolson Sings Again*). All were members of the American Society of Cinematographers.

Since the Technicolor camera and accessory equipment were precision machinery, a staff of trained technicians was maintained to care for them. On each studio set where Technicolor cameras were in use, there was a skilled technician functioning as an assistant cameraman. Backing up these men was a group of maintenance men who, at the end of each day's shooting, returned the cameras to the Technicolor service department in Hollywood for servicing and cleaning, both mechanically and optically. The cameras were then returned to the studio, in top condition, for the next day's work. On distant locations, cameras were maintained in the field.

COLOR COORDINATION. Mrs. Natalie Kalmus had at one time attended an art school in Boston. While in Europe with Dr. Kalmus, shortly after their marriage, she resumed her

TOP: **Working directly from scripts, Mrs. Kalmus and her staff prepared color charts for each scene, using actual fabric samples and paint swatches.**

ABOVE: **Natalie Kalmus, Technicolor's color consultant, ca 1930s.**

training at the University of Zurich in Switzerland. Later, she continued her studies at Queen's University in Ontario upon his appointment to the staff.

During the early days of Technicolor, she participated in many of the color tests, working as a "stand in" for the performers and offering artistic advice on color harmonies. Natalie Kalmus was, in fact, the model toward which the first crude Technicolor camera was pointed.

In 1921, unknown to all but the couple's closest friends and associates, Natalie and Dr. Kalmus divorced. Instead of living apart, however, they continued to share homes on both coasts part of each year: the primary Italianesque estate in Bel Air, outside Hollywood, and a New England farmhouse at Centerville on Cape Cod. The arrangement was in the traditional manner of the times which had broken New England families with estranged spouses living out the balance of their lives in the old home without speaking to each other. The Kalmuses broke with tradition, crossing the imaginary boundary lines down the center of their homes, only to dine or entertain, when Natalie acted as the gracious hostess. On those occasions, the doctor considered Natalie to be a guest under his roof. Guest or

not, Natalie insisted on being called Mrs. Kalmus.

This unusual relationship was ended in 1946 by a written agreement involving a hefty cash settlement plus continued alimony and a pension from the company. It was not her first trip to court. From 1921 until the mid-1950s Natalie made a second career of taking the doctor to court in an attempt to nullify the divorce, get her share of community property and part of the Technicolor pie.

Their personal lives had no bearing on their working relationship at the office, which remained professional and dedicated. By 1926, as part of the divorce settlement, Natalie had become an integral part of the company, having established the groundwork and fundamentals for Technicolor's "Color Advisory Service." Ten years later, as head of the department, she supervised a large staff and was destined to become one of the best known and most influential of the company's personnel. Until 1948, her name appeared as "Color Consultant" within the credits of virtually every motion picture made in Technicolor.

Dr. Kalmus had a reputation for being a perfectionist. He felt that the sight, on the screen, of less than ideal or improperly used color only impeded his company's aims and progress. It was his hope that this newly strengthened department would become a keystone to Technicolor's future. As such, it became the connecting link between the studios' creative experts (the art directors, set designers and decorators, wardrobe designers, and property departments) and Technicolor during both the preparation and the shooting of a film.

The work of Mrs. Kalmus and her staff, notably longtime associates Henri Jaffa and William Fritzsche, began long before the cameras rolled. "We first receive the script for a new film," she noted, "and we carefully analyze each sequence and scene to ascertain what dominant mood or emotion is to be

expressed. When this is decided, we plan to use the appropriate color or set of colors which will suggest that mood, thus actually fitting the color to the scene and augmenting its dramatic value. We then prepare a color chart, using actual samples of fabrics and materials, for the entire production—each scene, sequence, set and character being considered. This chart may be compared to a musical score, and amplifies the picture in a similar manner."

Because the early two-color pictures could reproduce color, producers often thought they should continually flaunt vivid hues before an audience. Such practices led Natalie Kalmus to develop a creed which she based on "the law of emphasis." That is, *Nothing of relative unimportance in a picture shall be emphasized.* She believed in simplicity and sought to eliminate distracting focal points within scenes, unnecessary busyness that succeeded only in disturbing a viewer's concentration or in tiring his eyes.

"Natural colors and lights do not tax the eye nearly as much as man-made colors and artificial lights," she stated. "Even when Nature indulges in a riot of beautiful colors, there are subtle harmonies which justify those colors." To that end she created a method of distinct "color separation," a term, she explained, which means "when one color is placed in front or beside another, there must be enough difference in their hues to separate one from the other photographically. If the colors are properly handled, it is possible to make it appear as though the actors are actually standing there in person, thus creating the illusion of the third dimension."

Because of the general warm glow of flesh tints, she usually introduced the cooler tones into the backgrounds. If she found it advantageous to use warmer tones in the set, she suggested lighting that would create shadows in back of the actor. As for the performers themselves, she noted, "We plan the colors of the actors costumes with especial care. Whenever possible, we prefer to clothe

ABOVE: **Wardrobe test for Olivia de Havilland in** *Gold Is Where You Find It,* 1937.

them in colors that build up his or her screen personality."

Mrs. Kalmus introduced the art of modifying colors so that the eye would accept the desired shade. For instance, she discovered that, under the strong Technicolor lights, white constantly changed in value and tone, picking up and absorbing the reflections of surrounding colors. When dyed a neutral gray, however, it would appear white on film. The practice had another advantage: it eliminated glare. A stark white shirt would often cast so much reflected light that an actor's face would either be undistinguishable or lost entirely. This artful trick was not limited to costumes. Props and sets were modified in color at times as well. But clothing was the big item, so much so that Malone's Studio Service, a dry cleaners in Hollywood, made a specialty of it.

Mrs. Kalmus was also a strong believer in the language of colors ("They alone speak with more eloquence than can be described by words . . .") and she often relied on it to establish a mood. But she exercised great restraint and never allowed the heavy-handed color symbolism that surfaced during the sweep of the 1920s. It was not uncommon to see the silent screen flooded with red to emphasize an actor's rage—or green to show his envy.

As the reigning Technicolor authority on color artistry, Natalie Kalmus certainly had her detractors, particularly in the latter days of her career (there was talk of overly officious behavior, drinking, even that she was color*blind*). Through it all, however, she never swayed from the beliefs she established in her department during the mid-1930s: "The principles of color tone, and composition make a painting a fine art. The same principles will make a colored motion picture a work of art."

MAKE-UP TECHNIQUES. Prior to the development of three-color Technicolor, during the days of black-and-white and two-color movies, motion

ABOVE: **Max Factor applies make-up to starlet Rita Cansino (the future Rita Hayworth) in his salon, 1935. Factor created a new line of cosmetics specifically for full-color Technicolor.**

picture make-up was applied in a heavy, theatrical manner, mainly to give the skin a smooth, unblemished appearance (the covering of minor skin problems, fine lines and wrinkles). The delicate shadings that are normal in good flesh tones were not required.

In 1928, however, Max Factor began experimenting with a new make-up for two-color Technicolor, which was first used in the Technicolor-produced short, *The Viking.* The new make-up, a variation of the old paste or greasepaint formula used for black-and-white filming, made the faces of the performers appear flawless—until the Technicolor cameras rolled. On film, in close-ups, their faces turned green or red or yellow depending on the color of a nearby object.

Perc and Ern Westmore, two sons of George Westmore, patriarch of the family of Hollywood make-up artists (and director of MGM's make-up department), worked for Max Factor during the late 1920s and early 1930s. Perc Westmore's first experience with Technicolor came when he was assigned to work with Broadway star Marilyn Miller for her role in the early sound, two-color musical, *Sally* (1930). "We gave her the prettiest peaches-and-cream make-up we knew," Westmore recalled at the time, "using a very light touch because of the camera's color magnification. We were horrified when her face turned up a bright red in the rushes.

Mine was almost equally red until, on checking, we found that her face had picked up a red reflection from the red-and-white checkered cover of the table she was leaning on. And this discovery of the importance of color near the player was a keystone for much of our later work.

"In black-and-white, for instance, an actress may wear a pink-and-white make-up that photographs beautifully in white light. But let her get under a blue arc and her face comes out gray and muddy on the screen. Under a magenta light, a pink make-up goes ghostly white."

With the arrival of the new three-color Technicolor process and its high sensitivity of the total color range, a radically different approach to make-up application and materials was needed. Sensing a possible trend toward color, Max Factor and his son Frank (later renamed Max Factor, Jr. after the death of his father) began to experiment on a new, non-reflecting make-up, one that was unlike any other form of make-up. It could not contain greasepaint in its composition, they determined, and had to be so extremely thin that the wearer (and Technicolor camera) would be unconscious of it.

By late 1937 the Factors had perfected a line of make-up expressly for the new full-color Technicolor. Called the "T-D" series, it offered a wide range of shades, from extremely light to extremely dark, in a numbered sequence. Developed in compressed "cake" form, "T-D" make-up was applied with a thin coat using a damp sponge, which offered a transparent matt finish. The line, which eventually became famous as "Pan-Cake" make-up, was first seen in the 1937 film, Walter Wanger's *Vogues of 1938.* "Pan-Cake" not only dramatically changed all concepts of professional make-up but became the fastest selling make-up essential in the history of the cosmetic industry.

The project was enormously complex, as Max Factor admitted:

Previous make-ups were based on various combinations of pink, yellow

ABOVE: Banks of lights flood the ballroom set for the Technicolor final sequence in *The House of Rothschild*, 1934.

and white. Well applied, they may have looked very nice to the eye but the more critical color camera unmasks it for the glaringly unnatural thing it is. In analyzing the human complexion with a spectroscope, we found that the darker pinks, or red, are present as well as certain proportions of yellow, white and blue. This is true because the skin itself is essentially a translucent covering with relatively little color of its own. So our new make-up had to be made to blend with not one but a number of colors.

The new Technicolor make-up was intended to duplicate, in tones the camera could interpret, the coloring of the underlying complexion. Radical changes in a person's coloration were avoided. Said Mr. Factor, "In black-and-white we worked with contrasts of light and shade. When making up a blonde, for example, we sought to heighten that tonal contrast by applying a rather dark make-up which gave a positive contrast to the light hair. In color, this is not the case. A blonde or brunette would use a make-up of a color in keeping with her own complexion . . . We are no longer striving for a purely artificial contrast but seeking to imitate and enhance the subject's natural coloring."

The application of make-up was the responsibility of the studio make-up departments, although the color cameramen could request "touch ups" when necessary. The heat of the lamps often caused problems, particularly on interior sets. Moist or oily skin surfaces, which caught or reflected color and light, had to be toned down. Other problems surfaced on exterior locations. With the actors working in bright sunshine, they usually began to sunburn and make-up changes became necessary to compensate for the gradually tanning complexions. The reverse was also true. When the cast moved indoors to continue shooting, their slowly fading tans needed attention.

During this early period, new make-up tricks were devised and honed to a high degree by the Factor group and others, notably Perc Westmore. Long faces were shortened, noses were narrowed, eyes were widened, and double chins were made to disappear. Leading men were handsome and debonair; leading ladies were beautiful and sophisticated. Glamour, in greater doses than ever before, was in vogue.

Make-up for Technicolor had certainly not been perfected by 1936. Continual

advances were made through the years to keep pace with the developments within color filming. It was a big start, however. To the film crowd, the flawless faces that began appearing on the tinted screens gave Technicolor performers a look all their own.

LIGHTS! LIGHTS! LIGHTS! Performers who had worked in Technicolor productions had one common complaint: the extreme heat of the lamps. Temperatures on the sets were so high that flowers wilted and paint blistered. Said one cameraman, "I once saw smoke rising from an actor's hair!"

The scene was a far cry from the earliest days of motion pictures when photography relied only on natural daylight to capture images on film. The very first studio, Thomas Edison's, was in fact constructed upon a giant turntable so that "the set" could be rotated to follow the sun.

Moving pictures began to mature just prior to World War I when various artistic accessories were brought into practice, such as artificial lighting to help establish mood and effect. Simple street-type lights were first used, then more powerful carbon-arc floodlamps. From the theater stage, spotlamps were adapted. The Kliegl brothers of New York developed the Klieg light especially for motion pictures.

Incandescent lights gained popularity because they could be used in areas where the larger lamps could not. They provided a softer, less direct source, and they were clean. (Stages frequently had to be aired to clear the smoke from some high powered sources.) "Inkies," as they were known, were also quieter. Microphones were keenly sensitive to the sizzling, sputtering sounds of arc lights.

During the mid-1920s, "inkies" created a revolution of sorts in motion picture lighting. But all of that changed with the introduction of Technicolor's new three-strip process. It was not a move in the right direction. The new Technicolor required an exceptionally high light level to record all the colors on film—a flat, white light and plenty of it. The only source really capable of providing that output was the old-fashioned arc lamp. This time, it returned in larger doses and with it came soaring temperatures and complaints from performers.

During the development of its new color process, Technicolor had contacted several suppliers and manufacturers of cinema lighting equipment. Initially, special units of improved quality were devised and, from time to time, new designs and modifications were brought into production. Still, they did little to relieve the discomfort, nor did they permit cinematographers the hoped-for flexibility (or level of artistry) they enjoyed with black-and-white filming.

The big breakthrough came in 1939 when Technicolor announced, after a lengthy period of secret research and development, the discovery of a new, faster film which would yield superior color rendition, less graininess, and sharper definition with greater depth of focus. The greatest benefit, however, was in the area of lighting. "The new film," said cameraman Ray Rennahan, "is three times as fast as the old film under artificial light and four times as fast to daylight. This brings color lighting to levels practically identical to those used in monochrome . . . In other words, this new film enables us to reduce our lighting levels by a good fifty percent."

The news had immediate impact. Now far less light was needed. Smaller, handier units could be used and with greater flexibility, especially in lighting people. An added benefit was the lowering of production costs.

The turnabout had not come overnight. When it did, color cinematography took an impressive step forward.

BELOW: **The powerful Mole-Richardson carbon arc lamp of the mid-to-late 1930s was used in large doses as a floodlight or spotlight in both interior and exterior Technicolor cinematography.**

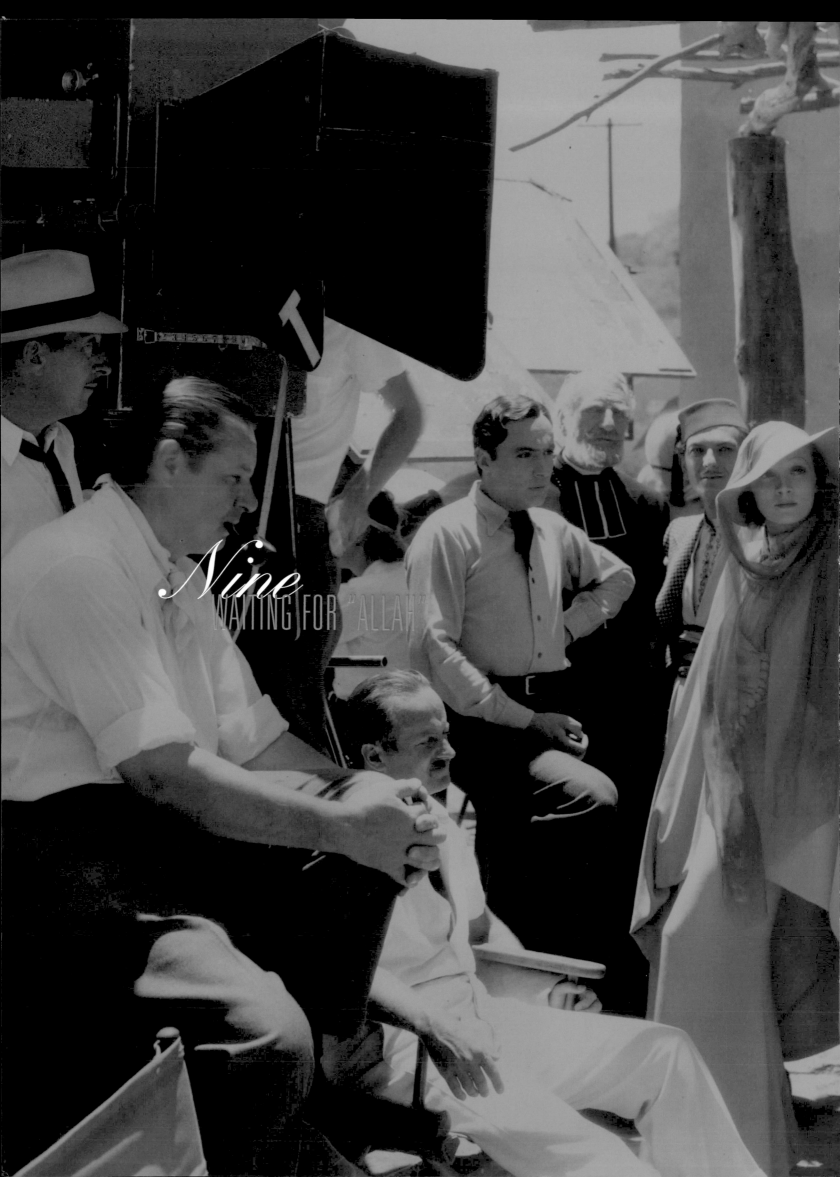

Nine
WAITING FOR "ALLAH"

As 1936 neared its close, there were indications that the coming year would show a noticeable increase in Technicolor production. Warner Bros. had contracted for its largest volume of shorts which included its *Color Parade* package. The first filmed tour, a look at the Netherlands,

was *Springtime in Holland.* Paramount followed with its series of *Color Cruises.* And Metro-Goldwyn-Mayer increased its color schedule of short subjects to about forty percent. Included were the *James A. Fitzpatrick Traveltalks*, a popular long-running series which began appearing in color with *Holland in Tulip Time.*

Searching for additional ways to expand the color market, Dr. Kalmus organized an affiliate office of Technicolor Motion Picture Corporation in Great Britain, Technicolor, Ltd. (later developed in association with Sir Adrian Baillie, Alexander Korda and the Prudential Assurance Company, Ltd.). The overseas subsidiary became active almost immediately with the production of the first Technicolor feature photographed in England, *Wings of the Morning.* Financed by New World Productions, the race track story starred Henry Fonda, in his second color role, and Annabella, a young French actress who had achieved considerable fame on the Continent. Shortly after completion of the production, which was processed in

Technicolor's Hollywood plant, a laboratory was built on Bath Road in West Drayton, just outside of London. There, future British-made Technicolor films would be serviced, as well as prints for American productions to be distributed in the United Kingdom.

Feature filming in the United States continued at a slow pace, although several productions had been completed. The majority of studios were still hesitant to use color in full-length packages, and were content to bide their time to await public reaction. It was an anxious period for the people at Technicolor. They were concerned not only about overall reception to these new films but about areas of production that had previously been criticized and, hopefully, improved.

The first of the major new features to be released was *Ramona*, Twentieth Century-Fox's initial entry into color in a big way. The film, a remake of the classic Indian saga, starred the studio's only Technicolor veteran, Loretta Young (she had appeared briefly in the closing color sequence in *The House of*

BELOW: **Publicity still of Loretta Young as Ramona, 1936.**

BOTTOM: **On location with James A. Fitzpatrick, whose *Fitzpatrick Traveltalks* became a popular, long-running series released by MGM.**

OPPOSITE PAGE: **Ad, 1936.**

Rothschild two years earlier). Don Ameche, and Jane Darwell.

Of *Ramona*, released in late 1936, the *Hollywood Reporter* wrote: "This picture in color raises the artistic status of the screen by several degrees. It will be acclaimed the most beautiful motion picture ever filmed . . .The color goes beyond anything previously achieved. Not only has the Technicolor process yielded truer values, more transparent shadows, closer uniformity, and sharper definition, but the use of color in costumes, properties, background, and make-up show a vastly finer taste and artistry."

The *New York Times* stated:

Chromatically, the picture is superior to anything we have seen in the color line. Without striving for the splashing effects of Becky Sharp, *but deepening the 'natural color' tones of* Trail of the Lonesome Pine, *it has achieved warmth and vigor without subjecting its beholders to a constant optic bombardment. Here and there, the cameramen have insisted upon showing off, inserting gaudy sunsets, sunrises . . . but generally they have been content with modest and harmonious tableaux, with tonal composition that is restful, pleasant and of definite relation to the dramatic context. To that extent, color has added to, not detracted from, the simple story the producers set out to retell.*

Variety commented: "Helen Hunt Jackson's haunting pastoral tragedy comes to the screen in its gorgeous Technicolor trappings as entertainment of high order. Technicolor tint plotting by Natalie Kalmus and Technicolor photography by William V. Skall are magnificent, standing with the best so far done in this medium . . ."

Most heartening, perhaps, were the reactions to the color camera's treatment of the female lead. Wrote one critic: "Loretta Young, the most appealing of the screen's ladies, wears a black wig, photographs beautifully in natural colors."

Another noted: "Loretta Young . . . is graced by the Technicolor camera in a mood of idyllic beauty . . .Color close-ups of Miss Young are breathtaking gems."

The color work on *Ramona* set studio heads thinking. But the real test was to come.

When Jock Whitney dissolved Pioneer Pictures and joined David O. Selznick in forming Selznick International, he took with him his continuing enthusiasm for color filming. Equally important, he brought along his contractual commitments with Technicolor.

The Selznick-Whitney team chose for its first subject Robert Hichens' *The Garden of Allah.* The property seemed to have all of the key elements necessary to make an outstanding motion picture: a compelling love story, an intriguing locale, glamorous settings, and a number of strong central characters.

Myron Selznick, David's brother, produced the picture with notable restraint, striving for understatement rather than the spectacular. He selected one of the industry's

Ramona

in the new perfected Technicolor
with

LORETTA YOUNG
DON AMECHE

and a cast of thousands featuring

KENT TAYLOR · PAULINE FREDERICK · JANE DARWELL
KATHERINE DeMILLE · JOHN CARRADINE · VICTOR KILIAN
J. CARROL NAISH · CHARLES WALDRON · CLAIRE DuBREY
PEDRO De CORDOBA · RUSSELL SIMPSON · WILLIAM
BENEDICT · ROBERT SPINDOLA · CHIEF THUNDER CLOUD

Directed by HENRY KING · Executive Producer SOL M. WURTZEL
Screen play by Lamar Trotti · Based on the novel by Helen Hunt Jackson
Songs by William Kernell · Associate Producer John Stone
A 20th Century-Fox Picture Darryl F. Zanuck in Charge of Production

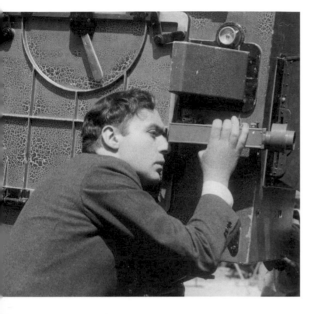

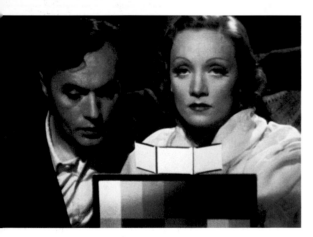

top talents as his director—Richard Boleslawsky—on the basis of his previous achievements, such films (all black-and-white) as *Clive of India* (1935), *Les Miserables* (1935) and *The Three Godfathers* (1936). The increasingly important area of art supervision was divided among three specialists: Sturges Carne, set designer; Ernest Dryden, costume designer; and Lansing C. Holden, a disciple of Robert Edmond Jones, color designer.

It was the casting, however, that started the film capital talking. The leading male role was given to the international favorite and matinee idol, Charles Boyer. Another popular import, the provocative Marlene Dietrich, was handed the starring female spot. In support were the highly respected actors, Basil Rathbone and Joseph Schildkraut.

The casting of Charles Boyer and, particularly, Marlene Dietrich, was not only a master stroke but a major accomplishment. Now, for the first time, a color movie could boast stars—and exploitation value. Hollywood knew that customers would find it difficult to ignore this dynamic pairing and, on that basis alone, felt the film would be immensely successful.

Ernest Hemingway once said of Miss Dietrich, "If she had nothing more than her voice, she could break your heart with it. But she also has that beautiful body and the timeless loveliness of her face."

The star, too, was not unaware of her assets. She had become intensely intrigued with the technique of color filming and prior to the start of the film worked seriously with the consultants on the best possible fabrics and tones to use in bringing the "Dietrich lure" to the new medium.

She voiced her opinions in other areas as well. Said Technicolor cameraman W. Howard Greene:

In this production, Hal Rosson and I had a rather peculiar problem. Much of the action was laid in the Sahara Desert and was filmed among the sand dunes near Yuma, Arizona. But our star, Marlene Dietrich required a very definite style of lighting—one which Josef von Sternberg devised years ago to enhance the glamour for which Miss Dietrich is famous. And while this lighting is simplicity itself using artificial light, it is extremely difficult to achieve with less controllable natural sunlight. So it was decided to make only the longer shots on location, and to make all of the closer shots in the studio, by artificial light.

Miss Dietrich's close-ups were eminently satisfactory . . . more pleasing than we could possibly have made them with the less precise tools of natural lighting, yet they did not in the least look as though they were made in the studio.

"The important thing is to underplay rather than overplay the color," Lyle Wheeler, art director, remembered years later. "We worked to avoid the obvious—for instance, having the desert scenes look like lurid postcard art."

As *The Garden of Allah* neared completion and its publicity increased, the black and white proponents stepped up their campaign. The privileged few who had seen some of the film's footage boasted that it had "everything." The skeptics retorted that "even 'everything' is far from perfection" and renewed their questioning, "Is the picture as good a picture in color as it would have been in black and white?" The fringe group remained rather passive, noting, "The occasional color films—and may we always have them with us—are pleasant and interesting interludes in our production season."

The Garden of Allah was too important a picture, however, to be swept aside or even minimized. Wrote the *New York Times* on its opening in November, 1936:

The Selznick International production is a distinguished motion picture, rich in pictorial splendor yet unobtru-

OPPOSITE PAGE, TOP: Charles Boyer checks scene through the Technicolor camera's viewfinder between takes on *The Garden of Allah*.

OPPOSITE PAGE, CENTER: W. Howard Greene and Harold Rosson's dramatic Technicolor cinematography for *The Garden of Allah* earned a special Academy Award.

OPPOSITE PAGE, BOTTOM: Marlene Dietrich and Charles Boyer pose for color test, *The Garden of Allah*, 1936.

BELOW: Ad for *The Garden of Allah* starring Marlene Dietrich and Charles Boyer. 1936.

sive, though accurate, in its color. (Director) Boleslawski's decision, despite the color medium, to emphasize the play and the players has placed the Music Hall's new presentation at the top of the Technicolor field. The choice, at long last of a story that permits of searching dramatic characterization made that possible for him, of course, but the realization that color, treated simply, will emphasize itself is Mr. Boleslawski's . . . Miss Dietrich and Mr. Boyer portray (the emotional turmoil) compellingly and before a camera that is not too preoccupied with color to pay attention to them.

Other reviews cited ". . . the most discriminating use of Technicolor thus far . . ." and called the film a ". . . feast of Technicolor splendor," pointing out that "Technicolor goes into refinements and effects heretofore never achieved, especially the desert and sky scenes and the extraordinary night effects."

The picture was nominated for two Academy Awards (Assistant Director Eric G. Stacey; Musical Score, Max Steiner) and on March 4, 1937, at the Biltmore Hotel in Los Angeles, the Academy of Motion Picture Arts and Sciences honored W. Howard Greene and Harold Rosson with special awards for their color cinematography. (Color cinematography did not become a separate classification until the 1939 awards.)

Prior to its release, many people in Hollywood felt that reaction to *The Garden of Allah* would be influential to the future of color in motion pictures. Their evaluation proved to be right. As studios firmed their production slates for the 1937 season, many stars were found to be more willing to give color a try. Among them, Carole Lombard. Selznick International had announced that she had been signed to co-star with Fredric March in Ben Hecht's satirical screenplay of *Nothing Sacred* in Technicolor.

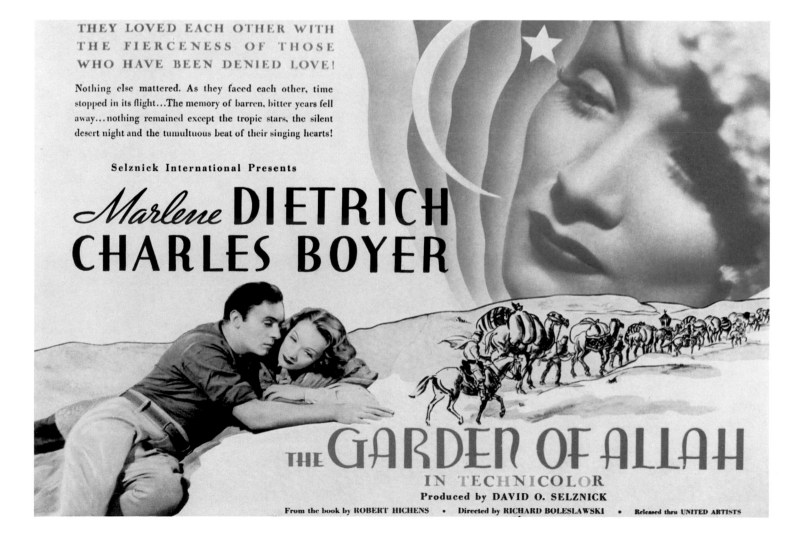

THEY LOVED EACH OTHER WITH THE FIERCENESS OF THOSE WHO HAVE BEEN DENIED LOVE!

Nothing else mattered. As they faced each other, time stopped in its flight...The memory of barren, bitter years fell away...nothing remained except the tropic stars, the silent desert night and the tumultuous beat of their singing hearts!

Selznick International Presents

Marlene DIETRICH
CHARLES BOYER

THE GARDEN OF ALLAH
IN TECHNICOLOR
Produced by DAVID O. SELZNICK
From the book by ROBERT HICHENS • Directed by RICHARD BOLESLAWSKI • Released thru UNITED ARTISTS

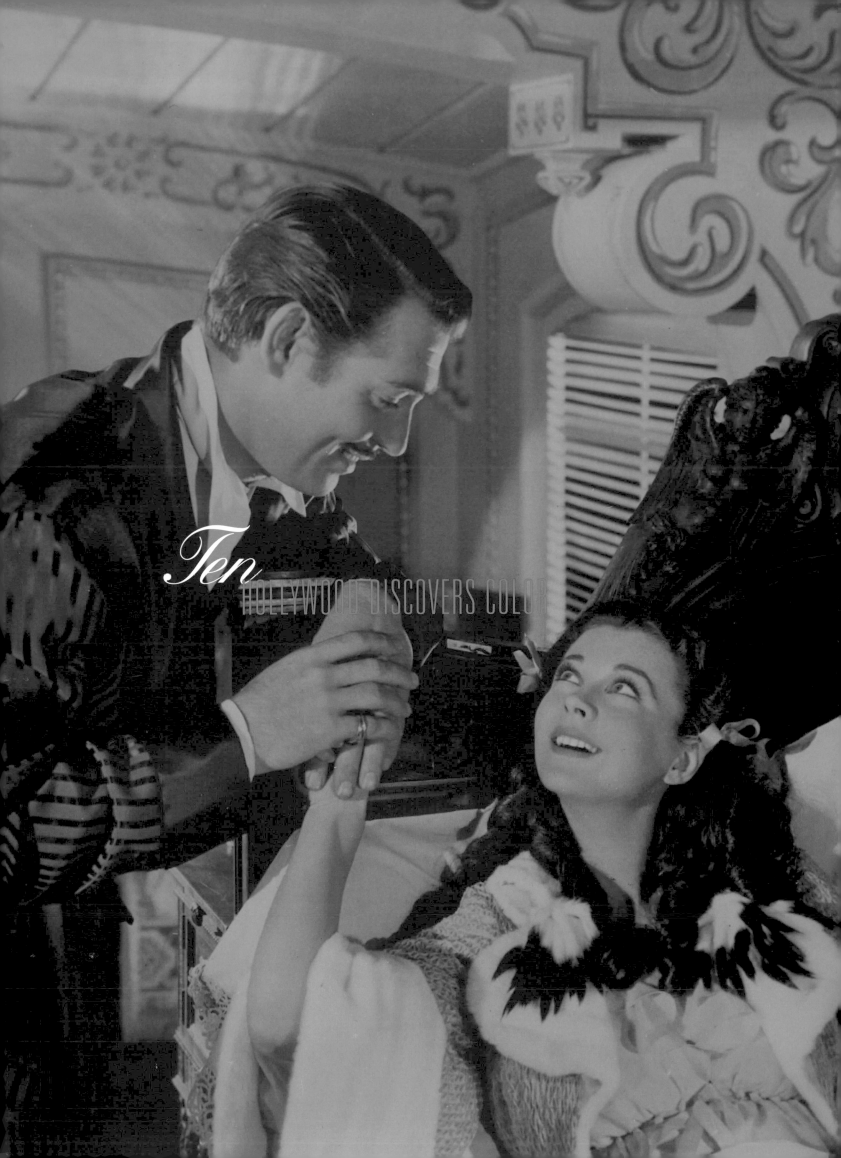

*D*uring the 1935-1936 production season, Technicolor's volume of release print footage had increased from over 22 million to slightly more than 37 million. Within the next two years that total would nearly double. ■ Hollywood was no longer saying color was simply

"an artistic stunt" or "just too cute" or "nice but you get tired of it in large doses." Color had served its apprenticeship. Just as radio had helped prepare audiences for the acceptance of early artificial film sound tracks, short subjects and cartoons had helped prepare the public for full-length features. It had only been two years since the release of *Becky Sharp*. During that period, the people at Technicolor continued to move ahead, but not without some apprehension. Now that gap had been bridged. Producers were beginning to call again, much as they did during the early rush to two-color in the late 1920s.

The success of a handful of color films in 1935 had an effect not only at the Technicolor plant but elsewhere. Other systems began to make noise. Kodachrome and Cinecolor were being pushed in their development and the heads of Magnacolor, Vericolor and Fin-a-color were offering previews of their processes to any interested parties.

Out of all the names that vied for the industry's attention, Technicolor remained

foremost in the minds of the studios and their policymakers—and for good reasons. Technicolor, with almost a quarter century of science and experience behind its cameras and laboratories, offered the most proven product to date. The company's personnel included many of the finest technicians available. It was nearly impossible for an individual to qualify without a master's degree, or five years (at least) in a university of the M.I.T. calibre. And, despite its detractors, Technicolor also had, as Dr. Comstock pointed out many years before, "the rare wisdom of Dr. Kalmus."

In 1937 and 1938, Technicolor made its biggest splash to date. Audiences were treated to a variety of feature film fare, colorful productions that were no longer restricted mainly to musicals and period pieces. Cameras moved indoors and out to capture the excitement of the land, the sea, and the air. They recorded the jungle, the country, the big city, and the lands of fantasy. They discovered comedy and contemporary drama, and gave history a fresh, new look.

BELOW (LEFT TO RIGHT): Janet Gaynor, Assistant Director Eric Stacy, Director William Wellman, and Dr. Kalmus confer during a break on the set of *A Star Is Born*, 1936.

BOTTOM: Richard Greene and Loretta Young rehearse a scene for *Kentucky*, 1938.

Film fans saw Janet Gaynor and Fredric March in David O. Selznick's modern classic, *A Star Is Born*; Ray Milland, Frances Farmer and Barry Fitzgerald in Paramount's exciting sea story, *Ebb Tide*; an all-star cast headed by Kenny Baker, Vera Zorina, Edgar Bergan and Charlie McCarthy in Samuel Goldwyn's lavish musical, *The Goldwyn Follies*.

With Walter Wanger's *Vogues of 1938*, the Joan Bennett-Warner Baxter feature, the reviews noted "Technicolor advances by a great stride toward the day when all important pictures will be prismatic" and applauded "Max Factor, with his new color harmony make-up . . . a great advance in the flesh tones, beautiful under the highlights and delicate in the shadows."

Men With Wings, an ambitious Paramount project tracing the early days of flight, starred Fred MacMurray, Ray Milland, Donald O'Connor and Louise Campbell. The film was the the third consecutive Technicolor production for producer-director William Wellman (preceded by *A Star Is Born* and *Nothing Sacred*). "At the drop of a hat," he stated at the conclusion of filming, "I'll talk for hours about color. There's nothing like it. Every night for years I used to get down on my knees and pray that I'd have the chance to make the first air picture in color.

I did, and now I get down on my knees every night and offer thanks for it. When you see the picture, you'll know what I mean. The air was never like this before, unless you have flown yourself. The color gives depth, perspective, reality. It's wonderful! But I'll try to be calm."

(Wellman's attitude was a complete reversal. Early in the making of *A Star Is Born*, the no-holds-barred director had stated: "Technicolor cameras are more cumbersome than black-and-white. They are hard to handle, and slow down the work. The camera requires three strips of negative instead of one, and takes longer to thread between takes. It demands more light, which means more arc lamps, more carpenters, more electricians, more current, and more time, not to mention all the problems of color composition, lighting, and make-up." By the end of production, however, he had softened his stance a bit, praising the Technicolor crew "for its hard work, its progress, its speed, and its photography," which he admitted had moved along almost as fast as with black and white.)

Men With Wings was a cinematic achievement in its day. For several months, three planes flew over Southern California, from San Diego to Santa Barbara, chasing clouds and a score of other aircraft. Huge Technicolor cameras (measuring about three feet long, two feet high and a foot wide, and weighing up to three hundred and fifty pounds each) were specially mounted on fuselages, behind and in front of the pilots, on top and under wings, and from cockpits equipped with swivel mountings similar to those used for machine guns. Pilot Paul Mantz supervised the aerial acrobatics while W. Howard Greene, fresh from two special cinematic Academy Awards (*The Garden of Allah* and *A Star Is Born*) was responsible for the demanding camerawork.

Other feature films of note during the period included Alexander Korda's *Drums* with Valerie Hobson, Sabu, and Raymond

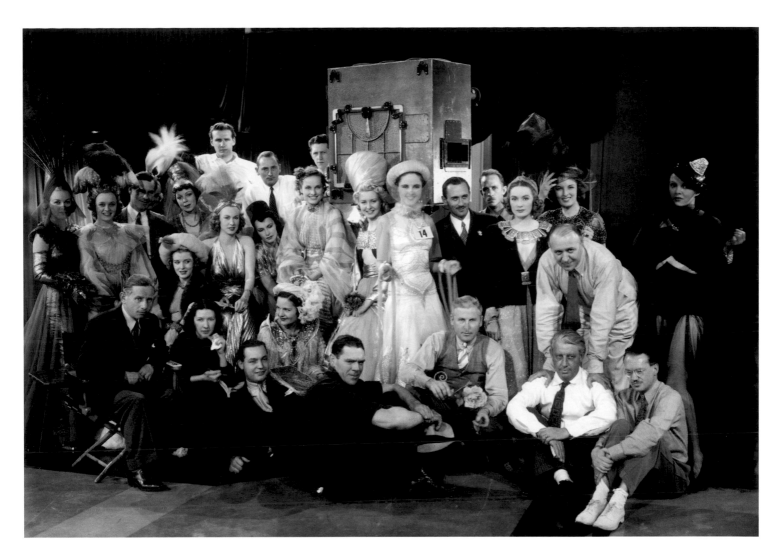

TOP: **Director Irving Cummings (leaning over at right) poses with the technical crew and "the most photographed girls in the world" on the set of the screen's first fun-and-fashion romantic comedy, *Walter Wanger's Vogues of 1938*.**

ABOVE: **Stunt pilot Frank Clarke (in cockpit) waves before taking off to film an aerial scene for *Men With Wings*, 1938. A Technicolor camera is mounted on the top of the wing.**

RIGHT: **Ad for *Her Jungle Love*, 1938.**

Massey; Twentieth Century-Fox's *Kentucky* with Loretta Young, Richard Greene, and Walter Brennan; Paramount's *Her Jungle Love* with Dorothy Lamour and Ray Milland; and David O. Selznick's *The Adventures of Tom Sawyer* with Tommy Kelly and Anne Gillis.

Two other motion pictures were particularly memorable but for different reasons. Ten years before, Jack Warner led the studio rush to two-color with a number of box office hits. Aside from the short subjects of the mid-1930s, he was rather cautious in guiding his studio back into color. In 1937, however he decided once again to splurge. His first three-color Technicolor feature production was *God's Country and the Woman*, starring George Brent and, in the role Bette Davis had rejected, Beverly Roberts. The second production, *Gold Is Where You Find It*, starred George Brent, again, and a relative newcomer named Olivia de Havilland. But it was Warner Bros.' third try that set a precedent.

One of the finest examples of the Technicolor process can be seen in *The Adventures of Robin Hood*, starring Errol Flynn and Olivia de Havilland, with Basil Rathbone and Claude Rains. Even today, color enthusiasts talk of the film's

BELOW: **Dr. Kalmus with Merle Oberon on the London set of** *The Divorce of Lady X,* **1938.**

BOTTOM: **Shooting the banquet hall scene for Warner's Technicolor triumph,** *The Adventures of Robin Hood,* **1938.**

esthetically pleasing tones, the soft greens and russets of Sherwood Forest, and the cool grays of Nottingham Castle against which the more violent hues were used simply as accents. In 1938, undoubtedly aided by its Technicolor, *The Adventures of Robin Hood* won more Academy Awards (three) than any other picture of the year.

Another milestone was recorded on December 21, 1937, when Walt Disney's first full-length animated feature, *Snow White and the Seven Dwarfs,* premiered at the Carthay Circle Theater in Los Angeles. Prior to its release, it was generally conceded that the Disney cartoons, no matter how successful they had been in the short versions, could never compete on any level with live action feature films. *Snow White and the Seven Dwarfs* took three years to reach the screen and, while it was eagerly awaited, most people felt that ninety minutes of drawings would only be tedious. But public opinion did an abrupt about-face after the first showing. *Snow White*

and the Seven Dwarfs was an instant success and received rave reviews everywhere.

"Let your fears be quieted at once," wrote the *New York Times.* "Mr. Disney and his amazing technical crew have outdone themselves. It is a classic . . . Chromatically, it is far and away the best Technicolor to date, achieving effects possible only to the cartoon, obtaining—through the multi-plane camera—an effortless third dimension. You'll not, most of the time, realize you are watching animated cartoons. And if you do, it will only be with a sense of amazement."

Snow White and the Seven Dwarfs was, in a sense, not a cartoon at all—at least, not in the exaggerated style that audiences had come to expect. The latest Disney offering was a triumph of art, each step totally plotted and executed with precision. With his first feature film, Walt Disney brought a new sophistication to the field of animation. On "Oscar night," the production was recognized by the Academy as "a significant screen innovation

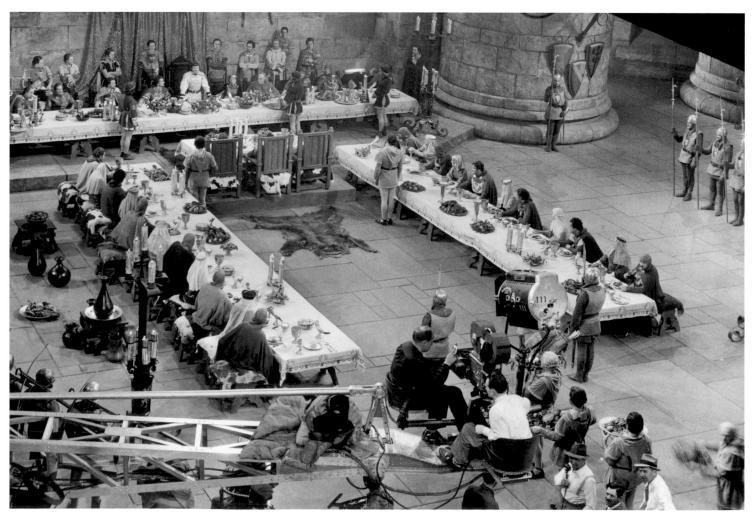

ABOVE AND RIGHT: *Snow White and the Seven Dwarfs*, 1938.

TOP: *Pinocchio*, 1940.

ABOVE CENTER: *Fantasia*, 1940.

ABOVE: **Micky Mouse in "The Sorcerer's Apprentice" sequence,** *Fantasia*, 1940.

which has charmed millions and pioneered a great new entertainment field for the motion picture cartoon." It was awarded a regulation-size statuette—and seven miniature versions.

Until now, Metro-Goldwyn-Mayer had been content to use Technicolor only for short subjects and cartoons. The studio had released a number of sepia-colored features during 1937 and 1938 but appeared hesitant to go full color. Two of the sepia productions, *Maytime* and *The Girl of the Golden West*, starred the enormously popular singing team of Nelson Eddy and Jeanette MacDonald. For their fifth picture together, MGM selected the romantic musical, *Sweethearts*, and planned to film it in black and white. At the last minute, because of a mix-up in scheduling, a decision was made to give audiences their first look at the duo in "living" color.

Jeanette MacDonald had appeared in the two-color version of *The Vagabond King* in 1930 with some success but she was recognized mainly for her physical appearance. "(She) is extremely beautiful in the clinging satins of the period," noted one reviewer. "Her performance supplies the requisite aroma of glamour." In the years following,

she achieved star status, not only for her beauty but for her vocal abilities as well. She had become a valuable property and the studio used every means to protect its investment.

For her various roles, Miss MacDonald wore wigs and pieces to match her natural hair coloring, a rather nondescript shade of blonde. Color tests for *Sweethearts* showed that she needed a change. Her eyes, which were hazel, photographed slightly green and it was felt that she should become a redhead. Many more tests were made until the right color was found and from then on audiences knew Jeanette MacDonald only with red hair.

By the end of 1938, Technicolor had twenty-five feature films in release. "Generally speaking," Dr. Kalmus said in December of that year, "these pictures have been extraordinarily well received, some of them having broken attendance records in many parts of the world." Technicolor was in the midst of its second great rush. The color process had turned into big business and the company was about to show a true profit for the very first time.

Despite the sunny outlook, the doctor was being cautious. He didn't want a repetition of the disaster that killed the color boom of 1929 and 1930. Expansion was rapid, but carefully paced. Over $1.5 million was appropriated for plant expansion to handle not only the commercial ventures but the new side line of non-theatrical films such as *Steel, Man's Servant* and *Men Make Steel* for the United States Steel Corporation. Additional cameras were built, plant capacity was doubled, a new office and research building was constructed, and a number of highly qualified technicians were hired.

The new Technicolor complex was a self-contained unit and nearly impregnable to outsiders. "It is the purpose of Technicolor, during the time that prints of any picture are being manufactured in its plant, to hold the laboratory open for, and at the disposal of, the customer as if it were

BELOW: **Ad, 1939.**

BOTTOM: **In 1938, Technicolor's Hollywood facilities were nearly doubled by expanding plant capacity and adding a new office/research building.**

his own," Dr. Kalmus explained. "His representative may inspect each of his prints and any changes suggested will be undertaken if practicable."

What the doctor didn't mention were the company's increasingly rigid security measures. With competitors on the scene, the by-words were "top secrecy." Very few people were privy to the know-how and workings within the various departments, or to the methods and procedures that were discovered (and constantly being improved) solely by trial and error. Almost no one was allowed to roam at will, even insiders. It was impossible to gain admittance to the processing lab, for example, without a pass or the personal accompaniment of top-level management. Those employees who worked on an operational level were compartmentalized and stayed exclusively within the boundaries of their specialities. Rarely was anyone transferred to another department or division and only a small number had an overall view of the workings of the company. To some, such an atmosphere may sound totally restrictive. But each division was a world all its own, and the technicians took tremendous pride in their individual and group accomplishments as well as in their contributions to an

increasingly prestigious wing of the growing motion picture industry.

As Technicolor entered 1939, newspapers traced the spreading war overseas. "The foreign situation is becoming more and more difficult," Dr. Kalmus reported to stockholders. "Sales to Germany, Spain, Japan and China have practically ceased, and in many other foreign countries they are below normal. The Italian government controls the entire distribution of films in Italy, which probably means that everything possible will be done to distribute Italian-made pictures at the expense of English and American-made pictures."

In spite of world news, the company was headed for its biggest year to date. Technicolor was proving itself at the ticket windows and any doubts the studios once had were quickly disappearing.

The London unit was involved with a screen version of Gilbert and Sullivan's *The Mikado*, featuring American-born Kenny Baker and an all-star cast, and Alexander Korda's *Four Feathers*, his follow-up to the previous year's *Drums*.

In Hollywood, Twentieth Century-Fox, one of the first studio's to give Technicolor a try, had firmed contracts for four features. Darryl F. Zanuck now had so much confidence in the process that he agreed to showcase Shirley Temple, the reigning box office champion for four straight years, in her first full-length color picture, *The Little Princess*.

Warner Bros. had scheduled the release of *Dodge City* with Errol Flynn, Olivia de Havilland and Ann Sheridan, and *The Private Lives of Elizabeth and Essex* with Bette Davis and Errol Flynn.

At the Disney Studios, two long-term feature projects were in the works: *Fantasia* and *Pinocchio*.

In Culver City, two others were in production: Metro-Goldwyn-Mayer's *The Wizard of Oz* and David O. Selznick's *Gone With the Wind* (later released by MGM). For Metro, surprisingly, *The Wizard of Oz* was only the

© Turner Entertainment Co.

© Warner Bros.

OPPOSITE: **Trapped inside the Wicked Witch's castle with Scarecrow, Tin Man, Dorothy and the Cowardly Lion.**

TOP: **Judy Garland, as Dorothy, takes in the wonders of Munchkinland in *The Wizard of Oz*, 1939.**

ABOVE: **Technicolor camera follows Judy Garland and Ray Bolger along the Yellow Brick Road.**

second venture into feature-length Technicolor filming.

Technically, *The Wizard of Oz* was not a full-length color film. It opened and closed in sepia (actually black-and-white film washed in brown bath). While the technique helped establish mood—from drab reality to a candy-colored dreamland and back—it put a stress on the make-up department, as make-up for the "black-and-white" scenes was not suitable for the color portions and vice versa.

The production was a masterpiece of imaginative design, the work of art director Cedric Gibbons and his assistant, William A. Horning. To create the total illusion of fantasy, they ingeniously had their artists combine painted backgrounds, on film, with the existing sets. The result was a stunning collage that helped bring the Frank Baum classic to life.

Throughout, color was an integral part of the picture—from the yellow brick road to the ruby slippers to the Emerald City and so on. It also caused a few problems, such as

finding the right shade of yellow for the legendary brick road. Said producer Mervyn LeRoy, "We tried all kinds of exotic dyes and imported paints and photographed them, and none of them looked really right. Then one morning I suggested to Gibbons that he try some ordinary, cheap yellow fence paint. He did and the yellow brick road finally looked like a yellow brick road should look."

The change from monochrome to color, in the early part of the film, had to be handled with extreme care. When Judy Garland, as young Dorothy, slowly opened the door of her home to go outside following the cyclone sequence, the exterior (Munchkinland), as seen through the door opening had to be revealed in color to keep the transition from being too abrupt. Each of the frames in the several-second scene required hand-tinting to show the visual richness of the outside fantasy world as it appeared through the opening door. From there, the screen went to full color.

More time was lost in preparing the

© Turner Entertainment Co.

"horse of a different color" scenes. In the story, Dorothy and her friends— the Straw Man, the Tin Woodman and the Cowardly Lion—follow the yellow brick road to Emerald City where the resident Wizard, with his magical powers, will grant their wishes. For Dorothy, it's a return to her home in Kansas; for the Straw Man, a brain; for the Tin Woodman, a heart; and for the Cowardly Lion, courage.

When the quartet arrives at the Emerald City, they are met by all the citizens and a carriage, which is pulled by a most unusual horse. On the way to the steps of the Wizard's secret chambers, it changes colors before everyone's eyes.

At first, the film's creative team thought the horse could be painted to create the multi-hued illusion but the American Society for the Prevention of Cruelty to Animals said no. The trick was to find a substance that would not only pass the ASPCA test but would photograph clearly. Food coloring was tried, even liquid candy, –both without success. The colors were too tame—and much too tasty. Finally, a paste of Jell-O powder was found acceptable. The horse continued to lick but, with frequent touch-ups, the problem was solved.

The role of the Tin Man was originally assigned to dancer Buddy Ebsen, but he became mysteriously ill and had to be rushed to a hospital where he was put in an iron lung for a time. It was later diagnosed that he had been poisoned from inhaling the silver-colored aluminum dust sprayed on his costume to give it a metallic look. The part was taken over by Broadway star Jack Haley.

The lands of Oz were constructed on the MGM back lot in one-fourth size. Even so, the full set covered twenty-five acres and consisted of one hundred and twenty-two buildings. Over sixty different shades and colors were used in painting them.

The *Wizard of Oz* took over a year to prepare and shoot at a cost of $2.7 million. *Gone With the Wind*, an even more ambitious pro-

ject, ran nearly $4 million.

The photoplay of Margaret Mitchell's Pulitzer Prize-winning novel went into production in late January, 1939, after a two year search for an actress to play the heroine, Scarlett O'Hara. Producer David O. Selznick talked to over 1,250 knowns and unknowns before he decided upon Vivien Leigh, a relatively obscure British actress who was in Hollywood only to be near her fiance, Laurence Olivier.

Gone With the Wind was one of the earliest motion pictures to be released with an intermission (it ran three hours and forty-two minutes) and was the first to be photographed using the new, faster Technicolor film, which revolutionized color lighting methods. Aside from cutting lighting requirements by at least fifty percent, and allowing the use of smaller units such as baby spots for precise facial lighting, the new film offered many other advantages. (Lighting cost for *The Wizard of Oz* amounted to $226,307—nearly $100,000 more than for *Gone With the Wind*.)

Cameraman Ray Rennahan noted at the time:

> The new film has naturally increased the scope of projected-background cinematography tremendously (process shots). Heretofore . . . we were limited to relatively small background screens. We can now use screens as large as those generally employed in monochrome, and with equal flexibility.
>
> Another important improvement . . . is improved color rendition, particularly in the greens. Every color process has found green one of the hardest colors to reproduce faithfully, and it is an especial problem here in California where the natural greens of the foliage, grass and the like seem to have a somewhat rusty shade unknown in moister climates . . .

The beautiful greens of the finished film, particularly on exterior shots, were an

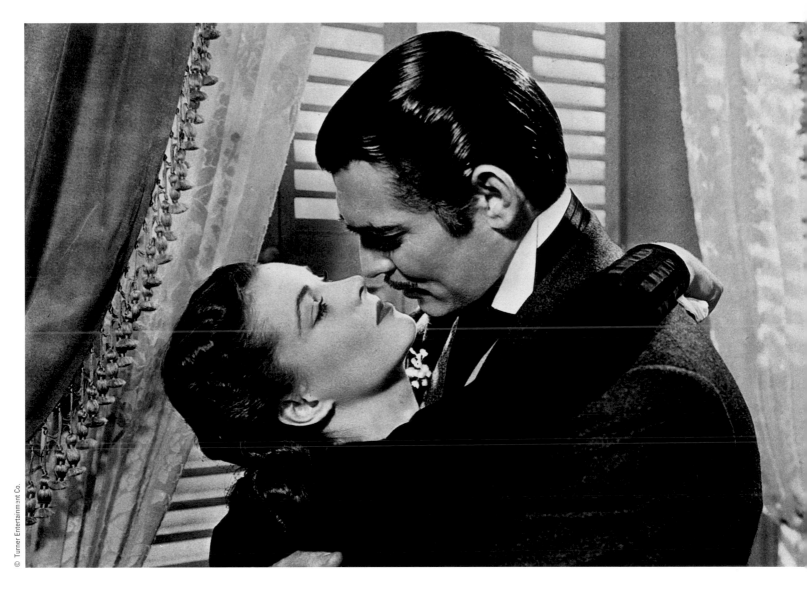

© Turner Entertainment Co.

ABOVE: **Clark Gable and Vivien Leigh in** *Gone With the Wind,* 1939.

asset in helping recreate the atmosphere of the Old South.

Ernest Haller, Mr. Rennahan's associate, had just completed the Bette Davis monochrome film, *Dark Victory*, when he landed the *Gone With the Wind* assignment. "I was amazed," he said, "to step into Technicolor production and find that instead of requiring immensely high light levels it now permitted me to light very much as I did for black-and-white . . .

"In the old days, shadows were strictly taboo in Technicolor; you had to crowd in 'filter light' from every angle to make sure that the shadows wouldn't vanish into inky blackness . . . Now that color has become more flexible technically, its artistic possibilities are so great one wants to keep on exploring them!"

Color may have become more flexible,

but Technicolor's color consultant was gaining a reputation for her unyielding manner. In fact, on many of the sound stages in Hollywood, it was being said that Natalie's personal tastes often ruled her judgment. When she protested that certain color harmonies or fabrics would not photograph well in Technicolor, others knew better. However, as the industry's "Goddess of Color," Natalie was a compulsory part of the Technicolor package, and her work was absolute law.

Throughout the preparation for *Gone With the Wind*, David Selznick and Natalie had numerous battles over differences of opinion. Against Selznick's will she ordered changes in various pieces of furniture and wardrobe. On one occasion, an entire set had to be replaced.

The conflict reached the boiling point over mulberry wallpaper, which Natalie

RIGHT: David O. Selznick (left) confers with Director Victor Fleming during the making of *Gone With the Wind* , 1939.

BELOW:: Cammie King Conlon as Bonnie Blue Butler in *Gone With the Wind*.

OPPOSITE: Vivien Leigh in *Gone With the Wind*.

deemed unacceptable. The wallpaper had been selected for the dining room at Twelve Oaks, and was to be seen briefly as a background for beige jackets worn by several male cast members. "Out with the wallpaper!" ordered Natalie. Her reasoning: the beige would fade into the mulberry, therefore, the actors would be lost in the scene.

Color tests were taken by art director William Menzies, which showed the hoped-for contrast between the two colors. Natalie was proven wrong, but she wouldn't give in and the mulberry paper was removed.

So was Natalie. Having had his fill of her, Selznick contacted Dr. Kalmus. An agreement was reached whereby Natalie would no longer work on the film—or be welcome on any of the sets. She departed for Technicolor's plant in Great Britain and busied herself on overseas productions.

Selznick had other reasons to appeal to Dr. Kalmus. Escalating production costs were a continuing problem and money was not always in ready supply. As Dr. Kalmus noted, "From time to time Selznick, quite understandably, would appeal to me to reduce Technicolor studio and laboratory charges. As much as I wanted David to be able to stay within his budget, and as much as I held Jock Whitney to be a firm friend, I was obliged every time to say that Technicolor had one scale of prices which, once broken for anybody, would mark the beginning of an end-

less appeal from everybody for reductions for one reason or another. Jock understood my position, and when I explained the reason for my refusal always promptly said, "Go ahead as you are."

When the Academy Awards were presented for 1939 productions, *Gone With the Wind* was named the best picture of the year (*The Wizard of Oz* was the only other color nominee). Ray Rennahan and Ernest Haller won the cinematography award and William Cameron Menzies was presented with a special plaque for his "outstanding achievement in the use of color for the enhancement of dramatic mood in the production of *Gone With the Wind*." Technicolor, too, received a coveted statuette "for its contributions in successfully bringing three-color feature production to the screen."

Dr. Kalmus was asked his reaction to this long deserved recognition after clinging "so tenaciously . . . through the 'dark ages' when color motion pictures were not so well appreciated."

His reply: "It was marvelously interesting, it was great fun. We couldn't let anybody down, neither customers, employees, stockholders not directors. But there was something else too. There was always something just ahead, a plan for tomorrow, something exciting to be finished—yes, and something more to be finished after that. And I am willing to predict that it won't be finished for many years . . ."

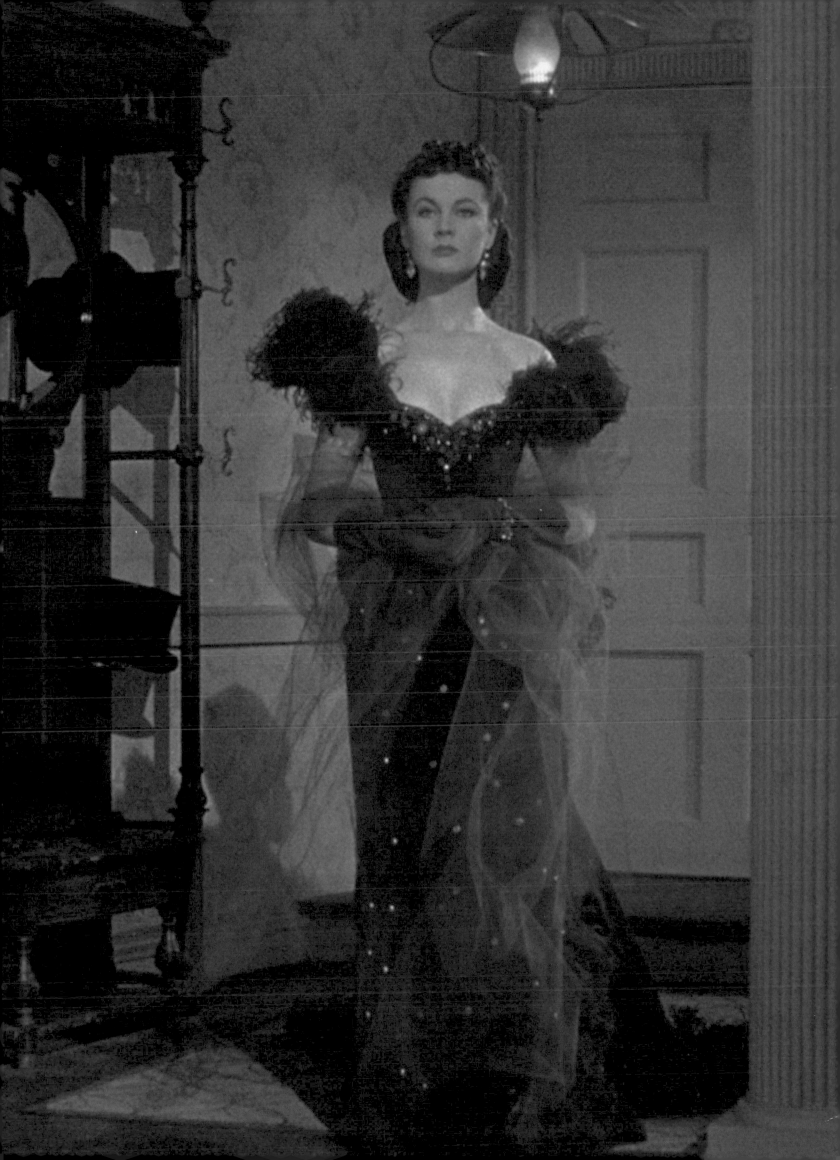

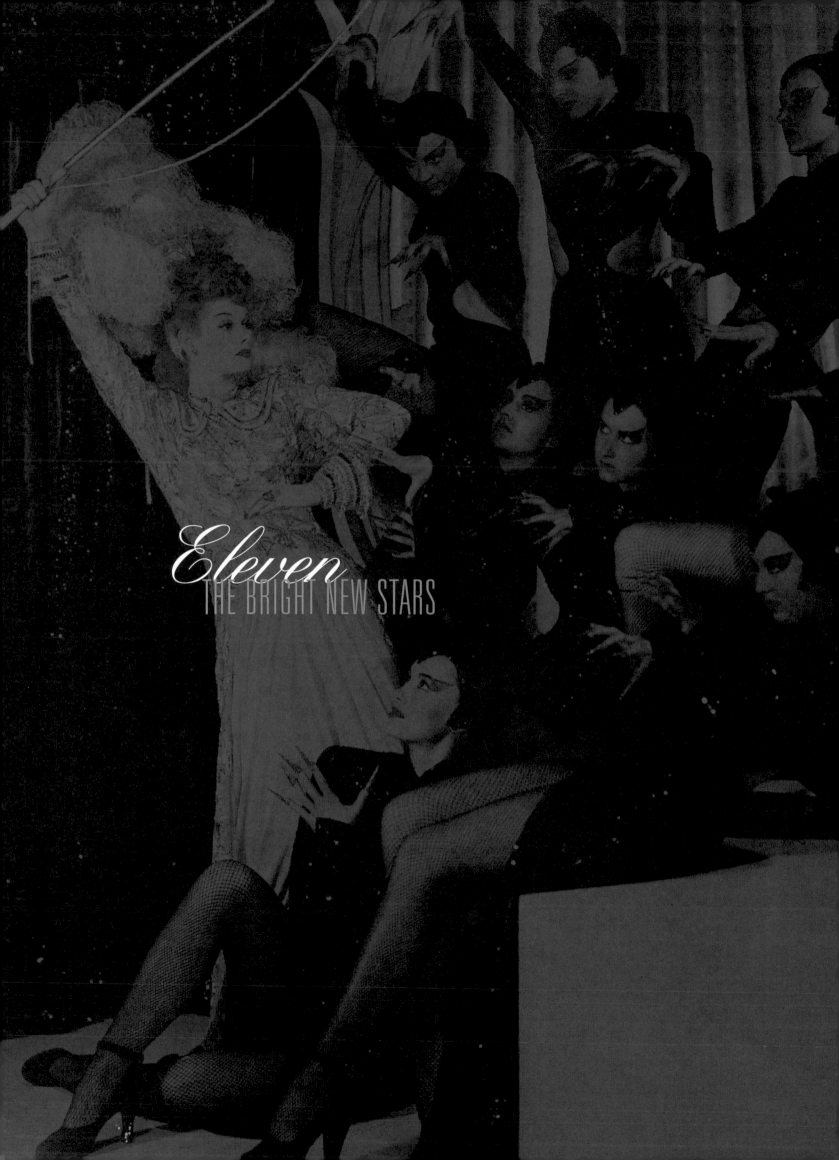

Eleven
THE BRIGHT NEW STARS

With the release of each new picture, the studios and exhibitors felt the growing value of Technicolor. Public reaction to a Technicolor movie was extremely favorable and producers soon realized that a film in color meant extra profits, despite higher production costs.

As America moved into the war years of the early 1940s, the color process became a major draw. The words "*In Technicolor*" on a theater marquee created excitement—and usually a long line of customers. More and more, newspaper and magazine advertising socked out coined phrases designed to lure readers into the vibrantly hued world, catch words in big, bold type, often above the film title and leading players. They read of "Glorious Technicolor" and "Sizzling Technicolor" and "Gorgeous Technicolor" and "Living Technicolor" and "Stirring Technicolor" and "Magnificent Technicolor." Suddenly, Technicolor had become a star in its own right.

During the filming of *Gone With the Wind*, cinematographer Ernest Haller remarked, "Whenever an established feminine star makes her first appearance in a color film the critics almost always exclaim at great length about the new personality color gives her.

"Now that we have this fast film, which enables a cinematographer to use all the little tricks of precision lighting he has used in monochrome to glamorize his stars, I am sure that color is going to be more flattering than ever to women."

It was wartime and there were millions of American G.I.'s around the world who wanted nothing more than to have lovely, talented ladies entertain them. Movies were a touch of home, and there were few things that pleased the men in the Armed Forces more than a Technicolor movie filled with attractive females.

The timing was perfect. Technicolor had managed to glorify the leading lady just when she was about to be in big demand. The combination of Technicolor *and* beautiful girls was hard to resist.

Hollywood searched for fresh, new personalities to use in its color creations. A hopeful didn't require an imposing list of credits—but she did have to be colorful in her own rights, either in looks or personality, or both.

Film fans wanted color and Technicolor gave it to them. Color became exaggerated, more colorful than life—extra rich, vibrant, and exciting. The performers, especially the

Betty Grable

Pin Up Girl
in Technicolor

20th CENTURY-FOX PICTURE

JOHN HARVEY ★ MARTHA RAYE ★ JOE E. BROWN ★ EUGENE PALLETTE

SKATING VANITIES ★ CHARLIE SPIVAK AND HIS ORCHESTRA ★

DIRECTED BY BRUCE HUMBERSTONE

PRODUCED BY WILLIAM LE BARON

SCREEN PLAY BY ROBERT ELLIS, HELEN LOGAN & EARL BALDWIN
LYRICS & MUSIC BY MACK GORDON & JAMES MONACO

MADE IN U.S.A. THIS POSTER IS THE PROPERTY OF THE TWENTIETH CENTURY-FOX FILM CORP. IT IS LEASED NOT SOLD. COPYRIGHT 1944 TWENTIETH CENTURY-FOX FILM CORP. TOOKER LITHO. CO., N.Y.

OPPOSITE: **Poster, 1944.**

BELOW : **"Betty Grable in Technicolor"** wrote the
New York Times, **"is balm for the eyes."**

females, reflected the palette that surrounded them. Nothing that could be dyed, tinted, toned, or painted remained the same. Honey blondes became butter blondes. Golden blondes became silver blondes. Brownettes turned strawberry or tangerine. Brunettes went henna or mahogany or jet. Complexions had to be peaches and cream. Lips, full and glistening, were brushed with one of any number of rose reds.

The studios, with their stables of stars, each had a number of performers who, with their looks and/or talent, seemed to be "born for Technicolor." Of those, only a few were true Technicolor stars. Technicolor helped take them to the top. In turn, they became the major contributing force in "selling" the Technicolor process to the vast motion picture public.

BETTY GRABLE

Betty Grable was among the top ten box office stars for ten consecutive years (1942-1951). During that period, she was the highest rated female seven times, and in 1948 the

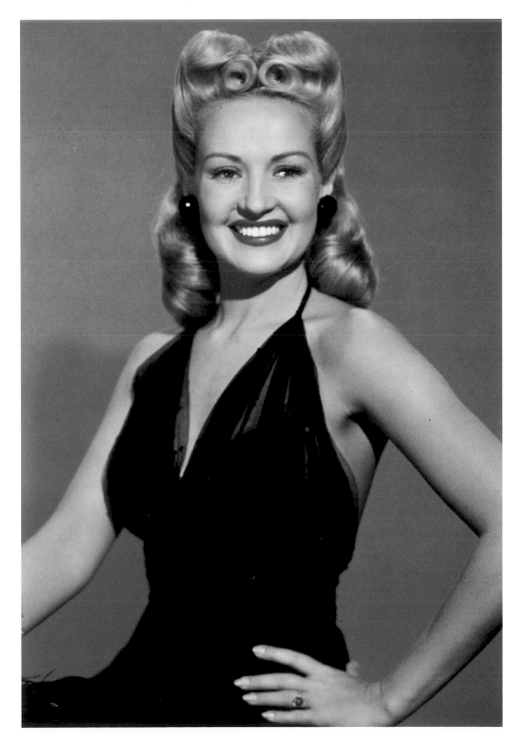

highest salaried woman in the United States. The G.I.'s favorite pin-up girl during World War II, she reportedly received over ten thousand fan letters a week and more than two million requests for a bathing suit photo that displayed her famous "gams." She often remarked that she thought Marlene Dietrich's were better. Of her talent, she noted, "There are a dozen girls I know who can sing better, dance better and act better. I can do a little of all three and I suppose that's why I get by." (Her mother took a slightly different view: "Betty's like any average American girl who makes a million a year.")

Born Elizabeth Ruth Grable on December 18, 1916, in St. Louis, Missouri, Betty was the daughter of Conn Grable, a wealthy stockbroker, and his wife, Lillian. While her mother had given up her own dreams of show business, she later became a driving force in her daughter's career. At age five, Betty was dancing, studying tap, ballet, acrobatics, while playing the ukulele and saxophone. By the time she was seven, she was appearing on local talent shows.

During a 1929 visit to Southern California, twelve-year-old Betty talked her mother into staying in Hollywood. But Lillian Grable didn't have to be coaxed. She had toured the studios and seen the stars. She knew that this was the life she wanted for her daughter. And when she heard, the following year, that Fox Studio was looking for song-and-dance girls, she found her opening. Lying about her age, Betty won a spot in the chorus line of *Let's 'Go Places* (1930). Shortly thereafter, she became a Goldwyn Girl and

appeared in Samuel Goldwyn's *Whoopee* (1930), *Palmy Days* (1931), and *The Kid From Spain* (1932), all with Eddie Cantor.

Betty Grable made her first big impression on movie audiences in the Fred Astaire - Ginger Rogers musical *The Gay Divorcee* (1934) when she was seen in a specialty number, *K-knock Knees*, with Edward Everett Horton. She followed this with a series of co-ed parts in college-themed pictures at Paramount and Twentieth Century-Fox (*Collegiate, Pigskin Parade, College Swing, Campus Confessions*) until offers became scarce. In 1939, she accepted a supporting role in the Broadway production of *DuBarry Was A Lady*. Despite the presence of powerhouse stars Ethel Merman and Bert Lahr, Betty stole the show. Darryl F. Zanuck summoned her back to Hollywood and Twentieth Century-Fox when Alice Faye became ill and was unable to do his 1940 Technicolor musical, *Down Argentine Way*. Betty replaced her; it was Grable's twenty-eighth film but, as far as audiences were concerned, they had never seen her until now. Technicolor made the difference.

Next came a black-and-white musical, *Tin Pan Alley*, opposite Alice Faye. Miss Faye had the bigger role, but Betty Grable further solidified her new reputation and was rewarded with a starring spot in another Technicolor production, *Moon Over Miami*.

In spite of her growing popularity and her obvious forte in Technicolor films, Fox surprisingly cast Betty Grable in three distinctly different black-and-white productions: *A Yank in the R.A.F.*, *Footlight Serenade* and *I Wake Up Screaming*. While audiences were

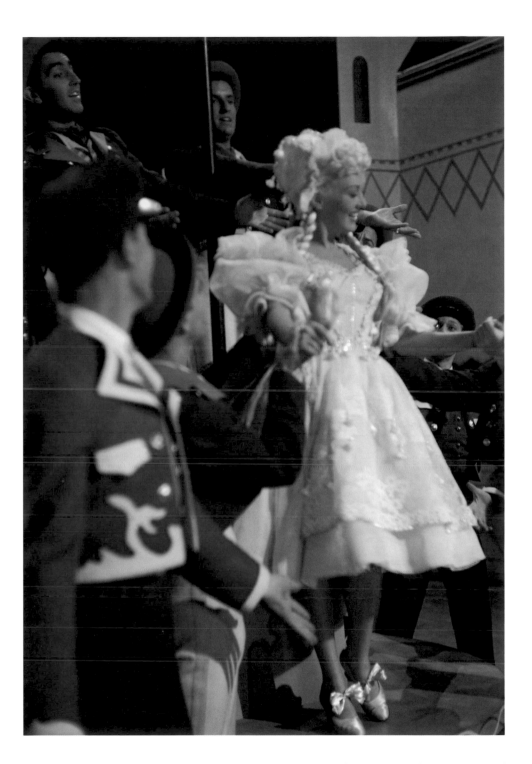

willing to pay to see her in anything, the studio now realized the best way to showcase its newest star was in color. Except for a guest appearance (as herself) in the 1944 *Four Jills In A Jeep*, she never again appeared in a black-and-white film.

Betty Grable was one of the most cooperative and unpretentious of the stars, and she knew best how to use her talents. She loved to dance and sing—and it showed. In 1945, after she had completed *The Dolly Sisters*, her biggest film to date (it broke every existing attendance record at New

York's Roxy Theatre). Darryl Zanuck offered her the role of the drunken Sophie in his black-and-white *The Razor's Edge*, promising that he could make her a great dramatic actress. "I'm strictly a song and dance girl," she told him good-naturedly. "If I play Sophie, my fans will expect me to rise from the ocean with seaweed in my hair and sing something." The role went to Anne Baxter and won her an Oscar.

After *The Dolly Sisters*, however, she did seek a change of pace. She had seen Judy Garland in *Meet Me In St. Louis* and was

BELOW: **Publicity still of Rita Hayworth for** *The Loves of Carmen,* **1948.**

impressed with the look of the film. Her own musicals, she began to believe, were too garish and glossy. Now she wanted to do a musical that was more subdued in color. The studio cooperated and began to plan *The Shocking Miss Pilgrim.* George Seaton, who had written and directed her earlier *Billy Rose's Diamond Horeshoe,* was hired for similar duties. He tried to create a new image for her, that of a turn-of-the-century stenographer in very proper Boston. Although utilizing Technicolor, it was a role with less flash, darkened hair and unseen "gams"—and a

musical without one big production number. The finished film, with its subdued color and subdued Grable, disturbed her fans. With her next movie, *Mother Wore Tights* in 1947, the garish, glossy colors were back. It proved to be one of her most popular pictures.

Betty Grable made twenty-two Technicolor features during her career. For millions of movie-goers around the world, she was the darling of the Technicolor screen. (Her Technicolor credits also included *Song of the Islands,* 1942; *Springtime in the Rockies,* 1942; *Coney Island,* 1943; *Sweet Rosie O'Grady,* 1943; *Pin Up Girl,* 1944; *Do you Love Me?,* 1946; *That Lady In Ermine,* 1948; *When My Baby Smiles At Me,* 1948; *The Beautiful Blonde From Bashful Bend,* 1949; *Wabash Avenue,* 1950; *My Blue Heaven,* 1950; *Call Me Mister,* 1951; *Meet Me After The Show,* 1951; *The Farmer Takes A Wife,* 1953; *How To Marry A Millionaire,* 1953; and *Three For The Show,* 1955.)

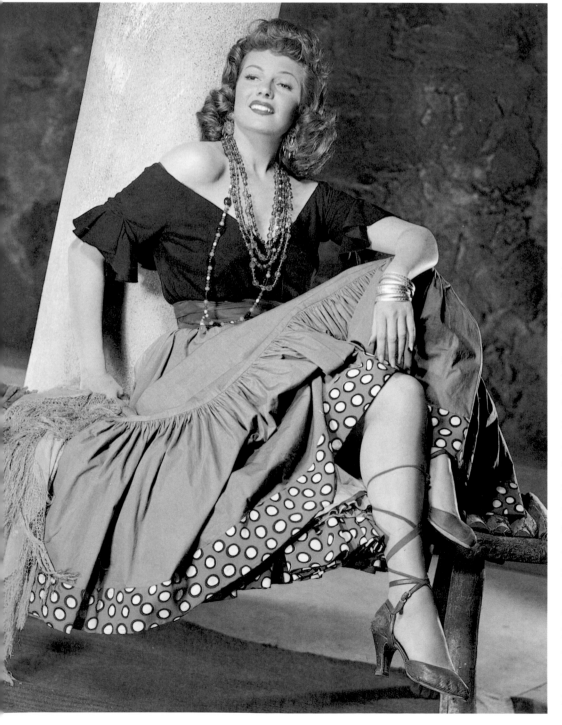

RITA HAYWORTH

Rita Hayworth was a blossoming star when she appeared in *Life* Magazine in 1941. The photo, a black-and-white pin-up shot, showed her kneeling on a bed, dressed in a white satin and black lace nightgown. Audiences had just seen her for the first time in a major role opposite Fred Astaire in a non-color musical *You'll Never Get Rich.* Later that year, *Blood and Sand*—her first Technicolor film—was released. If Rita Hayworth was beautiful in black and white, she was magnificent in color. The girl with the flowing tresses and sensuous movements would soon become America's "love goddess"—and one of the most publicized women in the world.

She was born Margarita Carmen Cansino in New York City, the daughter of Eduardo Cansino, a Spanish dancer, and Volga Haworth, an American who at one time had appeared on the English stage. Both parents wanted a theatrical career for

RIGHT : Poster, 1944.

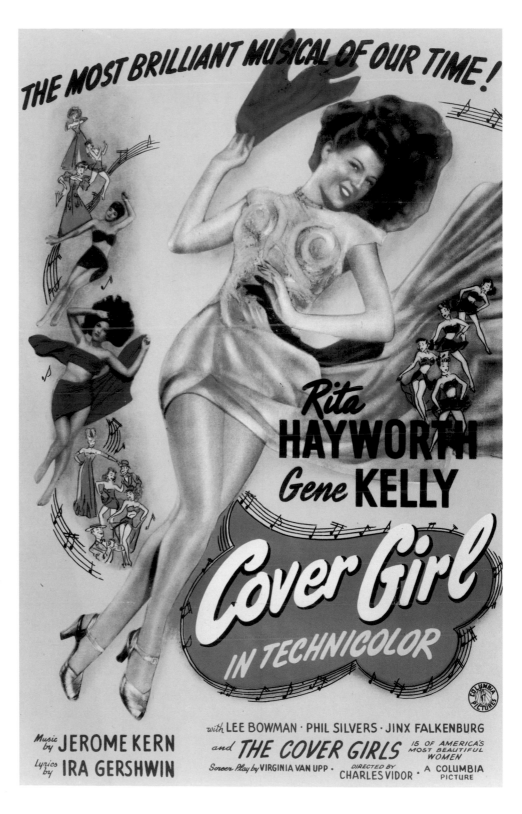

Margarita, a talented youngster with deep black hair and dark eyes. She was taking dancing lessons almost as soon as she could walk; by the age of six, she was part of the family act.

By 1935, she and her father had become a team and were appearing at Agua Caliente, a multi-million dollar hotel and casino complex located in a flowery oasis just south of Tijuana in Baja California, where she was spotted by movieman Winfield Sheehan. "That girl is a great beauty," he reportedly told friends at the time. "She could be a movie star with the right training." The others laughed. They thought she was a good dancer and had a lovely face but that she was too shy and too plump. He signed her to a contract, nevertheless.

Margarita Cansino made her official film debut as a dancer in Fox Film's *Dante's*

Inferno, although two later-made films were released first. Initially, she failed to impress audiences but she continued at Fox in a number of bit parts. The various studio press agents, at the time, were members of an organization called The Wampus, formed to promote promising young talent. They selected Miss Cansino to be one of their "Wampus Baby Stars" and, as Fox's representative, she received added recognition and was even announced to play the leading role in their Technicolor production of *Ramona*. Unfortunately, the studio was experiencing growing pains of its own. Fox Film Corporation merged with Twentieth Century Pictures to form Twentieth Century-Fox and Darryl F. Zanuck became head of production. With the change, Loretta Young (a favorite of Zanuck) got the part of Ramona and the newly named Rita Hayworth ("I do not like the name of Margarita Cansino," said one studio executive. "It's too long for billboards.") went to work in *Charlie Chan in Egypt* and other minor pictures.

At seventeen, she married Edward Judson, an ambitious automobile salesman from Texas, who saw Rita Hayworth as a good investment. He became her agent, persuaded her to change her dark hair to titian red, introduced her to the right people, and saw to it that she was never out of the limelight. One of the people she met was Columbia Pictures' Harry Cohn, who put her under contract to his studio. She continued to be cast in mediocre parts and it wasn't until she did some "loan outs" to other studios that things began to happen. Metro-Goldwyn-Mayer borrowed her for *Susan and God* (1940), Warner Bros. got her as a last minute replacement for Ann Sheridan in *The Strawberry Blonde* (1941). Fox used her in *Blood and Sand* (1941) and, when Alice Faye became pregnant, in *My Gal Sal* (1942)—both in Technicolor. Her success in *My Gal Sal* told the Columbia chief, a shrewd showman, what the public wanted. With each picture her fan mail increased sharply and,

before long, she was vying with Betty Grable for the affections of the servicemen. More photos of these two stars were sent to the war zones—the South Pacific, Africa and Europe—than of any others.

Although her great success, *Gilda*, was in black-and-white, Rita Hayworth's lingering impression is in Technicolor images—thanks to the memorable *Cover Girl*, 1944; *Tonight and Every Night*, 1945; *Down To Earth*, 1947; *The Loves of Carmen*, 1948; *Salome*, 1953; *Miss Sadie Thompson*, 1953; *Fire Down Below*, 1957; *Pal Joey*, 1957; and *Circus World*, 1964.

MARIA MONTEZ

Maria Montez was one of Universal's biggest money-makers throughout the war years. From *Arabian Nights* (1942) through *Sudan* (1945), she was seen adorning some of the most opulent and exotic sets Hollywood could create, gowned and jeweled in wondrous style. A fiery Latin beauty, she had reddish-brown hair, a magnificent complexion, and total confidence. She once noted, quite candidly, after viewing one of her performances, "When I look at myself I am so beautiful I scream with joy." Another time, after meeting Orson Welles, she commented, ". . . he is every bit as spectacular as I am."

Born on June 6, 1920, in the Dominican Republic, she was christened Maria Africa Gracis Vidal de Santos Silas. Her father Ysidro Gracis, was the local Spanish council; her mother, Teresa Vidal de Santos Silas, the daughter of a political refugee. Unlike her nine brothers and sisters, she was educated at the Sacred Heart Convent in the Canary Islands where she learned to speak and read French and English as well as her native Spanish.

After her schooling, she traveled throughout Europe. In Ireland, she began her acting career with minor roles in a small theatrical group. It was in New York City,

ABOVE: **Maria Montez. . . "I am so beautiful. . ."**

OPPOSITE: **Maria Montez as Scheherazade in** *Arabian Nights*, **1942**.

ABOVE: **Maureen O'Hara**

OPPOSITE: **Trade ad, 1949.**

to cast her opposite Jon Hall in Walter Wanger's Technicolor production of *Arabian Nights*. It was the studio's first venture in full color filming. Her sultry beauty and rich accent were ideally suited to the role of Scheherazade. And Technicolor.

By the end of 1942, Maria Montez was a top star with a string of exotic Technicolor costume fantasies to follow, including *White Savage*, 1942; *Ali Baba and the Forty Thieves*, 1944; *Cobra Woman*, 1944; *Gypsy Wildcat*, 1944; *Sudan*, 1945; and *Pirates of Monterey*, 1947.

MAUREEN O'HARA

Maureen O'Hara was crowned "Queen of Technicolor" after only a few appearances before the color camera. What sounds like a publicist's inspiration came instead from the Technicolor Corporation itself, which used footage of her during the early 1940s to help sell their process to the studios. "In those days," she said, "we did not receive reenumeration for such use of our name or likeness. I was proud of the honor."

Born in Dublin, Ireland, the oldest of six children, she inherited a love of the stage from her mother, Marguerita FitzSimons, who somehow found time while rearing her family to win a number of dramatic contests and become a member of the Abbey Players, Ireland's famed national theater group.

Young Maureen FitzSimons dramatized everything in her life. At five, she appeared in a church play; at twelve, she went on the radio and earned her first money as a professional entertainer. By the time she was fourteen, she too had joined the Abbey Players. Over the next few years she would win every award and medal bestowed in Ireland's play festivals and dramatic contests.

When she was eighteen, Harry Richman, the American singer, urged her mother to take her to London for screen tests. One was shot at Elstree Studios during the filming of

however, while working as a photographer's model, that she was spotted by a Hollywood agent. It took only one screen test for Universal to sign her, and soon she was appearing in several low budget films which were not to her liking. When she became temperamental, the studio arranged for her to play a small role in Twentieth Century-Fox's 1941 Technicolor musical, *That Night In Rio*, with Alice Faye, Don Ameche and Carmen Miranda. On her return to Universal, she was again relegated to relatively unimportant features—but not for long. Servicemen everywhere were starting to request publicity photos of her to pin up in their barracks. Universal executives took another look at their property and decided

the 1938 Richman film, *Kicking the Moon Around* (originally released in the U.S. as *The Playboy* and reissued in 1942 as *Millionaire Merry-Go-Round*). To her surprise, a portion of this test—showing her peeking around a door to announce a caller on the telephone—was used in the film.

If this brief exposure went unnoticed the full screen test did not. Actor Charles Laughton and producer-director Erich Pommer, who "discovered" Marlene Dietrich a decade earlier, saw it and signed her to a long-term contract with their company, Mayflower Pictures. Much against her will, they changed her name from FitzSimons to O'Hara, then cast her in the 1939 production of *Jamaica Inn* opposite Mr. Laughton.

With her background limited to theater, the Mayflower group felt she needed camera experience prior to the start of their feature and, as Maureen FitzSimons, was loaned out for the title role in *My Irish Molly*. A modest film originally intended for viewing only in small English towns, *Molly* made it to the United States in 1940, undoubtedly prompted by the success of *Jamaica Inn*.

Maureen O'Hara appeared in a handful of dramatic black-and-white movies, among them, *The Hunchback of Notre Dame* (1939) and *How Green Was My Valley* (1941), before her statuesque Irish beauty and cascading auburn hair were captured by the Technicolor cameras in Twentieth Century-Fox's *To the Shores of Tripoli* (1942). Because the harsh lights hurt her eyes, she felt she could never again make another Technicolor film. Today, with thirty-three color films on record, she credits the combination of Technicolor and great cameramen (specifically Edward Cronjager and Leon Shamroy) for escalating her productive screen career.

She was a film favorite in Technicolor and at Technicolor. Prior to the start of each picture she made, whether in color or not, the company sent her an enormous basket of roses in every color of the spectrum. They came to be known as her "Technicolor roses."

Maureen O'Hara's lengthy list of Technicolor features spans nearly thirty years, from *To the Shores of Tripoli* and *The Black Swan*, 1942; *Buffalo Bill*, 1944; *The Spanish Main*, 1945; *Sinbad the Sailor*, 1947; and *The Quiet Man*, 1952, to the more recent *The Parent Trap*, 1961; *Mr. Hobbs Takes A Vacation*, 1962; *Spencer's Mountain*, 1963; *McLintock!*, 1963; *The Rare Breed*, 1966; and *Big Jake*, 1971.

CARMEN MIRANDA

Carmen Miranda, the lady who wore fruit baskets on her head, was a Technicolor extravaganza in her own right—on and off the screen. The exuberant entertainer had tremendous influence on fashion as well as on the music of the day.

She was a creature of contradictions. Known as "the Brazilian Bombshell," she was actually born in Portugal, on February 9, 1914. As a so-called product of the world's

©1941 Twentieth Century Fox.

OPPOSITE: **Alice Faye and Carmen Miranda in**
***Week-End in Havana,** 1941.*

RIGHT: **Carmen Miranda, the "Brazilian Bombshell."**

leading coffee producing country, she let it be known she detested the drink.

Her real name was Maria da Carmo da Cunha and she was educated in a convent in Rio de Janeiro. When she was fifteen, she knew that she wanted to be a singer but her well-to-do parents thought it would be improper for a girl to appear on the stage. She turned to radio and found a job at a local station. Within a short time, she was making phonograph records of her most popular radio numbers. Her success on records led to engagements in casinos, night clubs and theaters, and parts in South American films.

It was only a matter of time until the United States discovered her. Lee Shubert, of the Broadway Shuberts, was on a South American cruise in 1938 when he was invited to see Miss Miranda perform at the Casino Urqua in Rio. He placed her, and her six singing accompanists, under contract at once.

In New York, her unique talent and style created a sensation and, within months, she had been spotted (and signed) by a Twentieth Century-Fox scout. She was first cast in *Down Argentine Way* with Betty Grable and Don Ameche, but getting her to Hollywood proved difficult, as commitments prevented her from leaving New York. Instead, the studio sent the director, Irving Cummings, and the entire Technicolor crew to New York and filmed her scenes at the

RIGHT: **With Victor Mature at her side, Esther Williams, as Australian swimming star Annette Kellerman, gets arrested for wearing a "daring" one-piece bathing suit in *Million Dollar Mermaid*, 1952.**

© Turner Entertainment Co.

Movietone Studio on Tenth Avenue. It was not until the following year, 1941, when the studio decided to do a film set in her adopted country (*That Night In Rio*) that she was able to head west. Even then, the start of production had to be postponed to permit her to fulfill a longstanding engagement at Chicago's Chez Paris.

When Carmen Miranda arrived in California, her vocabulary consisted of less than two dozen words. But it was the way she handled dialog—or mishandled it—and her flashy interpretations of catchy tunes (*I'Yi,Yi, Yi, Yi, Yi I Like You Very Much*; *Chica, Chica, Boom, Chic*; *Cuanta La Gusta*; *Mamae Eu Quero*) that captivated Americans. For a time, she was the rage of the fashion world. New York debutantes started it by "borrowing" her look: the Bahiana costume she originated for a Rio carnival, distinguished by an abundance of chunky junk jewelry, colorful bandannas, and high platform wedgies.

Carmen Miranda's Technicolor features also included *Week-End In Havana*, 1941; *Springtime in the Rockies*, 1942; *The Gang's All Here*, 1943; *Greenwich Village*, 1944; *A Date With Judy*, 1948; and *Nancy Goes to Rio*, 1950.

It is not surprising that this colorful performer failed to be at her best when cast in several non-Technicolor musicals. Such black-and-white films as *Doll Face* (1946), *If I'm Lucky* (1946), and *Copacabana* (1947) undoubtedly helped speed the decline of her meteoric screen career.

ESTHER WILLIAMS

Esther Williams brought a special talent to motion pictures: swimming. Over ten spectacular years, she appeared in sixteen Technicolor extravaganzas, more than any other Metro-Goldwyn-Mayer star—and earned the distinction of being the studio's all-time female money-maker.

She was born in Los Angeles in the shadows of MGM. Even as a child, she was obsessed with swimming to such an extent that she spent part of every day at the local municipal pool in Inglewood where she paid her admission by counting towels.

As a teenager, Esther Jane Williams won

sixteen titles and held the world's breast stroke record. In 1940, she qualified for the American Olympic team, winning three berths, but the games were canceled because of war.

The long-legged, freckle-face girl was working as a stock girl at I. Magnin & Co., with her sights set on being a buyer, when she was contacted by showman Billy Rose who wanted to star her in his glittering aquacade at the San Francisco World's Fair. The result was a measure of fame and a call from one of Louis B. Mayer's aides at MGM. Surprisingly, she did not jump at the opportunity to appear in pictures. The biggest obstacle, she felt, was that she couldn't act. (Years later, after her stardom was long established, she commented, "If they ever teach a duck to act, I'm in trouble.") Mr. Mayer, who was known to be persuasive at times, signed her to a seven year contract at $250 a week.

The studio groomed Esther Williams for stardom, giving her lessons in everything from "how to walk" to "how to sit." After a few minor roles in black-and-white films, she was cast in her first Technicolor movie, *Mr. Co-ed*, starring Red Skelton. Technicolor heightened her natural assets to such an extent that the studio built up her part, changed the title of the film to *Bathing Beauty*, and gave her co-star billing. An average picture with an average plot, *Bathing Beauty* became a bigger draw than anticipated. In South America, it broke many attendance records, even those of *Gone With the Wind*. The first three Technicolor pictures in which she starred (*Bathing Beauty*, 1944; *Thrill of a Romance*, 1945; *Easy to Wed*, 1946) grossed over $15 million in the United States alone. Except for a minor black-and-white melodrama with William Powell called *The Hoodlum Saint* (1946), her future films were exclusively color.

By the early 1950s, Esther Williams had been showcased in every conceivable water setting and dreaming up new ways to display her skills became a real problem. Twentieth

Century-Fox had encountered similar problems with its Olympic ice skating champion, Sonja Henie, a few years earlier. Miss Henie normally had three skating sequences in each picture and finding new ways to get her on the ice, logically or otherwise, was not easy. Too, the Norwegian-born star was less versatile, making the situation even more difficult. Esther Williams had learned to dance and sing. Still, in an effort to please her public, production numbers became more astonishing and colorful with each outing. (Miss Henie, incidentally, only once had the advantage of color during her ten-picture career: RKO's *It's A Pleasure* in 1945.)

In 1952, Busby Berkeley was hired to create the water sequences for *Million Dollar Mermaid*, the dramatic, true story of swimmer Annette Kellerman. Of all her films, it is Miss Williams' favorite. For her millions of fans, it marked a high point in a glamorous career that included such other Technicolor features as *Fiesta*, 1947; *This Time For Keeps*, 1974; *On An Island With You*, 1948; *Take Me Out To The Ball Game*, 1949; *Neptune's Daughter*, 1949; *Duchess of Idaho*, 1950; *Pagan Love Song*, 1950; *Texas Carnival*, 1951; *Skirts Ahoy!*, 1952; *Dangerous When Wet*, 1953 and *Easy To Love*, 1953.

LUCILLE BALL

Lucille Ball, the self-made redhead with the big blue eyes, was once called "Technicolor Tessie" by *Life* Magazine. That tag was a long time coming, however. For several years, prior to 1943, she played brittle, smart-girl roles in nearly thirty colorless productions where "I'd say one fresh line and exit . . . I hated it." Then came *DuBarry Was A Lady*. The filmed version of the Broadway success, in Technicolor, was a turning point in Lucille Ball's career.

Her ambition to become an actress surfaced in Jamestown, New York. As a young

OPPOSITE: **Lucille Ball in** *Ziegfeld Follies*' **opening number, "Bring on the Beautiful Girls," 1946. (Another song, "I Love You More in Technicolor Than I Did in Black and White" had been planned for Judy Garland and Mickey Rooney but was never recorded.)**

RIGHT: **Lucille Ball.**

girl she would play "show business" in the attic of her home, dressing in her mother's costumes and acting out little plays. When she graduated from high school, she persuaded her mother to let her go to New York City to enroll in John Murray Anderson's dramatic school. "No talent," was Mr. Anderson's appraisal of her ability.

Disillusioned but not discouraged, she turned to bread-and-butter jobs, working as office help, waitress, soda jerk and wholesale garment model. In between, she managed to land chorus jobs with various Broadway musical productions, but never got beyond the rehearsal stage. An agent finally got her a

spot as a showgirl in Samuel Goldwyn's movie, *Roman Scandals*, which led to a contract with Columbia Pictures and a series of featured roles in "B" films Unhappy, she went to RKO Radio Pictures and did small parts in *Roberta*, *Top Hat*, and *Follow the Fleet*. She felt she found her big chance when she was hired for the lead in an out-of-town musical called *Hey, Diddle Diddle*. But it never reached Broadway, and she returned to Hollywood for more minor parts. Then Metro-Goldwyn-Mayer discovered her.

Lucille Ball had reddish-brown hair when she arrived at MGM. While the color was serviceable enough for black-and-white

© Turner Entertainment Co.

ABOVE: **Arlene Dahl** in *Three Little Words,* 1950.

OPPOSITE: **Arlene Dahl.**

pictures, it lacked the proper punch for the Technicolor cameras. Sidney Guilaroff, the famed MGM hair stylist, decided to make her a definite redhead, and in *DuBarry Was A Lady* she appeared for the first time with flaming tresses. They became her trademark throughout an active career that also included such Technicolor films as *Best Foot Forward*, 1943; *Thousands Cheer*, 1943; *Ziegfeld Follies*, 1946; *Easy to Wed*, 1946; *Fancy Pants*, 1950; *Critic's Choice*, 1963; and *Mame*, 1974.

ARLENE DAHL

Arlene Dahl was called "the girl for whom Technicolor was invented." She had red-gold hair, bright blue eyes, a flawless complexion, and two heart-shaped beauty marks—one above the corner of her mouth, the other on her shoulder. Her publicity releases were peppered with irresistible phrases, such as

"Oh, you beautiful Dahl," "Dahl face" and "Hollywood's Dahl-ling."

She was born in Minneapolis, Minnesota, descendant of a line of Scandinavian ancestors. At seven, she was named "*Queen of the May*" by her grammar school classmates. In high school, she was doubly honored as "the prettiest girl ever graduated from Washburn High" and "the most likely to succeed."

Because she had received some acclaim as an art student, she was offered a job in interior display for a Minneapolis department store. Her good looks and height (nearly five-foot-seven) also led to modeling assignments. By 1945, she was the leading model at Marshall Field & Company in Chicago.

During a vacation in New York, she was seen at a party by Broadway producer Felix Brentano. She was soon in show business with a contract to appear in the musical comedy revue, *Mr. Strauss Goes to Boston*. This was

© Paramount Pictures.

followed with the ingenue lead in the pre-Broadway disaster, *Questionable Ladies.* Warner Bros. director Curtis Bernhardt had spotted her, however, and it wasn't long before she was heading for Hollywood.

Her first film assignment was in Technicolor, opposite Dennis Morgan in Warner Bros.' 1947 musical, *My Wild Irish Rose.* It led to an MGM contract and an appearance in another important Technicolor production, *Three Little Words,* with Fred Astaire, Red Skelton and Vera-Ellen.

Arlene Dahl's Technicolor credits also include *Desert Legion,* 1953; *Sangaree,* 1953; *Woman's World,* 1954; *Bengal Brigade,* 1954; and *Slightly Scarlet,* 1956.

DANNY KAYE

Danny Kaye was the only male star whose personality and appearance were best captured in Technicolor. Like many of the top female Technicolor stars, he had red hair.

OPPOSITE: **Angela Lansbury and Danny Kaye in**
The Court Jester, **1956.**

RIGHT: **Danny Kaye.**

But audiences were nearly denied seeing the versatile entertainer's most distinguishing feature—at least, during the early part of his film career. Samuel Goldwyn, who had lassoed Kaye from Broadway, was not happy with Kaye's color tests for his screen debut in *Up in Arms* (1944). It was his flame top, Goldwyn decided. The hair had to be toned down or changed altogether. Additional tests were made showing Kaye with a range of colors, from blonde to brunette. Goldwyn didn't like those either, so Kaye's original hair coloring, with highlights, was returned to normal. A funnyman should look "different," announced Goldwyn.

Danny Kaye was born David Daniel Kaminsky on January 18, 1913 in Brooklyn, New York, the son of Ukranian immigrants. As a youngster, he was tall and gangly with large white ears and an unruly mop of copper-colored hair. Although shy and nervous at the very thought of performing, he longed to be in show business, so much so that at thirteen he ran away from home with a schoolmate to sing, often comically, before anyone who would listen. He returned home, but his school days were over. After a succession of "odd jobs"—from soda jerk to dental assistant—he finally made it to the Catskills, and the borscht belt circuit, as part of a clowning , mugging twosome called "Red and Black." Kaye captivated audiences with his unique rendition of Cab Calloway's signature song, "Minnie the Moocher."

It was on Broadway, however, that critics really took notice, first in 1939, in "The Straw Hat Revue" with Imogene Coca, then in 1941 in "Lady in the Dark" with Gertrude Lawrence. His tongue-tripping, scene-stealing moments on stage did not sit well with Miss Lawrence, but Danny Kaye had already made an impression. In 1950, at the height of his career, he was named "the world's greatest entertainer."

In addition to *Up in Arms*, Danny Kaye's

other Technicolor credits include *Wonder Man*, 1945; *The Kid From Brooklyn*, 1946; *The Secret Life of Walter Mitty*, 1947; *A Song Is Born*, 1948; *It's a Great Feeling* (unbilled cameo), 1947; *The Inspector General*, 1949; *On the Riviera*, 1951; *Hans Christian Anderson*, 1952; *Knock on Wood*, 1954; *White Christmas*, 1954; *The Court Jester*, 1956; *The Five Pennies*, 1959; *On the Double*, 1961; and *The Madwoman of Chaillot*, 1969.

RHONDA FLEMING

Rhonda Fleming was an accomplished singer and an excellent actress. With her lustrous auburn hair, gray-green eyes and classic beauty, she was a natural for color films. Of all the "Technicolor stars," her talent was perhaps the most misused.

She was born Marilyn Louis in Los Angeles. Her mother, Effie Graham Louis had once gained national fame on the Broadway stage where she starred as Al Jolson's leading lady in the 1916 production of *Dancing Around*. Her Grandfather, John C. Graham, was a famous actor and producer at the old Salt Lake City Theatre.

BELOW: Rhonda Fleming.

Her career really began when she entered Jesse Lasky's "Gateway to Hollywood" radio contest while in high school. She didn't win, but her picture appeared on the cover of the high school magazine. A Hollywood talent scout saw it and she won a spot in Ken Murray's *Blackouts Revue*. She left the show after only six weeks when she was offered a contract with Twentieth Century-Fox.

Rhonda Fleming found herself sitting around at Fox and asked for her release. She was soon signed by David O. Selznick and in 1945 she made her screen debut in *Spellbound*, the Ingrid Bergman-Gregory Peck classic. For her portrayal of a neurotic patient in a sanitarium, she was hailed as the finest dramatic newcomer of the year. Had her role figured more importantly in the story, one critic commented, she would have won an Oscar as best supporting actress.

Appearing with Bing Crosby, she achieved stardom in the 1949 Paramount musical, *A Connecticut Yankee in King Arthur's Court*. It was her first film in Technicolor, and audiences and producers were highly impressed with her beauty. At that point, however, Miss Fleming's career took a turn.

Too quickly forgetting the dramatic promise shown in *Spellbound*, she was cast in stock"siren" roles that provided little opportunity for her potential. In rapid succession, she starred in a series of colorful, high-adventure films, among them: *The Eagle and the Hawk*, 1950; *Little Egypt*, 1951; *Crosswinds*, 1951; *Those Redheads From Seattle*, 1953; *Yankee Pasha*, 1953; *Slightly Scarlet*, 1956; *Gunfight at the OK Corral*, 1957; *The Big Circus*, 1959; and *The Crowded Sky*, 1961.

LASSIE

Lassie was a major box office attraction all during the 1940s when "she" (actually a female impersonator) appeared exclusively in Technicolor productions.

Lassie, the collie, was created in 1938 when Eric Knight wrote a short dog story for his young daughter. The manuscript was later expanded into a children's book and published as *Lassie Come Home*. Metro-Goldwyn-Mayer purchased the film rights from the author in 1941 for a flat fee, less than ten thousand dollars. That same year Lassie, the star, was born.

MGM planned to film *Lassie Come Home* as a low-budget production with a cast of English character actors and two youngsters named Roddy McDowell and Elizabeth Taylor. The casting had been completed with the exception of the canine lead. Auditions were held at a baseball park in Los Angeles but not one of the three hundred dogs, mostly mongrels, was acceptable—including the one brought by trainer Rudd Weatherwax.

Mr. Weatherwax's collie, Pal, was a two-year-old that he had been given as a pup in exchange for an unpaid kennel bill. The dog was mild mannered and well-trained but lacked the look of "the perfect collie" that everyone thought would endear him to the hearts of movie fans. Pal was summoned, however, in desperation when the studio had a chance to film some rare footage for one of the scenes in the picture.

The San Joaquin River in northern California was overflowing its banks and, as producer Sam Marx put it, "We needed a collie fast. As a last resort we signed with Weatherwax for one scene, using Pal to swim the flooded river. All wet collies look alike anyway. We figured we could match long shots of Pal with close-ups of the dog we eventually picked."

According to studio sources, the dog was phenomenal. "Pal jumped into that river but it was Lassie who climbed out."

Lassie Comes Home was one of MGM's biggest hits of the year. Others followed, including *Son of Lassie*, 1945; *Courage of Lassie*, 1946; *Hills of Home*, 1948; *The Sun Comes Up*, 1949; and *Challenge to Lassie*, 1949. In 1994, as a salute to her staying power (50-plus years as a family favorite), Lassie raced back into public view with a PBS special, two new books, countless merchandising tie-ins, and a new film from Paramount, *Lassie*, in color by Technicolor.

DORIS DAY

Doris Day became a star in her first film, *Romance on the High Seas* (1948) — in Technicolor. A last minute replacement for Betty Hutton, she was the musical star Warner Bros. had long been searching for. With the release of her next two films, both in Technicolor, the Cincinnati native was on her way to becoming Hollywood's most popular female star and one of its highest paid.

As a teenager she had dreams of becoming a dancer, but an automobile accident ended that. She took singing instead, and within a few years she was singing locally, then with big bands (Bob Crosby and Les Brown), cutting records and catching the eyes of studio scouts. Movie audiences immediately took to her wholesome blonde looks, wonderful voice, perfect figure, and bubbly personality. And she looked sensational in Technicolor. She also proved to be more than a musical star when she turned to saucy bedroom comedies opposite such popular leading men as Cary Grant and Rock Hudson, and dramatic roles top-billed with Kirk Douglas, James Cagney, Rex Harrison and Frank Sinatra. While on location with James Stewart for

Hitchcock's *The Man Who Knew Too Much* (1956), she saw the mistreatment of animals used in the film, which began her lifelong commitment to caring for animals.

Throughout her versatile 20-year career in films, Doris Day appeared in a dozen Technicolor films, which also included *My Dream Is Yours*, 1949; *It's a Great Feeling*, 1949; *Tea for Two*, 1950; *Lullaby of Broadway*, 1951; *On Moonlight Bay*, 1951; *April In Paris*, 1952; *By the Light of the Silvery Moon*, 1953; *Calamity Jane*, 1953; *It Happened to Jane*, 1959; and *Send Me No Flowers*, 1964.

There were others, too, who were well known for their Technicolor appearances—but to a lessor degree and for varied reasons. Vera-Ellen, Jane Powell and Kathryn Grayson appeared almost exclusively in lush Technicolor productions, but they were performers whose talents, incidentally, happened to be filmed in color. Virginia Mayo's blonde beauty reached the screen in over twenty color productions. Her best role, however, was in the black-and-white *The Best Years of Our Lives* (1946). June Haver danced and sang her way through thirteen Technicolor Fox musicals, but she was always overpowered—by Betty Grable in the 1940s and by Marilyn Monroe in the 1950s. Sabu, in the early days of his career, appeared in a number of magnificently produced Technicolor pictures, notably Korda's *Drums* (1938), *The Thief of Bagdad* (1940) and *Jungle Book* (1942), only to be upstaged by the colorful effects and surroundings. Judy Garland, Gene Kelly, Betty Hutton, Jeanne Crain, Paulette Goddard, Olivia de Havilland, Dorothy Lamour, and others appeared in Technicolor productions but with less consistency.

As time went on and Technicolor increased in popularity, appearances in color became the rule. Today, it would be difficult to name five established stars who, at one time or another, have not had a Technicolor credit.

OPPOSITE: **Doris Day**

BELOW: **Sabu**, star of ***The Thief of Bagdad***, 1940.

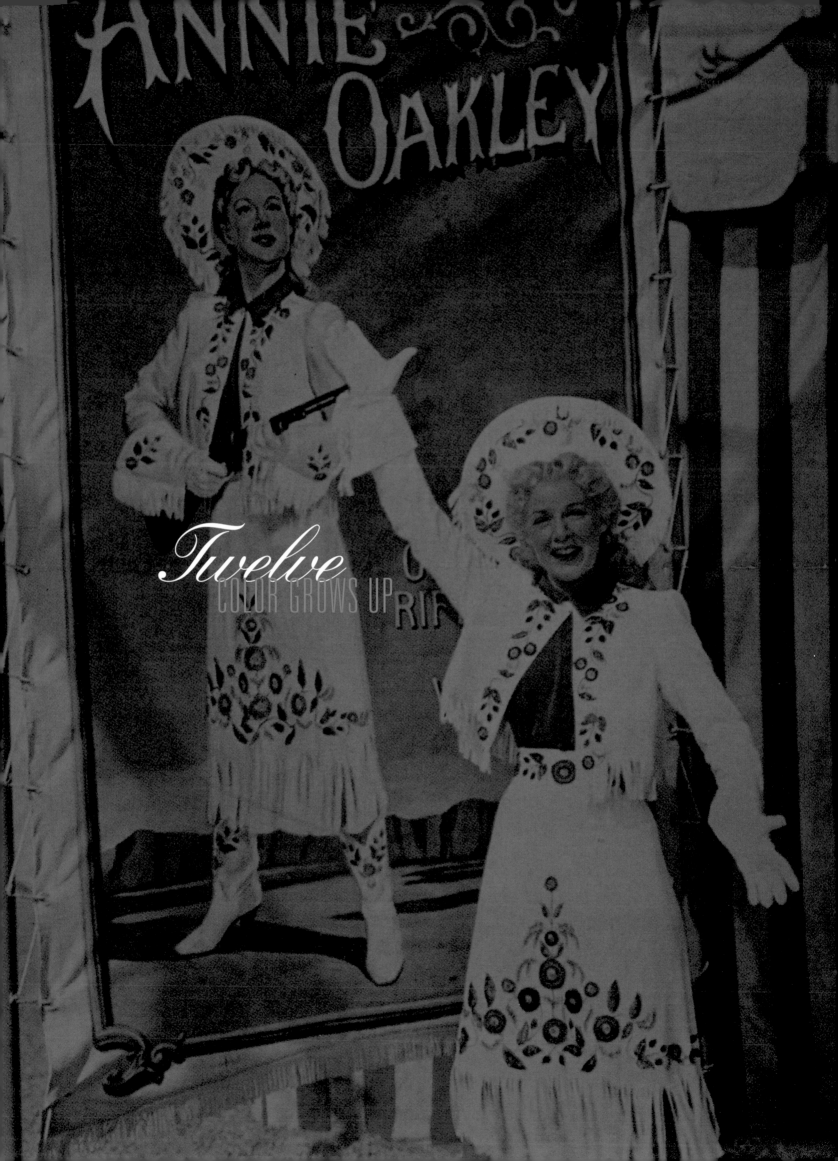

Twelve
COLOR GROWS UP

As long as color was denied the cinematographer, his art was necessarily incomplete. But once Technicolor features had been produced in sufficient numbers to be regarded as a staple commodity, the motion picture reached its maturity and became, for the first time, a true art form.

When Rouben Mamoulian accepted Darryl F. Zanuck's offer to direct *Blood and Sand* in 1941, it had been six years since he'd worked on the first full-length full-color picture, *Becky Sharp*. Looking back, he stated, "The story was, I am convinced, none too happily chosen as a vehicle for launching the color medium . . . nevertheless, in that first pioneering effort we all learned valuable lessons about color and its use."

During the intervening years, the Technicolor process had been greatly improved, particularly in efficiency and technical smoothness. Like many others within the industry, Mr. Mamoulian tried to advance with the process in his understanding of color in all its uses. Hoping for another opportunity to direct a Technicolor feature, he noted, "I have tried to study color from every angle—the history of color, the psychology of color, the artistic application of color as four thousand years of painters have taught it to us, and something at least, of the scientific aspect of color as regards color in pigments and light values."

That Mr. Mamoulian was extremely well prepared to handle the new assignment on *Blood and Sand* was evident from the start. Working with co-cameraman Ernest Palmer and Ray Rennahan, he developed a color plan which would coordinate the emotional aspects of action and dialog with the physical production—keying the coloration of the settings and costumes for each scene and sequence to the emotional mood of that particular action in exactly the same way a cinematographer keys his lighting to match the mood of the action.

Blood and Sand was not only a story of Spain, it was a story of Spanish people. The aim of the creative team in preparing the film was to capture the authentic atmosphere of the country, in its literal everyday reality as well as in its poetic essence, an atmosphere that had been best expressed pictorially by the great Spanish painters. It was only fitting then that they should become the basis of inspiration. As Mr. Mamoulian stated:

After all, in making a motion picture, and especially a motion picture in

OPPOSITE: **Betty Hutton** in ***Annie Get Your Gun,*** **1950.**

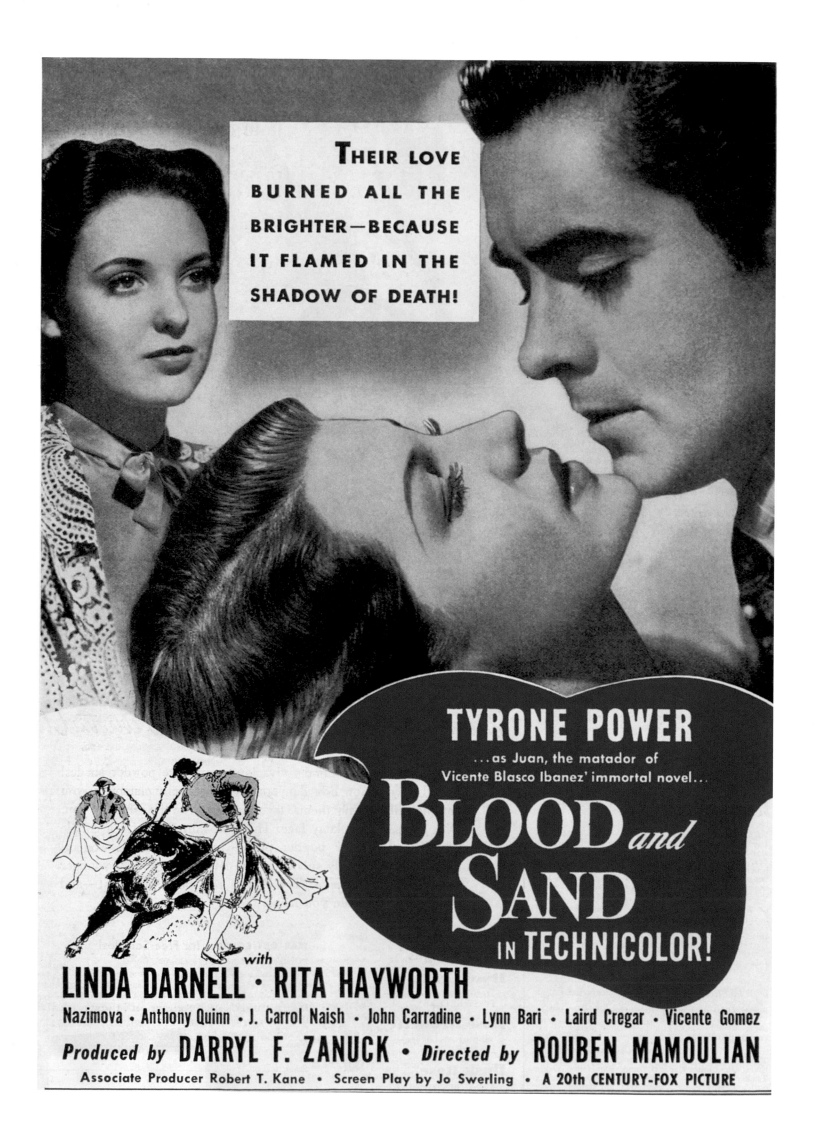

THEIR LOVE BURNED ALL THE BRIGHTER—BECAUSE IT FLAMED IN THE SHADOW OF DEATH!

TYRONE POWER
...as Juan, the matador of Vicente Blasco Ibanez' immortal novel...

Blood and Sand
in TECHNICOLOR!

with
LINDA DARNELL · RITA HAYWORTH
Nazimova · Anthony Quinn · J. Carrol Naish · John Carradine · Lynn Bari · Laird Cregar · Vicente Gomez
Produced by DARRYL F. ZANUCK · Directed by ROUBEN MAMOULIAN
Associate Producer Robert T. Kane · Screen Play by Jo Swerling · A 20th CENTURY-FOX PICTURE

BELOW: **Linda Darnell and Tyrone Power in** *Blood and Sand*.

color, we are essentially making a series of paintings. What does it matter if we are not painting our picture with water color or oil paint, but with colored light projected on a white screen? What does it matter if our picture moves and speaks? It is still fundamentally a picture. To what better source of inspiration could we turn than the greatest masters of painting?

Not that any of us made a slavish attempt to imitate them! That would have been fatal. We were working in a different medium, expressing different thoughts. But we could—and did—turn to them as fellow artists who knew the country and its emotions, for guidance in expressing similar emotions in our own medium. Their use of color,

proven by centuries of approval, could guide us in choosing the color we used in expressing similar emotions, painting comparable scenes.

For the early sequences showing Juan's (Tyrone Power) poverty-ridden childhood, they turned to the painting of Murillo and borrowed the bronze-browns and blacks of his *Young Spanish Beggar*. For the bullring scenes, and those of violent action, they followed the style of Goya, using dramatic and vivid colorings. The paintings of Spain's foremost religious painter, El Greco, supplied the color mood for sequences in the chapel, and those of Sorolla were used as guides for the street and market scenes. Finally, they turned to the Venetian painters, particularly Titian and Veronese, for help in capturing the luxuriousness of color and strong sugges-

tions of bustling movement.

In selecting colors for the costuming, they tried to express the essential qualities of each character. For Juan's childhood sweetheart and wife, played by Linda Darnell, they selected white, the color of purity. Later, when she was in danger of losing her husband, she wore either blue or black. Dona

TECHNICOLOR

is

*appreciative
of the part played by
skillful cinematography in the
increasing popularity
of Technicolor
pictures.*

TECHNICOLOR MOTION PICTURE CORPORATION

Herbert T. Kalmus, President

Sol, performed by Rita Hayworth, was an aristocratic seductress. In her introductory scene, she was seen wearing royal purple and, during a passionate love sequence, a hot orange.

To achieve a look of total realism with the props and backgrounds, a number of unrealistic steps had to be taken. According to the director, "On the set, they looked incredibly artificial. But on the screen, they gave the effect we desired. Often they proved more realistic than reality its literal self." Those steps included the coloring of selected white objects, a practice introduced by

Natalie Kalmus years earlier. In *Blood and Sand*, however, it was carried to the extreme.

For one scene, a white shirt was sprayed with traces of greens and blues. For another, a death-bed scene, hospital accessories (white sheets and enameled surgical cases) were sprayed a dull gray-green. Throughout the film, wherever necessary, various white objects were either falsified or subdued for effect. Left alone they would have been too stark and jarring within the setting. Though toned down, they still appeared to be white on film .

Blood and Sand, nominated by members of the Academy of Motion Picture Arts and Sciences for best Interior Decoration (color) and winner of the Academy Award for the year's best Color Cinematography, ranks as one of the first truly artistic cinematic achievements in Technicolor. In many respects, it was the forerunner of another visually magnificent film from Twentieth Century-Fox, 1947's *Forever Amber*. Highly acclaimed for its camera work, though controversial in regard to its dramatic values, the lusty Kathleen Windsor novel of Restoration England was said to have been "brought to the screen in a burst of Technicolor glory."

"We worked with a period that was by nature flamboyant," said supervising art director Lyle Wheeler. "We wanted richness, but not distracting over-vividness, so what we actually did was to gray down everything in the picture but the wedding dress."

As one critic exclaimed, ". . . *Amber* is distinguished (and the word is used literally) by color photography that probably comes as close to perfection as any blending of art and mechanics can come. Leon Shamroy (cinematographer) has infused the production with jewel-like color that seems to sparkle and glow at the same time. His camera treatment, combined with art direction and costume design of superlative quality, results in a screen pageant that is like nothing so much as Gobelin tapestry brought to life."

Leon Shamroy, whose work on *Forever*

ABOVE: **June Dupres and John Justin in *The Thief of Baghdad,* 1940.**

Amber, starring Linda Darnell and Cornel Wilde, followed his previous award-winning efforts (*The Black Swan,* 1942; *Wilson,* 1944; *Leave Her To Heaven,* 1945), was a master of the color camera and highly acclaimed for his highly individualistic style of "painting with light." Unlike many other cinematographers of the day who believed that only white light should be used for Technicolor, Mr. Shamroy employed colored light to great effect, infusing a warm tone here, a cooler tone there, until he achieved the correct emotional pattern of the scene. Like Rouben Mamoulian, he admitted to being inspired by the works of famous painters: Rembrandt, Rubens, and others.

The photography of *Forever Amber* was enhanced by the use of "the ultimate lamp," the Type 450 "Brute" Molarc introduced in 1946, which offered a hard, clean streak of light (at double the intensity) that could be employed from a relatively long distance to produce a "single shadow" impression. It enabled cinematographers to turn their attention, more than ever, toward lighting for mood and dramatic effect.

As Technicolor pictures grew in stature during the 1940s, the cinematographer gained new respect within the industry. Now officially titled Director of Photography, his select group included a number of newcomers to the color field—though hardly new to motion picture cinematography. Ray Rennahan, W. Howard Greene, William V. Skall and Allen M. Davey were among the most respected veterans of their craft. To this group was added such names as Shamroy, Jack Cardiff, Charles Rosher, George Barnes, Robert L. Surtees, Winton Hoch, Robert Burks and Harry Stradling.

For the years 1927 and 1928, Charles Rosher was nominated for his black-and-

OPPOSITE: **Gregory Peck, Claude Jarman, Jr. and Jane Wyman in** *The Yearling*, **1946.**

BELOW: **The courtroom scene in** *Leave Her To Heaven*, **with Jeanne Crain, Cornel Wilde (back to camera), Vincent Price and Ray Collins, 1945.**

white cinematography on three films. One of them, *Sunrise*, won the Academy Award at the first Oscar ceremony. In 1945, Mr. Rosher, in tandem with Arthur Arling and Leonard Smith, began filming the picture that would win him another "best" trophy. The film was Metro-Goldwyn-Mayer's Technicolor production of Marjorie Kinnan Rawling's *The Yearling*, the story of a family's fight for survival in the Florida wilderness.

"As a Director of Photography," Mr. Rosher recalled, "my main concern was achieving on film the complete realism envisioned by director Clarence Brown. In my first discussion with Mr. Brown, I learned of his decision to dispense with all artificial make-up. It was a bold step and a photographic challenge. It meant that the normal control over flesh tones possible with make-up, a very important factor in color, would be removed. Although I had more than an inkling of the difficulty involved, it was some-

thing I had long wanted to do . . . to show skin color and texture as they really are."

Maintaining constant color values in the faces of the principal players was not easy. Claude Jarman, Jr., who played the character of young Jody, was made to wear a large straw hat when away from the cameras to keep his delicate complexion from tanning (Florida was in the midst of a drought and heat spell during much of the company's stay). As Pa Baxter, Gregory Peck's naturally ruddy complexion had to be treated frequently with iced chamois skin to hold the redness down. The situation was reversed for Jane Wyman. Her role as the drab Ma Baxter was a complete departure for the star who had, until then, made a career of playing snappy, modern career girls. Miss Wyman spent fifteen minutes a day under a sunlamp to achieve the outdoorsy look associated with the backwoods life.

If *The Yearling* was a milestone in the

ABO

The

BI

B

E

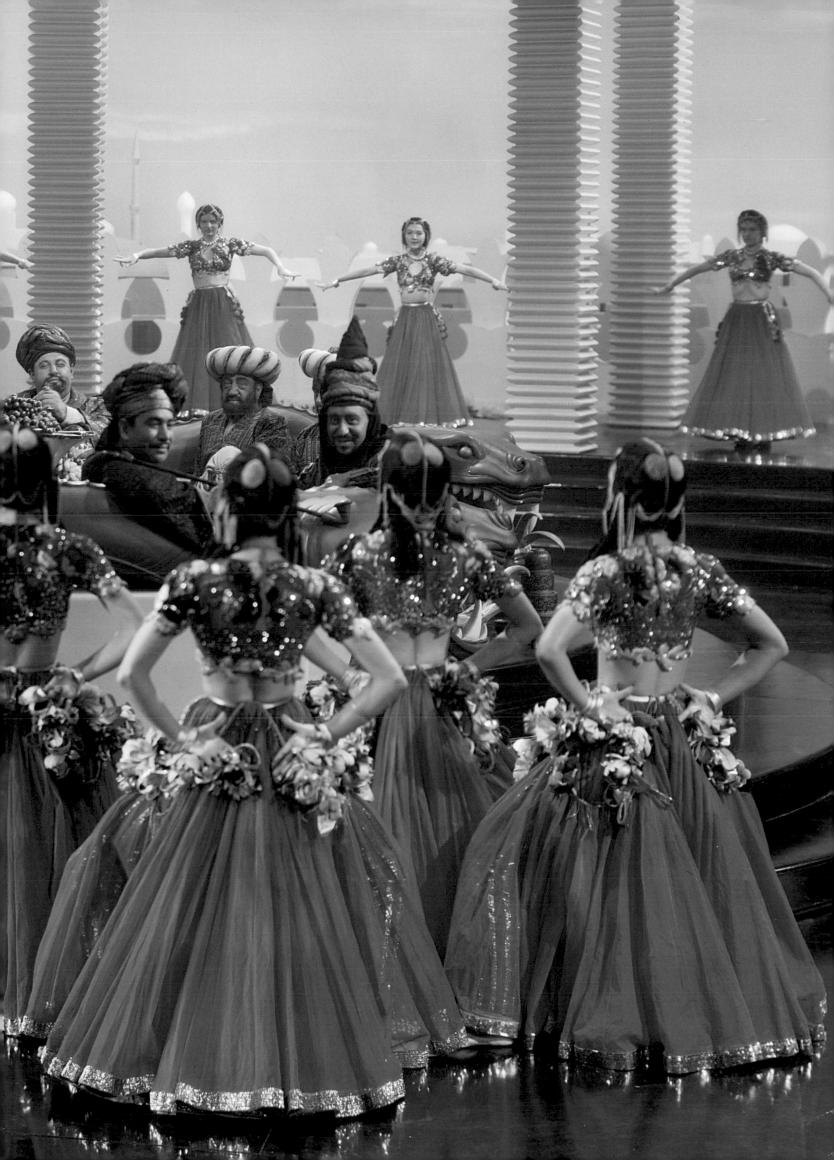

ABOVE: Anchored by ropes, the heavy Technicolor camera tilts downward to capture Dorothy Lamour's reflection for *Aloma of the South Seas*, 1941.

RIGHT: Gary Cooper and Ingrid Bergman in *For Whom the Bell Tolls*, 1943.

OPPOSITE, ABOVE: Victor Mature and Hedy Lamarr in *Samson and Delilah*, 1949.

OPPOSITE, BELOW: Dr. Kalmus trades notes with producer-director Cecil B. DeMille during the filming of *Samson and Delilah*.

"Huston and I did so many odd things with filters on *Moulin Rouge* that the laboratory people disclaimed all responsibility."

As a rule, Mr. Huston filmed in black-and-white when the plotline was basically concerned with human emotion. *Reflections In A Golden Eye* was such a story. But because of the unusual nature of the theme, he felt it demanded more. In this case, color was used sparingly. Said Mr. Huston:

> Color in nature is very different from color on the screen. When you sit in a darkened theater your attention is so concentrated on the screen that the images seem more fully saturated with color than they are in reality. Thus color effects are unnaturally heightened. This kind of color has been fine for extravaganzas and spectacular films. But when we are dealing with material of psychological content it becomes invariably distracting as it gets between the viewer and the mind he is trying to search into. Until now, the filmmaker had a single choice, the use of black and white or of color. This is as though all painters were limited to either pure pigment or black india ink washes., This day and night difference is no longer the only choice ...

When *Reflections In A Golden Eye* was released, critics and ticket buyers were divided in their feelings toward color desaturation. Successful or not, it marked another advance in technology. Dr. Frank P. Brackett, Director of Research at Technicolor, stated at the time:

> It opens a whole avenue of new color combinations which can be obtained in varying degrees of saturation from extremely vivid color to black and white. John Huston chose to work in an overtone of sepia with the pinks and reds accentuated. Someone else might prefer a shift to accentuate another color of the spectrum with a totally different overtone. For example, in a night sequence, a producer might want an overall cold tone—or he might prefer a shift to the green, with perhaps a warm tone accented. Moreover,

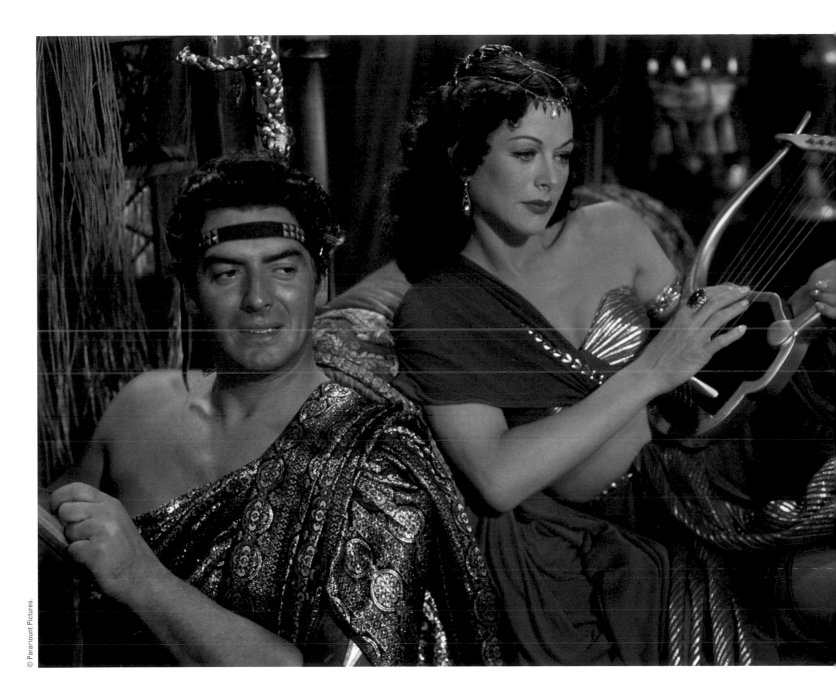

alterations of the color mood can be made from sequence to sequence or even from scene to scene. There is an almost unlimited range of effects available.

That range, however, would be controlled to some degree by a factor that has influenced color guidelines from the very beginning—that of maintaining a certain fidelity to the complexions of the cast members.

Technicolor, as projected on the screen, has undergone many changes since audiences first saw the original three-color process in the mid-1930s—from the then self-conscious use of color to the garish, candy-coated look of the 1940s to the more natural,

Thirteen

CHANGING TIMES

In 1941, Technicolor introduced its new multi-layer single film process, Monopack, originally developed by Dr. Leonard Troland in the 1920s. The aerial shots in *Dive Bomber* (1941) and *Captains of the Clouds* (1942) took advantage of the more compact camera.

It was used again for the spectacular fire sequence in *The Forest Rangers* (1942) as well as for all the exterior scenes in *Lassie Come Home* (1943). By 1944, Monopack was improved to the point that it was used entirely for both exteriors and interiors on *Thunderhead, Son of Flicka.* (It is generally conceded that MGM's 1950 production of *King Solomon's Mines,* filmed in remote areas of Africa, could never have been filmed in color with out Monopack since filming would have been impractical with Technicolor's three-color camera.)

Dr. Kalmus believed that Monopack would one day replace the bulky three-color Technicolor camera. He also believed that, had it not been for World War II, Monopack would have accomplished that feat before the end of the decade. But with the Navy and the Air Force converting much of the Technicolor laboratory into a top-secret plant during the early 1940s, its development was interrupted. Because of Dr. Kalmus' faith in the future of Monopack, coupled with his feeling that the present system would eventually, if not soon, be obsolete, he decided not to add any more expensive three-color cameras to the company's existing stock of thirty-six.

Following the war, box office attendance zoomed. Producers were anxious to get their productions before audiences as quickly as possible. But the Technicolor process was much in demand and a number of films had to be rescheduled according to the availability of cameras. The smaller studios found it impossible to obtain cameras, because the majors had them reserved months in advance.

Too, the processing of prints was considerably slowed by the industry labor strikes of 1945 and 1946. With a skeleton crew and a demand for "rush" jobs—which the company tended to ignore, preferring instead to maintain the quality of its product—Technicolor found itself with a growing reputation for being uncooperative and "difficult." The company soon became the target of a number of nuisance suits.

In 1947, the United States Department

by Gael Sullivan, Executive Director of Theater Owners of America, speaking at the 41st convention of Tri-States Theatre Owners Association. "We've got to get all films in color," Sullivan declared, "and this is a must."

And *Film Daily* for February 16, reporting from Washington, D.C. on the meeting of the board of the Allied States Association of motion picture exhibitors, stated:

> *At its opening day's session yesterday, the board adopted a resolution calling on picture companies to make as many color films as possible before color TV becomes of general use. Behind the movement was the purpose to protect the film industry in the event color TV becomes a fact rather than a FCC decision.*

Exotic and unusual locales, places not seen on low-budget, studio-bound TV fare, also found favor. In 1950, very little location photography had been shot in Technicolor outside the United States. Within the coming few years, Technicolor cameras could be found in such far-off locations as Kenya and Paris (*The Snows of Kilimanjaro*), Tel Aviv (*Salome*), Australia (*Kangaroo*), Guatemala (*Golden Condor*), Jamaica (*Pleasure Island* and

Road to Bali), Puerto Rico and Cuba (*Tropic Zone*), Spain (*Pandora and the Flying Dutchman*), and India (*The River*).

In 1955, Dr. Kalmus wrote, "The fourth Technicolor process which took care of a very substantial part of the motion picture requirements from 1934 to 1953 was tailored to make prints in the laboratory from Technicolor special three-strip negative and to be projected on screens not larger than thirty or thirty-five feet in width. Both of these conditions have changed and again Technicolor research and development departments have had to do something to meet the new demands." (With the introduction of the single-strip negative, Technicolor had rather successfully adapted its three-strip processing techniques to the new product. While the resultant prints were satisfactory in tonal quality and color rendering, they lacked in definition. This became increasingly apparent when the images had to be projected upon the wider and larger screens.)

When the first signs of change swept through the industry, Technicolor began to modify its procedures, devise new ones, and install new equipment to serve the large

OPPOSITE: **Trade ad, 1953.**

ABOVE: *Quo Vadis?*, **1951.**

Yul Brynner leads the charging chariots in *The Ten Commandments*, 1956

screen requirements. According to Dr. Kalmus:

> This work progressed on an emergency basis through a period of about two years until in May, 1955, I saw on a fifty-foot screen in Hollywood a demonstration of an improved new Technicolor process. The 35mm print used for this demonstration embodied all the changes in its imbibition (dye-transfer) process that Technicolor has been striving for since the advent of Eastman and Ansco color type negative and the advent of large screens in the theaters. The result was the most wonderful picture in color made by any process that I have ever seen on the screen from all technical points of view, including sharpness or definition and especially color rendition.

The Technicolor camera may have become obsolete but the company's heralded method of processing prints had been reborn.

Early wide-screen releases featuring Color by Technicolor were Twentieth Century-Fox's *The Robe*, the first CinemaScope picture; Paramount's *White Christmas*, the first

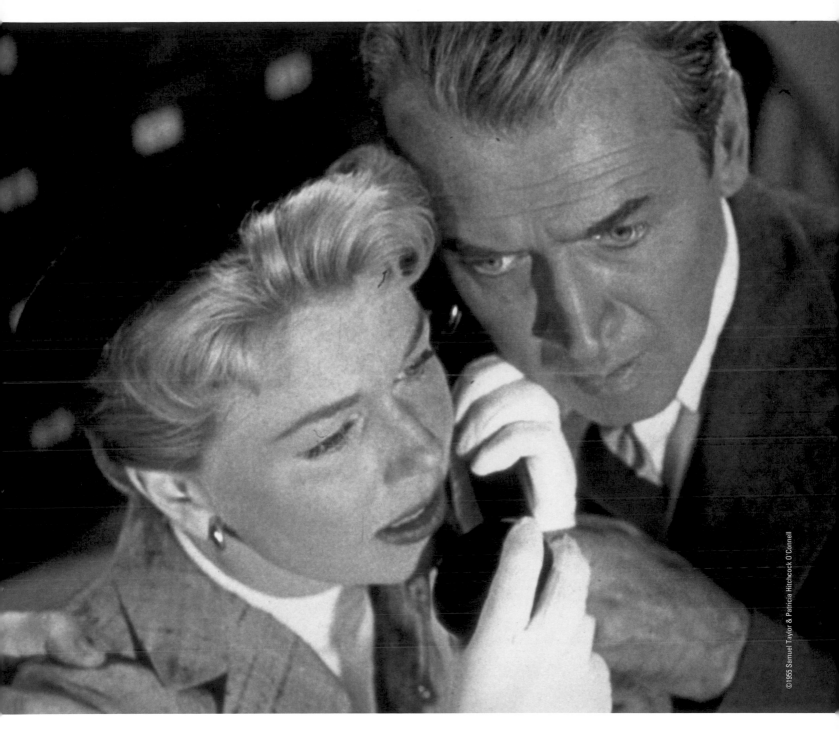

©1955 Samuel Taylor & Patricia Hitchcock O'Connell

Above: Doris Day and James Stewart in Alfred Hitchcock's *The Man Who Knew Too Much,* **1956.**

OVERLEAF: **Rosalind Russell in** *Auntie Mame,* **1958.**

VistaVision feature; and Cinerama's *This Is Cinerama,* for which Technicolor manufactured the prints. Three-dimensional Technicolor productions included Columbia's *Miss Sadie Thompson* and *Fort Ti,* and Fox's *Inferno.* Technicolor also introduced such widescreen developments as Technirama and Technirama-70. Walt Disney, who had pioneered Technicolor's three-color process in 1932, did the same for Technirama-70 with his feature film, *Sleeping Beauty.*

Color by Technicolor, a term that was commonly used in movie ads of the 1950s, meant that Technicolor handled all stages of the

laboratory work. *Print by Technicolor* indicated that Technicolor was responsible only for the final release prints, not for any of the steps that preceded in the laboratory. Today, the distinction is still made, but generally appears in the film's end credits.

Since 1946, on reaching his 65th birthday, Dr. Kalmus had thought of retiring. He had even gone so far as to formally tender his resignation to the Board of Directors, only to have been persuaded to remain in office. On December 31, 1959, just weeks after turning 78, he decided it was finally time to leave. There were now other inter-

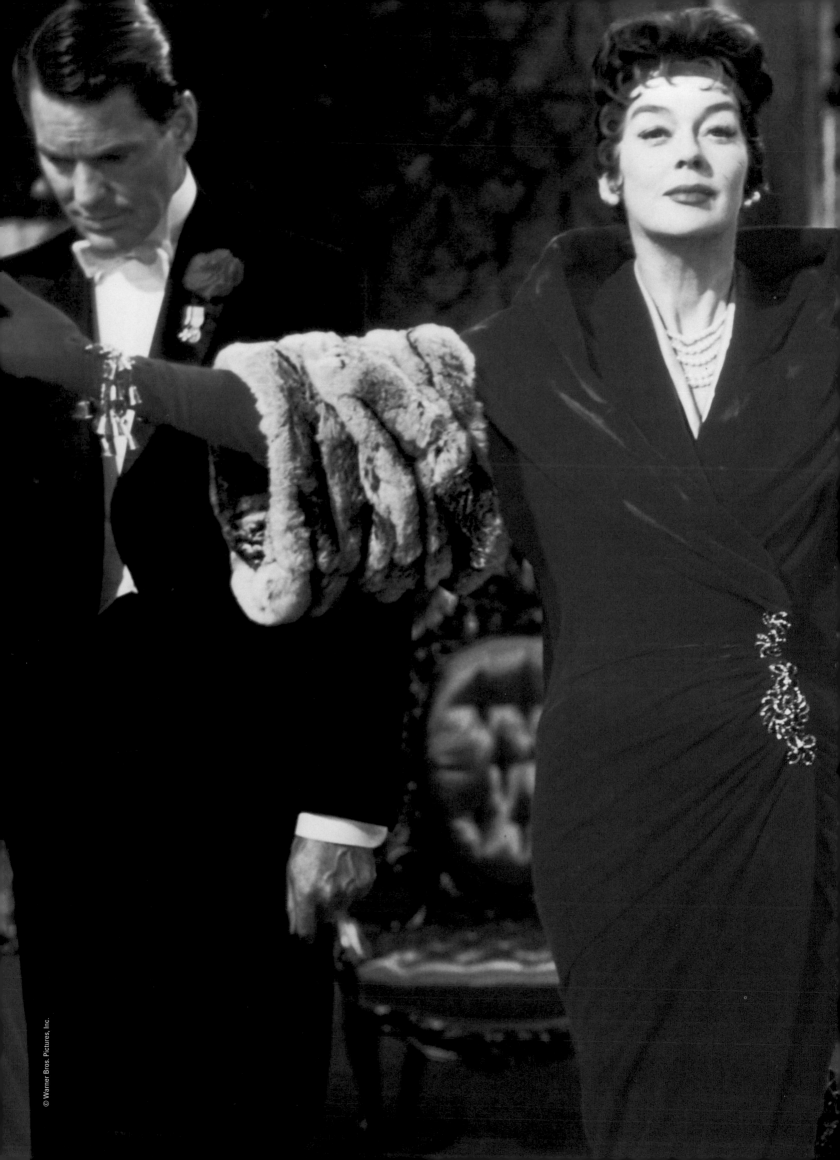

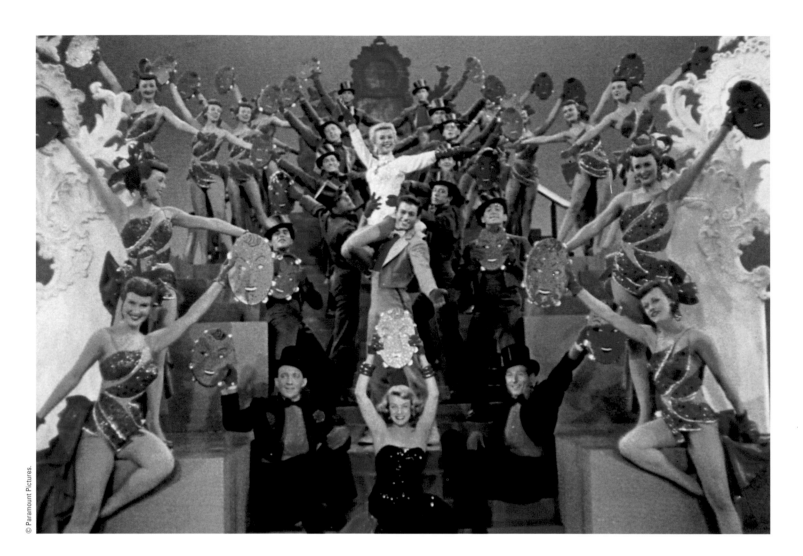

© Paramount Pictures.

ests he wanted to pursue: music, books, sports, travel, and his family. Ten years earlier, he had happily remarried. His wife, Eleanore King, had been a newspaper columnist. She had two daughters, Diane and Cammie. By a strange coincidence, it was young Cammie who had played Clark Gable's daughter, Bonnie Blue, in one of Dr. Kalmus' proudest achievements, *Gone With the Wind*.

Leaving Technicolor— "his baby," as he put it—was not easy for the doctor, particularly with the generous offers extended by incoming Chairman Patrick J. Frawley. One was the newly created post of Honorary Chairman of the Board of Directors. "I would have enjoyed serving in such a capacity," he recalled. "But I declined on the ground that if my name appeared on the company's letterhead as an officer or director, it would imply that I had some responsibility for the company, and I wanted no such

responsibility nor the authority that would have to accompany such responsibility. Let the new men—bringing youth, energy, ideas, strong financial standing and the habit of success—have that authority and responsibility."

Dr. Kalmus officially retired on August 31, 1960. During his forty-five years with Technicolor, he had guided the company he founded through four severe depressions, each one resulting in the invention and development of a new and separate process. Following the original plan of progressive step development, his scientists and technicians proved, working in an early atmosphere of "it can't be done," that commercial color cinematography not only was possible but practical. Technicolor had become not only Hollywood's most famous name in color, but a synonym for rich, glorious color.* Dr. Kalmus, though virtually

unknown by the general public, found himself being honored world-wide as "the man who threw color on the silver screen."

*By the early 1950s, the registered trademark and tradename "Technicolor" had become such a popular descriptive word that many companies and their advertisers were using it improperly (and illegally) in headlines and phrases. In 1951, Technicolor published a list of correct and incorrect usage that holds true today. For example: it is incorrect when applied in any way to any commercial product which is not a product of the Technicolor companies, such as "Technicolor fabrics" or "luggage in Technicolor." It is not objectionable, however, when tied to non-commercial subjects which could not be produced or sponsored by Technicolor, such as "a Technicolor sunset" or "birds with Technicolor plumage." Adaptations such as "Technicolorful" or "Technicolored" are incorrect, as is spelling Technicolor, a proper name, with a lower case "t."

ABOVE, TOP: Shortly after his retirement, Dr. Kalmus became one of the few non-performers to be honored on Hollywood Boulevard's "Walk of Fame".

RIGHT: Marilyn Monroe, Lauren Bacall, and Betty Grable in *How To Marry a Millionaire*, 1953.

OPPOSITE, TOP: Vera-Ellen (top center), Bing Crosby, Rosemary Clooney and Danny Kaye in "I'd Rather See a Minstrel Show" production number, *White Christmas*, 1954.

OPPOSITE, CENTER: The Technicolor plant at Cole and Romaine in Hollywood, late 1960s.

OPPOSITE PAGE, BOTTOM: Technicolor Italiana in Rome, launched in 1955 to service foreign producers filming in continental Europe, Asia and Africa.

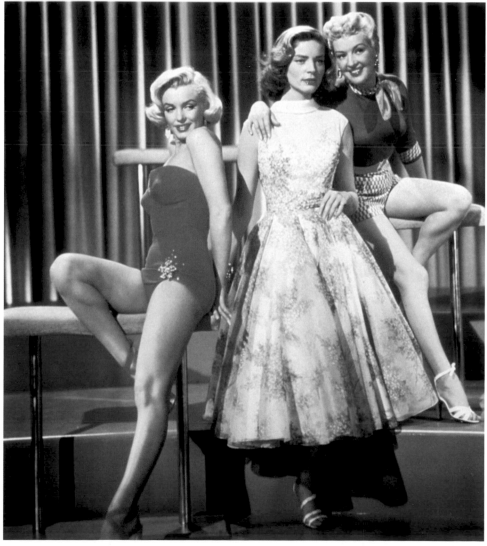

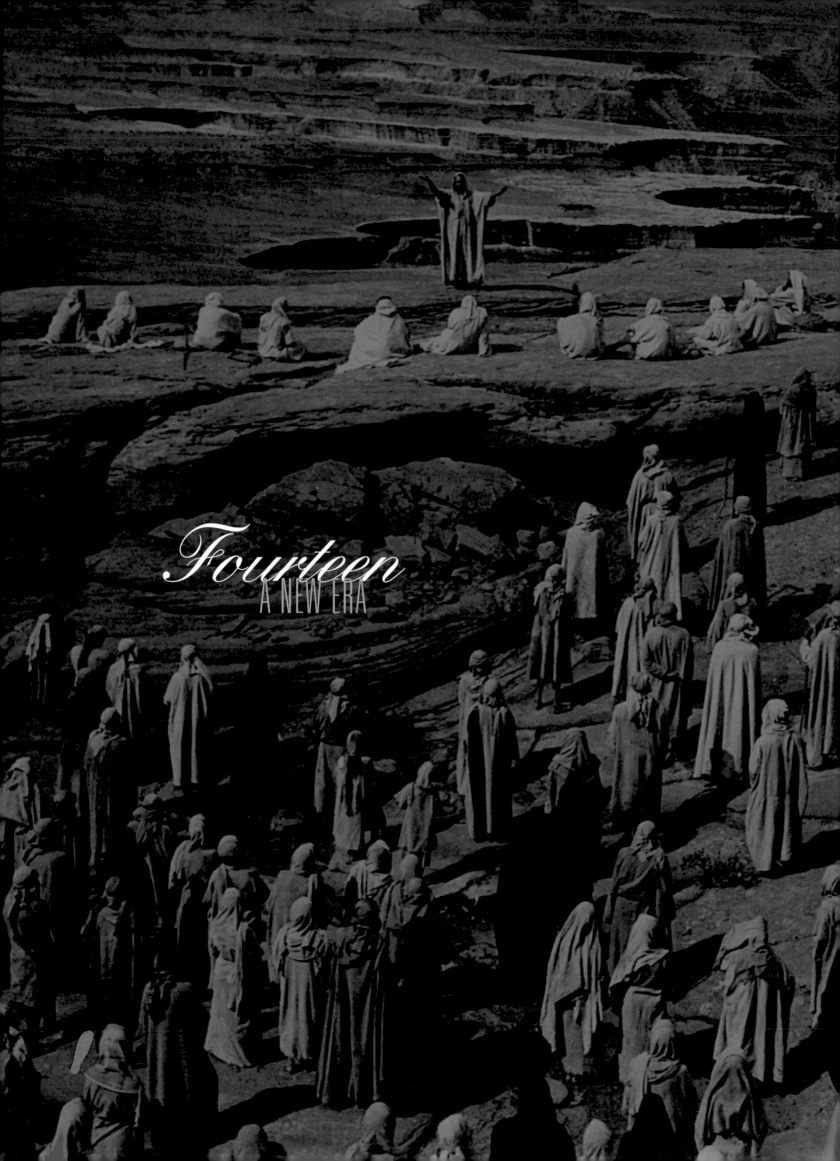

Fourteen
A NEW ERA

As a new era began, Technicolor moved in many directions. Diversification became the rule and the company expanded its operations to include not only motion pictures but television, photographic services and film processing for government and industry,

audio-visual systems for schools and industry, and consumer photo processing.

Diversification had actually begun even before the retirement of Dr. Kalmus in December of 1959. A few years earlier, Technicolor had announced it was expanding its operations to include a complete range of services for amateur photographers, offering processing for all sizes of Kodachrome, Anscochrome, Ektachrome and Kodacolor film. These services included processing in "Color by Technicolor" of 8mm and 16mm home movie color film. (Two decades later, Technicolor announced it was entering the one-hour photo business with plans to open 1,000 stores nationwide using the Technicolor name. At the same time the company readied to introduce a portable home videotape manufactured by Funai Electric in Tokyo.)

In searching for additional areas of corporate growth, Technicolor determined that the government support service field provided a natural market for its existing technology and capability, one that could benefit from the management and technical skills

Technicolor was able to offer.

Evaluation of the needs and requirements of government contracting led Technicolor to form a separate division to meet the unique demands of this market. The newly established Technicolor Graphic Services, Inc., a wholly owned subsidiary, provided government customers contract support services such as aerial photography, cartography, image enhancement, microfilming, systems and digital image analysis, software design and development, technical writing and graphic arts. Technicolor also offered the full backup capabilities of a major corporation.

As early as 1964, Technicolor began work with the National Aeronautics and Space Administration, the Air Force, the Department of the Interior, and the Government of West Germany, providing support services at the Kennedy Space Center and the Eastern Test Range in Florida, the Johnson Space Center in Texas, the Earth Resources Observation System (EROS) Data Center in South Dakota, the Space Operations Center in West Germany,

OPPOSITE: *The Greatest Story Ever Told*, 1965.

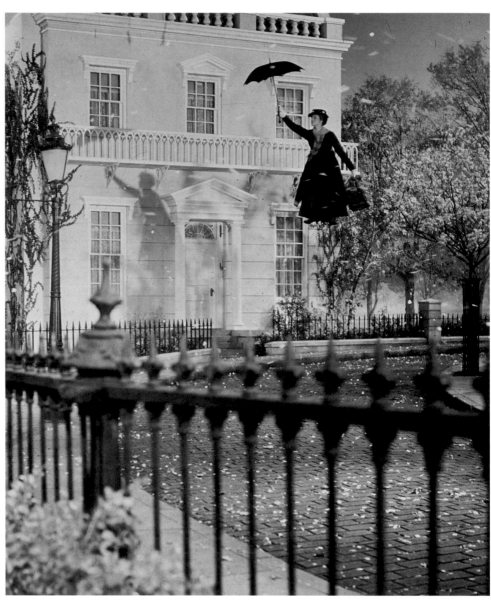

TOP: **Rosalind Russell as Rose in *Gypsy*, 1962.**

ABOVE: **On the set of *Gypsy* with Natalie Wood, Gypsy Rose Lee and Mervyn LeRoy.**

RIGHT: **Julie Andrews in *Mary Poppins*, 1964.**

and the Department of Justice in Washington, D.C. Technicolor cameras recorded the departure and early flight of numerous space missions including Apollo 17 and Saturn V, which carried three astronauts – Neil Armstrong, "Buzz" Aldrin, and Michael Collins – to man's first landing on the moon.

As Technicolor neared its Fiftieth Anniversary in the mid-1960s, motion pictures – Technicolor's foundation since its earliest days – continued to play the dominant role in company operations. With its silenced three-strip cameras on display at the Smithsonian Institute in Washington, D.C. and Eastman House in Rochester, New York, Technicolor had become almost exclusively a laboratory in direct competition with other processing plants. In addition to the Hollywood laboratory, Technicolor also had labs in London (established in 1936) and Rome (established in 1955). And the name was still associated with much of the finest in filmed entertainment, such prestigious features as *Spartacus* (1960), *West Side Story* (1961), *Lawrence of Arabia* (1962), *My Fair Lady* (1964), *A Man for All Seasons* (1966), *Funny Girl* (1968), and more. Year after year, scores of films traveled through the Technicolor laboratories, in California and overseas. But Technicolor had broadened its scope and was no longer limited only to color work. Black-and-white films printed by Technicolor included 1965's *The Spy Who Came In From The Cold*, and 1966's *Who's*

LEFT: **Nancy Kwan and dancers in**
Flower Drum Song, **1961.**

BELOW: **Warren Beatty and Natalie Wood in**
Splendor in the Grass, **1961.**

ABOVE: **Gary Lockwood and Keir Dullea in** *2001: A Space Odyssey*, **1968.**

RIGHT: **During 1977, Technicolor completed its move from the processing plant in Hollywood to a modern new complex in North Hollywood.**

OPPOSITE: **Audrey Hepburn in** *My Fair Lady*, **1964.**

Afraid of Virginia Woolf? and *Is Paris Burning?* among others.

The swing, however, was to color. Monochromatic filming, once the overwhelming choice of the industry, was now being pushed aside. The ratio of color to black-and-white took a pronounced lead in 1965 when practically all film exposed for television was multihued. And, beginning in 1967, with so few black-and-white films being made, the Academy of Motion Picture Arts and Sciences no longer felt it was necessary to continue a separate classification for color in their awards structure.

Technicolor's decision to enter the television field was influenced by its major customers and independent producers, as well as by the move of the three major networks to increase broadcasting of programs filmed in color. The company's reputation was enhanced almost immediately by the announcement, in 1967, of a revolutionary technical breakthrough developed by its subsidiary division, Vidtronics. The new technique made possible production of full-color television prints from television color tapes of both feature shows and commercials. Previously, shows and commercials on color

ABOVE: **Charlton Heston amid the spectacle of old Spain in *El Cid*, 1961.**

video tape could not be used overseas because of incompatibility with foreign telecasting equipment. Transferring such color-taped shows to color film by the Technicolor Vidtronics systems made taped color shows economically available for telecasting anywhere in the world. It wasn't long before the Vidtronics division became the acknowledged leader in the field, providing videotape post-production services to more prime-time television shows than any other non-network operation.

Over the years, Technicolor also processed a number of popular television shows. Among them: *The Virginian, Marcus Welby, M.D., Ironside, Columbo, Hawaii Five-O, The Six-Million Dollar Man, Emergency, Kojak, The Wonderful World of Disney, Baretta,* *Battlestar Galactica, and Rich Man, Poor Man.*

The glory days of the 1960s would soon fade, however, and the slowdown in the economy would be reflected by a precipitous decline in motion picture production. Too, Technicolor's labs were geared for large print orders of the "old Hollywood." Latter-day filmmakers were cautious of the softening market and began ordering only small numbers of prints to test the strength of their productions. Handling of these projects became tailor-made and distribution patterns began to reflect the new awareness of audiences to specialized attractions. For Technicolor and its clients, the dye transfer process was competitive only with orders of approximately one hundred or more prints. Anything less was custom and expensive.

ABOVE: **Liftoff of Apollo 17, the first night launch of Saturn V Moon Rocket, from Kennedy Space center, Florida, on December 17, 1972.**

RIGHT: **Peter O'Toole and Richard Burton in** *Becket*, **1964.**

Fifteen
THE CHANGING FACE
OF THE INDUSTRY

*F*or nearly two decades, Technicolor had followed a policy of diversification. All that changed in late 1982 when MacAndrews & Forbes, headed by Ronald O. Perelman, approached Technicolor with an offer to acquire the company. Technicolor's Board of Directors approved and MacAndrews & Forbes purchased Technicolor the following year. For the first time since the early 1940's, when Technicolor's stock was offered to the public on a stock exchange, Technicolor had gone private.

In 1983, with the arrival of Ronald O. Perelman, Technicolor took on a new philosophy, that of concentrating on the company's core businesses. In refocusing the company, Technicolor sold the majority of its other interests, leaving only its strong suits: motion picture film processing and videocassette duplication.

That basic philosophy continued after the acquisition of Technicolor by Carlton Communications Plc from MacAndrews & Forbes in October, 1988. Carlton, a U.K. corporation based in London, is diversified in television, video products, video and film processing in Europe and the United States.

With Technicolor's new focus came tremendous growth, thanks to changing trends in film distribution and the public's on-going fascination with films, old and new.

Prior to the mid-1970s and the release of *Jaws*

and *Star Wars*, the studios showcased their new films through limited release, generally one or two theaters within an area, before expanding to widespread general release. As the decade moved on, a new trend began to take hold. That trend became the norm, continuing today, with the majority of new features being widely released from the start – blanketed in some areas – showcasing on multiple screens in new or renovated cinema complexes. The theaters may have been smaller, but the number of screens increased dramatically.

Broader release strategies resulted in a huge growth for Technicolor in terms of the manufacture of 35mm release prints for distribution to theaters. Wider releases, coupled with Technicolor's greater capacity to manufacture release prints and its enduring reputation for quality, again pushed Technicolor to the forefront of a highly competitive business.

The growth of the videocassette market was even more phenomenal. When Technicolor entered into video duplication in 1981, the future looked promising. Just how promising no one really knew, but it's doubtful anyone could have predicted what was to come: a jump from

OPPOSITE: *Batman*, 1989.

© Disney Enterprises, Inc.

© 1998 Disney Enterprises, Inc./Pixar Animation Studios.

© 1993 Columbia Pictures Industries, Inc.

OPPOSITE TOP: *Aladdin*, 1992.

OPPOSITE BOTTOM: *Geronimo: An American Legend*, 1993.

ABOVE; *A Bug's Life*, 1998

Blu-ray, a disc format jointly developed by leading consumer electronic companies, including Thomson, Technicolor's parent company, and endorsed by The Walt Disney Company. "Our tradition is based on being a trusted service provider to content owners, independent of format choices," said Quentin Lilly, President, Technicolor Home Entertainment Services. "We will support the format our studio customers select to grow their businesses and support their growth with the highest quality replication, distribution and other media services available in the industry today."

Throughout much of the twentieth century, Technicolor was known by its motto, "The greatest name in color." While those words remain true, the company has become much more than moving pictures. "Moving Entertainment," Technicolor's new signature line, is all-encompassing to include managing end-to-end services, implementing new technologies, and physically serving the media and entertainment industry.

Sixteen
GOING DIGITAL

The start of the 1990s saw sweeping changes for the film industry as digital tools came on-line powered by huge advances in computer processing. Following the lead of film editing, which had in the 1980s moved to digital non-linear editing systems, traditional photochemical processes for film completion also began a process of rapid evolution.

Filmmakers, more and more, came to expect to work in a digital environment much more akin to broadcast postproduction where directors, cinematographers, editors or even producers, could actually work in a "hands-on" fashion in digital editorial suites while making creative choices in real-time. The most dramatic shift was in visual effects for feature films. Two significant films that demonstrated the power of these digital tools were James Cameron's *The Abyss* (1989) that utilized visual effects created at Industrial Light & Magic, and Cameron's monster 1991 hit, *Terminator 2: Judgment Day*, films that dazzled audiences with never before seen imagery.

Technicolor saw the potential of these digital technologies and quickly expanded its core services to include digital postproduction, audio services, visual effects, digital intermediates and digital cinema technologies. Through key acquisitions and organic growth, Technicolor re-imagined itself to capture new business opportunities.

One exciting new technology was the "digital intermediate" which took color timing for films to a whole new level. Traditionally, color-timing has taken place in the photo-chemical environment. Red, green and blue lights are projected through the film's negative to expose intermediate film stocks which are the master printing elements for theatrical release prints. In this way, the cinematographer can adjust the color of the finished film.

With digital intermediates, the filmmaker had an alternative approach to the traditional photochemical process that has existed since the beginning of the film industry. The digital intermediate process combines final "color-grading," with digital editorial capabilities to "conform" a film. The process gives filmmakers the ability to "paint" over the photographed image and arrange the order of images before the final prints are struck and delivered to theaters. Minute adjustments can be made to color, lighting and positioning of the images allowing filmmakers much greater creative freedom and control.

Racing to finish line in *Seabiscuit*, 2003

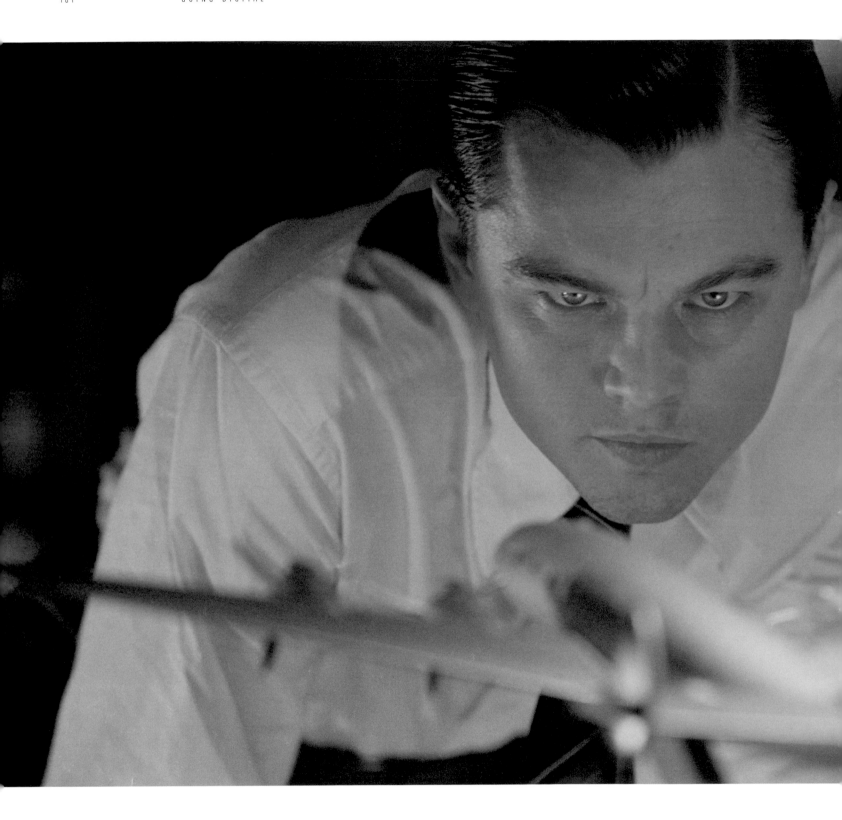

Leonardo DiCaprio in *The Aviator*, 2004.

OPPOSITE: Director Michael Mann with the
Viper Cam on the set of *Collateral*, 2004.

time Los Angeles the conventional way—on motion picture film—but failed to record Mann's vision. "It just wasn't there," said Mann "I doubt if I'd have made this movie if it hadn't been for digital, because there would be nothing to photograph. I'd have a bunch of darkness outside the windows of the cab, instead of this mobile landscape moving around. The best I'd have gotten would be defocused circles of colors or something. You wouldn't have seen with clarity and focus all these buildings of downtown from two miles away." With digital capture it was possible to see into the night. Even with low light levels, the Viper Filmstream provided Mann with a longer, crisper depth of field looking down into the city's long boulevards through a car windshield.

At the 2005 British Academy Film and Television Awards, *Collateral* won the top award for Best Cinematography. Another big winner that night was *The Aviator* for Best Film.

In addition to digital intermediates, Technicolor was also exploring other digital technologies. In 1999 it launched a new division called Technicolor Digital Cinema to support the studios' goals of providing digital distribution of digital movie files to theaters worldwide. Although many direc-

tors and audiences continue to enjoy the look of film, and it continues to be the dominant medium as of this writing, digital movies may someday be standard fare. In the years between 1999 and 2005, Technicolor Digital Cinema deployed 76 digital cinema systems worldwide and delivered hundreds of digital releases. *Ocean's Eleven* (2001), the first movie to utilize Technicolor's digital cinema system, was a major milestone for the company.

Three years after the release of *Ocean's Eleven*, its sequel, *Ocean's Twelve* (2004) pioneered the use of yet another new technology—Technicolor's high-definition dailies – which facilitated work across production sites in Hollywood, Amsterdam, Rome, and Lake Como. "No matter where they are," said a Technicolor executive, "filmmakers need to view footage quickly, economically, and at the highest quality possible." For *Ocean's Twelve*, Technicolor's "dailies on demand" workflow allowed for transmitted digital images within hours via Technicolor's proprietary secure digital production network. The growth of high-definition processes that have served as the foundation of the company's offering to the film world for digital dailies and digital preview

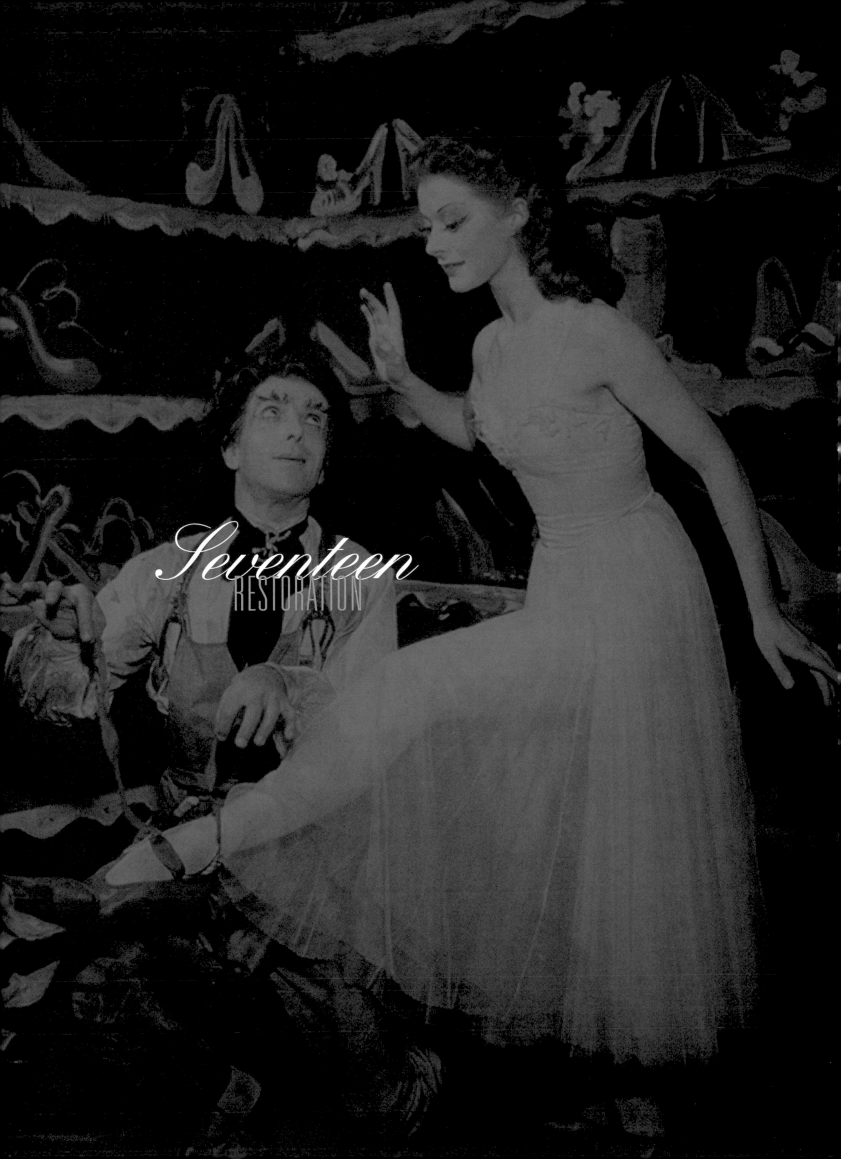

D r. Kalmus once said that "until a story is filmed in Technicolor it hasn't been told in color." His words, obviously aimed at the decision-makers of the day, were also prophetic. Films made less than a decade earlier, processed by methods other than Technicolor's dye-transfer process, were beginning to fade, slowly turning red in studio vaults.

The furor to save old movies—not only from fading and decay but general deterioration—began in the 1970s. One of the most outspoken activists is director Martin Scorsese. "Films over seven years old have lost their effectiveness because the color is fading," he said early on. "The negative can fade in 12 years. Most of the prints made during the 1950s on the Eastmancolor Kodak color-positive process are already shot. Everything is disappearing and no one cares. It's an outrage. Making movies has become like writing on water."

Scorsese's concern had started in 1972 and intensified after a seven-year search to find a 35mm print of Luchino Visconti's 1963 film, *The Leopard*. When he finally found a print it turned out to be pink. "It's a pink leopard!" said Scorsese in disgust.

Upon seeing a print of *Jaws* (1975), Steven Spielberg wrote Scorsese, "After only five years, the blue is leaving the waters of *Jaws*, while the blood spurting from Robert Shaw's mouth gets redder."

And prints of Fox's 1963 multi-million dollar epic, *Cleopatra*, had turned purple.

"There has been no method of color developed to give permanent color as the three-strip method did," noted a UCLA film archivist. "In our collection of films we have Technicolor prints that were made back in the '30s that we still show. However, we will be lucky if the new color prints that we get today will still be showable ten years from now."

According to a study by the Library of Congress, half of all film titles produced before 1950 have been lost forever, and archives are unable to keep up with the deterioration of even modern film stocks.

The preservationists pointed fingers at Eastman Kodak and its revolutionary one-strip process, introduced in 1954. The new color-positive stock was cheaper than Technicolor's three-strip process, but few filmmakers seemed to be aware that within a short time Eastman prints would turn into a pale imitation of their original color.

A spokesman from Kodak countered: "We have the technology to prevent color films from fading but, thus far, Hollywood

© 1998 Twentieth Century Fox.

difficult. The red was ultimately "painted" in the appropriate place digitally.

One of the most awaited restorations in years was *Black Narcissus*, the 1947 British production regarded by film historians, along with *The Red Shoes* (1948), as the finest example of Technicolor cinematography. Completed for the opening presentation at the Cannes Film Festival (Classics Film Section) on May 14, 2005, honoring director Michael Powell's 100th anniversary, the premiere showing of the newly restored *Black Narcissus* was attended by cinematographer Jack Cardiff OBE BSC, the grandsons of co-director Emric Pressburger, and Powell's widow, Thelma Schoonmaker Powell, award-winning editor.

According to Fiona Maxwell, Controller of Operations and Servicing of Granada International, owner of the J. Arthur Rank Film Library, "With *Black Narcissus* we went back to the original 3-strip negatives—the YCMs*— which were held at the British Film Institute in

*YCM Master – A black-and-white three-part element made in an optical printer for archival storage of film. Each element is a duplication of the three dye layers: Y (yellow), C (cyan), M (magenta), the three colors from which a full color image is made. The elements contain no dyes, only silver, thus they do not fade over time.

the UK. The negatives were then taken to the Technicolor London laboratory on Bath Road, which was rather nice since that's where the work was done originally on the film. Because we were working with the original nitrate negatives, we had some interesting dilemmas to deal with as far as safety regulations and the number of nitrate reels we could have on site at one time because the reels were so inflammable." Extra fire protection required having someone standing within the telecine suite with fire extinguishers ready in case of any problem.

"Because Technicolor London had the original timing cards from the original prints," Fiona Maxwell noted, "we were able to refer to them as we remade the new film elements from the nitrate negatives. From these we created a new combined interpositive with corrected registration, which was necessary because with the three strips there were different rates of shrinkage and fading over the years."

Another problem, along with registration, was to recreate the color, to try to match the Technicolor look of the original dye-transfer prints, a real challenge because of the differences in today's processes and film stock. Ultimately, however, the team at Technicolor London was able to produce a high definition digital master that was free of dirt, scratches and imperfections, resulting in a crisp sumptuous look, along with restored and enhanced sound.

Thomson, in conjunction with film restoration experts at Technicolor, continues to develop new methods to improve the efficiency and quality of film restoration. At Cannes in 2005, Thomson demonstrated a new digital YCM process that uses sophisticated computer algorthms to automatically compensate for the shrinkage and warping of aging film.

In recent years film preservation and restoration has provided a feast of riches for filmgoers of all ages. Now younger generations can see the film stars that their parents and grandparents grew up with. With the new digital technologies—combined with proven lab processes—many of these films look even better than they did at their original premieres.

ABOVE **Jim Caviezel in *The Thin Red Line*, 1998.**

OPPOSITE: **George C. Scott in Patton, 1970.**

TECHNICOLOR TODAY . . . AND TOMORROW

*T*he motion picture business today is a far cry from the "nickelodeon era" of 1915 when Dr. Kalmus and his associates banded together to bring color to the movie screens of America. They had a dream and a motto: "We do not live in a black-and-white world, so our entertainment should not be in black-and-white."

They realized that the dream would not be easy. Decades would pass before the producers, stars, and the public would think of color—Technicolor—as more than a passing fancy. But when color finally took hold, the world embraced it with such passion and enthusiasm there was no letting go. Technicolor became a star in its own right, often receiving top billing in films. Over time, the name became much more than a coined word; it became a word synonymous with rich, glorious color. Today, black-and-white films are as rare as color was in its infancy.

The creative technology of the early Technicolor Corporation, with its handful of scientists, revolutionized the film industry. The old railway car, Technicolor's first laboratory, is gone now, as is the venerable Hollywood headquarters of its growing years. But what remains is the pioneering spirit behind Technicolor—the desire to make entertainment more realistic and more accessible to audiences—that brought the film industry to a whole new level of sophistication and refinement.

It's been decades since Technicolor created the color sensation seen around the world, but the same progressive energy that fueled the young company continues to propel Technicolor today as it pioneers the most advanced methods of delivering visual entertainment to millions of people through film, digital, video and optical technologies.

Over the years Technicolor has greatly expanded its scope and vision to include not only film processing and printing but also a full range of postproduction technologies and distribution services to support global productions for both film and television.

As Technicolor has grown, it has added services to support the needs of its major customers at every point along the production pipeline from the creation of entertainment to the delivery of entertainment into the hands—or eyes—of viewers around the world. Now audiences can enjoy first-class entertainment on the big screen or the small screen thanks in part to advances created by Technicolor. For example, in addition to

TECHNICOLOR FILMOGRAPHY

Hello, Frisco, Hello—Twentieth Century-Fox
Lassie Come Home—Metro-Goldwyn-Mayer
My Friend Flicka—Twentieth Century-Fox
Phantom of the Opera*—Universal
Report from the Aleutians—Independent
Riding High—Paramount
Saludos Amigos (animated)—Disney/RKO Radio
Salute to the Marines—Metro-Goldwyn-Mayer
Sweet Rosie O'Grady—Twentieth Century-Fox
This Is the Army—Warner Bros.
Thousands Cheer—Metro-Goldwyn-Mayer
Victory Through Air Power (animated)—
Disney/United Artists
White Savage—Universal

Academy Award winner for Best Color Cinematography

1944

Ali Baba and the Forty Thieves—Universal
An American Romance—Vidor/Metro-Goldwyn-Mayer
Bathing Beauty—Metro-Goldwyn-Mayer
Broadway Rhythm—Metro-Goldwyn-Mayer
Buffalo Bill—Twentieth Century-Fox
Can't Help Singing—Universal
The Climax—Universal
Cover Girl—Columbia
The Desert Song—Warner Bros.
Frenchman's Creek—Paramount
Greenwich Village—Twentieth Century-Fox
Gypsy Wildcat—Universal

1944 Joan Fontaine and Basil Rathbone in *Frenchman's Creek*

© 1944 Paramount Pictures.

Home in Indiana—Twentieth Century-Fox
Irish Eyes Are Smiling—Twentieth Century-Fox
Kisenga, Man of Africa—British—Independent
Kismet—Metro-Goldwyn-Mayer
Lady in the Dark—Paramount
Meet Me in St. Louis—Metro-Goldwyn-Mayer
Pin Up Girl—Twentieth Century-Fox
The Princess and the Pirate—Goldwyn/RKO Radio
Rainbow Island—Paramount
Shine on Harvest Moon (sequence)—Warner Bros.
Something for the Boys—Twentieth Century-Fox
The Story of Dr. Wassell—DeMille/Paramount
Up in Arms—Goldwyn/RKO Radio
Wilson*—Twentieth Century-Fox

Academy Award winner for Best Color Cinematography

1945

Anchors Aweigh—Metro-Goldwyn-Mayer
Belle of the Yukon—International/RKO Radio
Billy Rose's Diamond Horseshoe—Twentieth Century-Fox
Blithe Spirit—British—Two Cities/United Artists
Bring on the Girls—Paramount
Colonel Blimp—British—Powell-Pressburger/United Artists
The Dolly Sisters—Twentieth Century-Fox
The Fighting Lady—Twentieth Century-Fox
Frontier Gal—Universal
Incendiary Blonde—Paramount
It's a Pleasure—International/RKO Radio
Leave Her to Heaven*—Twentieth Century-Fox
National Velvet—Metro-Goldwyn-Mayer
Nob Hill—Twentieth Century-Fox
The Picture of Dorian Gray (sequences)—Metro-Goldwyn-Mayer
Salome, Where She Danced—Wanger/Universal
San Antonio—Warner Bros.
Son of Lassie—Metro-Goldwyn-Mayer
A Song to Remember—Columbia
The Spanish Main—RKO Radio
State Fair—Twentieth Century-Fox
Sudan—Universal
The Three Caballeros (part animation)—Disney/RKO Radio
A Thousand and One Nights—Columbia
Thrill of a Romance—Metro-Goldwyn-Mayer
Thunderhead, Son of Flicka—Twentieth Century-Fox
Tonight and Every Night—Columbia
Where Do We Go from Here?—Twentieth Century-Fox
Wonder Man—Goldwyn/RKO Radio
Yolanda and the Thief—Metro-Goldwyn-Mayer

Academy Award winner for Best Color Cinematography

1946 Jennifer Jones and Gregory Peck in *Duel in the Sun*

1946

The Bandit of Sherwood Forest—Columbia
Blue Skies—Paramount
Caesar and Cleopatra—British—Pascal/United Artists
Canyon Passage—Wanger/Universal
Centennial Summer—Twentieth Century-Fox
Courage of Lassie—Metro-Goldwyn-Mayer
Do You Love Me?—Twentieth Century-Fox
Dreams That Money Can Buy—Independent
Duel in the Sun—Selznick Releasing Organization
Easy to Wed—Metro-Goldwyn-Mayer
The Harvey Girls—Metro-Goldwyn-Mayer
Henry V—British—Olivier/United Artists
Holiday in Mexico—Metro-Goldwyn-Mayer
I've Always Loved You—Republic
The Jolson Story—Columbia
The Kid From Brooklyn—Goldwyn/RKO Radio
Laughing Lady—British—Independent
Make Mine Music (animated)—Disney/RKO Radio
Margie—Twentieth Century-Fox
Meet the Navy (sequences)—British—Independent
Men of Two Worlds (Witch Doctor)—British—Independent
Night and Day—Warner Bros.
Night In Paradise—Wanger/Universal
The Raider—British—Independent

Renegades—Columbia
Smokey—Twentieth Century-Fox
Song of the South (part animation)—Disney/RKO Radio
Stairway to Heaven—British—Universal-International
Three Little Girls in Blue—Twentieth Century-Fox
Till the Clouds Roll By—Metro-Goldwyn-Mayer
The Time, the Place and the Girl—Warner Bros./First National
The Virginian—Paramount
Wake Up and Dream—Twentieth Century-Fox
The Yearling*—Metro-Goldwyn-Mayer
Ziegfeld Follies—Metro-Goldwyn-Mayer

** Academy Award winner for Best Color Cinematography*

1947

Black Narcissus*—British—Universal-International
California—Paramount
Captain from Castile—Twentieth Century-Fox
Carnival in Costa Rica—Twentieth Century-Fox
Desert Fury—Wallis/Paramount
Down to Earth—Columbia
Fiesta—Metro-Goldwyn-Mayer
Forever Amber—Twentieth Century-Fox

Fun and Fancy Free (part animation)—Disney/RKO Radio

Good News—Metro-Goldwyn-Mayer

Gunfighters—Columbia

The Homestretch—Twentieth Century-Fox

I Wonder Who's Kissing Her Now?—Twentieth Century-Fox

Life With Father—Warner Bros.

Mother Wore Tights—Twentieth Century-Fox

My Heart Goes Crazy (London Town)—British—Independent

My Wild Irish Rose—Warner Bros.

The Perils of Pauline—Paramount

Pirates of Monterey—Universal-International

The Private Affairs of Bel Ami (sequences)—United Artists

The Secret Life of Walter Mitty—Goldwyn/RKO Radio

The Shocking Miss Pilgrim—Twentieth Century-Fox

Sinbad the Sailor—RKO Radio

Slave Girl—Universal-International

Song of Scheherazade—Universal-International

The Swordsman—Columbia

This Happy Breed—British—Universal-International

This Time for Keeps—Metro-Goldwyn-Mayer

Thunder in the Valley (Bob, Son of Battle)—Twentieth Century-Fox

Tycoon—RKO Radio

Unconquered—DeMille/Paramount

The Unfinished Dance—Metro-Goldwyn-Mayer

** Academy Award winner for Best Color Cinematography*

1948

Apartment for Peggy—Twentieth Century-Fox

Black Bart—Universal-International

Blanche Fury—British—Eagle-Lion

The Boy With Green Hair—RKO Radio

A Date With Judy—Metro-Goldwyn-Mayer

Easter Parade—Metro-Goldwyn-Mayer

Elizabeth of Ladymead—British—Independent

The Emperor Waltz—Paramount

Fighter Squadron—Warner Bros.

The Gallant Blade—Columbia

Give My Regards to Broadway—Twentieth Century-Fox

Green Grass of Wyoming—Twentieth Century-Fox

Hills of Home—Metro-Goldwyn-Mayer

1948 Lana Turner and Gene Kelly in
The Three Musketeers

TOP: **1949 Gene Kelly and dancers in**
On the Town

BELOW: **1947 Judy Garland and Peter Lawford in**
The Easter Parade

© Turner Entertainment Co.

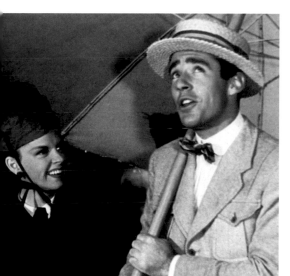

© Turner Entertainment Co.

An Ideal Husband—British—Korda/Twentieth
Century-Fox
Jassy—British—Universal-International
Joan of Arc*—Wanger/RKO Radio
The Kissing Bandit—Metro-Goldwyn-Mayer
The Loves of Carmen—Columbia
Luxury Liner—Metro-Goldwyn-Mayer
The Man from Colorado—Columbia
Melody Time (animated)—Disney/RKO Radio
On An Island With You—Metro-Goldwyn-Mayer
One Sunday Afternoon—Warner Bros.
The Paleface—Paramount
The Pirate—Metro-Goldwyn-Mayer
Portrait of Jenny (sequence)—Selznick
The Red Shoes—British—Powell-
Pressburger/Eagle-Lion
Relentless—Columbia
The Return of October—Columbia
River Lady—Universal-International
Romance on the High Seas—Warner Bros.
Rope—Warner Bros.
Scudda Hoo, Scudda Hay—Twentieth Century-Fox
The Secret Land—Metro-Goldwyn-Mayer
The Smugglers—British—Eagle-Lion
A Song Is Born—Goldwyn/RKO Radio
Summer Holiday—Metro-Goldwyn-Mayer
Tale of the Navajos—Metro-Goldwyn-Mayer
Tap Roots—Wanger/Universal-International
Task Force (sequences)—Warner Bros.
The Lady in Ermine—Twentieth Century-Fox
Three Daring Daughters—Metro-Goldwyn-Mayer
Three Godfathers—Argosy/Metro-Goldwyn-Mayer
The Three Musketeers—Metro-Goldwyn-Mayer
Two Guys from Texas—Warner Bros.
The Untamed Breed—Columbia
When My Baby Smiles at Me—Twentieth Century-
Fox
Whispering Smith—Paramount
Words and Music—Metro-Goldwyn-Mayer

** Academy Award winner for Best Color
Cinematography and the first film to win an*

*Oscar for Costume Design (motion picture
costume design was not honored by the
Academy until 1948)*

1949

Adventures of Don Juan—Warner Bros.
The Adventures of Ichabod and Mr. Toad (animat-
ed)—Disney/RKO Radio
Bagdad—Universal-International
The Barkleys of Broadway—Metro-Goldwyn-
Mayer
The Beautiful Blonde from Bashful Bend—
Twentieth Century-Fox
The Big Cat—Eagle-Lion
The Blue Lagoon—British—Universal-
International
Calamity Jane and Sam Bass—Universal-
International
Christopher Columbus—British—Universal-
International
Cinderella (animated)—Disney/RKO Radio
A Connecticut Yankee in King Arthur's Court
—Paramount
Dancing in the Dark—Twentieth Century-Fox
The Dancing Years—British—Independent
The Gal Who Took the West—Metro-Goldwyn-
Mayer
The Gay Lady—British—Independent
The Inspector General—Warner Bros.
It's a Great Feeling—Warner Bros.
Jolson Sings Again—Columbia
Little Women—Metro-Goldwyn-Mayer
Look for the Silver Lining—Warner Bros.
Mother is a Freshman—Twentieth Century-Fox
The Mutineers—Columbia
My Dream is Yours—Curtiz/Warner Bros.
Neptune's Daughter—Metro-Goldwyn-Mayer
Oh, You Beautiful Doll—Twentieth Century-Fox
On the Town—Metro-Goldwyn-Mayer
Red Canyon—Universal-International

1952

Aaron Slick from Punkin Crick—Paramount
About Face—Warner Bros.
Against All Flags—Universal-International
All Ashore—Columbia

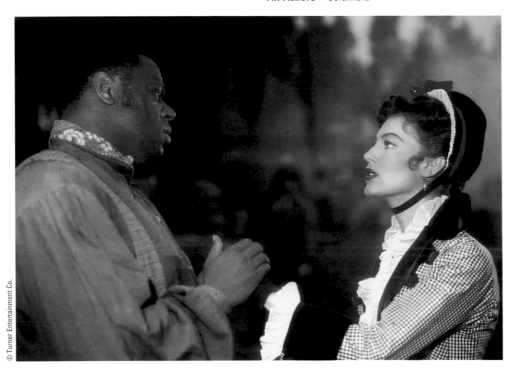

© Turner Entertainment Co.

1951 William Warfield and Ava Gardner in *Show Boat*

Ambush at Tomahawk Gap—Columbia
Animated Genesis (animated)—British—Independent
At Sword's Point—RKO Radio
Battle of Apache Pass—Universal-International
Because You're Mine—Metro-Goldwyn-Mayer
Belle of New York—Metro-Goldwyn-Mayer
Belles on Their Toes—Twentieth Century-Fox
Bend of the River—Universal-International
La Bergere et le Ramoneur—French—Independent
The Big Trees—Warner Bros.
Blackbeard the Pirate—RKO Radio
Blazing Forest—Paramount
Bloodhounds of Broadway—Twentieth Century-Fox
Bonnie Prince Charlie—British—Korda/United Artists
Brave Warrior—Columbia
The Brigand—Columbia
Bronco Buster—Universal-International
Bugles in the Afternoon—Warner Bros.
California Conquest—Columbia
Captain Pirate—Columbia
Caribbean—Paramount
Crimson Pirate—Warner Bros.
Cripple Creek—Columbia
Denver and the Rio Grande—Paramount
Duel At Silver Creek—Universal-International
The Dupont Story—Independent
Everything I Have is Yours—Metro-Goldwyn-Mayer

The Firebird—United Artists
Girls of Pleasure Island—Paramount
Golden Hawk—Columbia
The Greaterst Show on Earth—DeMille/Paramount
Half Breed—RKO Radio
Hangman's Knot—Columbia
Hans Christian Anderson—Goldwyn/RKO Radio
Has Anybody Seen My Gal—Universal-International
Hong Kong—Paramount
Horizons West—Universal-International
Hurricane Smith—Paramount
The Importance of Being Ernest—Universal-International
The Iron Mistress—Warner Bros.
Island of Desire—United Artists
Isn't Life Wonderful?—British—Independent
Ivanhoe—Metro-Goldwyn-Mayer
Ivory Hunter (Where No Vultures Fly)—British—Universal-International
Just For You—Paramount
Kangaroo—Twentieth Century-Fox
Latuko—Independent
The Lawless Breed—Universal-International
Lovely to Look At—Metro-Goldwyn-Mayer
Lure of the Wilderness—Twentieth Century-Fox
Lydia Bailey—Twentieth Century-Fox
Made in Heaven—British—Rank
The Magic Box—British—Independent
Maytime in Mayfair—British—Independent
The Merry Widow—Metro-Goldwyn-Mayer
Million Dollar Mermaid—Metro-Goldwyn-Mayer
Montana Territory—Columbia
Montemarte—French—Independent
Moulin Rouge—Horizon/United Artists
Mutiny—United Artists
Naked Spur—Metro-Goldwyn-Mayer
Plymouth Adventure—Metro-Goldwyn-Mayer
Pony Soldier—Twentieth Century-Fox
Powder River—Twentieth Century-Fox
Prisoner of Zenda—Metro-Goldwyn-Mayer
The Quiet Man*—Argosy/Republic
Rainbow Round My Shoulder—Columbia
Ramble in Erin—Irish—Independent
Rancho Notorious—RKO Radio
Red Skies of Montana (Smoke Jumpers)—Twentieth Century-Fox
Riders of Vengeance (The Raiders)—Universal-International
The Savage—Paramount
Scaramouche—Metro-Goldwyn-Mayer
Scarlet Angel—Universal-International
She's Working Her Way Through College—Warner Bros.
Singin' in the Rain—Metro-Goldwyn-Mayer
Skirts Ahoy—Metro-Goldwyn-Mayer
The Snows of Kilimanjaro—Twentieth Century-Fox
Somebody Loves Me—Paramount
Son of Ali Baba—Universal-International
Son of Paleface—Paramount
Stars and Stripes Forever—Twentieth Century-Fox

Steel Town—Universal-International
The Story of Robin Hood—Disney/RKO Radio
The Story of Will Rogers—Warner Bros.
Thief of Damascus—Columbia
This Is Cinerama—Cinerama Releasing Corp.
Treasure of Lost Canyon—Universal-International
Tropic Zone—Paramount
Untamed Frontier—Universal-International
Wait Till the Sun Shines Nellie—Twentieth
Century-Fox
Way of a Gaucho—Twentieth Century-Fox
What Price Glory—Twentieth Century-Fox
Where's Charlie?—Warner Bros.
The Wild Heart—Selznick/RKO Radio
With a Song in My Heart—Twentieth Century-Fox
The World in His Arms—Universal-International
Yankee Buccaneer—Universal-International

** Academy Award winner for Best Color
Cinematography*

1953

Aan Indian—United Artists
Affair in Monte Carlo—British—Allied Artists
All Ashore—Columbia
All the Brothers Were Valiant—Metro-Goldwyn-

Mayer
Ambush at Tomahawk Gap—Columbia
April in Paris—Warner Bros.
Appointment in Honduras—RKO Radio
Arrowhead—Paramount
Back to God's Country—Universal-International
The Band Wagon—Metro-Goldwyn-Mayer
The Beggar's Opera—British—Warner Bros.
Below the Sahara—RKO Radio
Beneath the Twelve Mile Reef—Twentieth
Century-Fox
Bonjour Paris—French—Independent
Botany Bay—Paramount
By the Light of the Silvery Moon—Warner Bros.
Calamity Jane—Warner Bros.
Call Me Madam—Twentieth Century-Fox
Captain Scarlet—United Artists
Caroline Cherie—French—Independent
City Beneath the Sea—Universal-International
City of Bad Men—Twentieth Century-Fox
Column South—Universal-International
Conquest of Cochise—Columbia
Conquest of Everest—British—United Artists
Cruisin' Down the River—Columbia
Dangerous When Wet—Metro-Goldwyn-Mayer
Decameron Nights—British— RKO Radio
Desert Legion—Universal-International

1953 Richard Burton, Jay Robinson and Jean
Simmons in *The Robe*

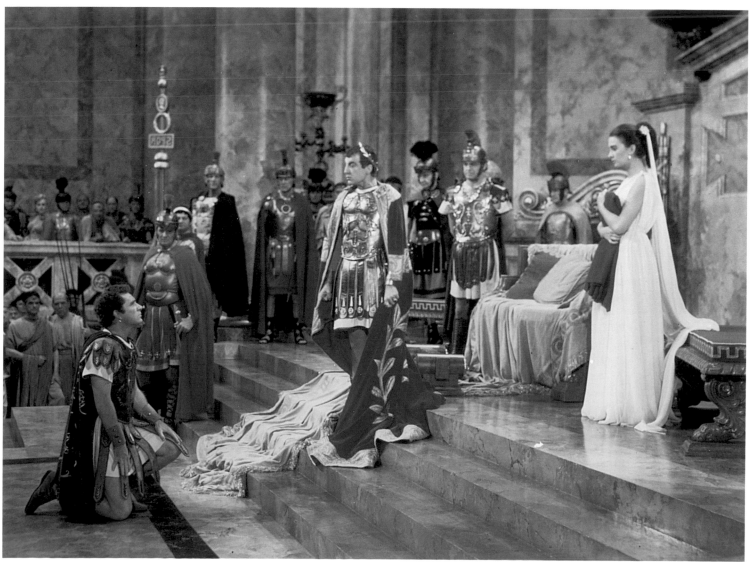

1962 Peter O'Toole and Omar Sharif in
Lawrence of Arabia

Duel of the Titans—Italian—Independent
Fanny—Warner Bros.
Flower Drum Song—Universal-International
Ghosts in Rome—Italian—Independent
Gorgo—Metro-Goldwyn-Mayer
Go to Blazes—British—Independent
Greyfriar's Bobby—Disney/Buena Vista
The Guns of Navarone—British—
Foreman/Columbia
The Hellion's—British—Columbia
Hercules in the Haunted World—Italian—
Independent
The Honeymoon Machine—Metro-Goldwyn-
Mayer
I Bombed Pearl Harbor—Japanese—Independent
The Jokers—Universal-International
King of Kings—Bronston/Metro-Goldwyn-Mayer
The Ladies Man—Paramount
Loss of Innocence—British—Columbia
Love in a Goldfish Bowl—Paramount
The Minotaur (The Wild Beast of Crete)—Italian—
United Artists
Mysterious Island—British—Columbia
Nikki, Wild Dog of the North—Disney/Buena Vista
On the Double—Paramount
One-Eyed Jacks—Paramount
One Hundred and One Dalmations—Disney/Buena
Vista
The Parent Trap—Disney/Buena Vista
Parrish—Warner Bros.
The Pleasure of His Company—Paramount
Pocketful of Miracles—United Artists
Posse from Hell—Universal-International
The Queen's Guards—Twentieth Century-Fox
Raising the Wind—British—Independent
The Roman Spring of Mrs. Stone—Warner Bros./7
Arts
Romanoff and Juliet—Universal-International
Rommel's Treasure—Italian—Independent
The Sins of Rachel Cade—Warner Bros.
Splendor in the Grass—Warner Bros.
The Steel Claw—Warner Bros.
Summer and Smoke—Wallis/Paramount

Susan Slade—Warner Bros.
The Terror of the Tongs—British—Independent
The Trojan War—Italian/French—Independent
Two Rode Together—Ford/Columbia
Vanina Vanini—French/Italian—Independent
West Side Story*—Mirisch/United Artists
Wonderful to Be Young—British—Independent
The Wonders of Aladdin—U.S./Italian—
AvcoEmbassy
The White Warrior—Warner Bros.
The World By Night—Warner Bros.
X-15—United Artists

*Academy Award winner for Best Color
Cinematography*

1962

Almost Angels—Buena Vista
Barabbas—Columbia
Big Red—Disney/Buena Vista
Boccaccio '70—Italian—Levine/Embassy
Bon Voyage—Disney/Buena Vista
The Chapman Report—Zanuck/Warner Bros.
The Counterfeit Traitor—Paramount
Damn the Defiant!—British—Columbia
Dangerous Charter—Independent
Divorce - Italian Style—Italian—Columbia
Dr. No—British—United Artists
Dr. Syn, Alias the Scarecrow—British—
Disney/Buena Vista
Escapade in Florence—Paramount
Escape from Zahrain—Paramount
A Family Diary—Italian—Metro-Goldwyn-Mayer
The First Spaceship on Venus—Independent
Forever My Love—Austrian—Paramount
Gay Purr-ee (animated)—UPA/Warner Bros.
Geronimo—United Artists
A Girl Named Tamiko—Wallis/Paramount
Girls! Girls! Girls!—Wallis/Paramount
Gypsy—Warner Bros.
Hatari!—Paramount
Hero's Island—United Artists
How the West Was Won—Metro-Goldwyn-Mayer
If a Man Answers—Universal-International
In Search of the Castaways—Disney/Buena Vista
Jack the Giant Killer—Small/Independent
Jessica—U.S,./Italian/French—United Artists
Lad: A Dog—Warner Bros.
Lafayette—French/Italian—Independent
Lawrence of Arabia*—Columbia
The Legend of Lobo—Disney/Buena Vista
Madam Sans-Gene—Italian/French/Spanish—
Independent
The Magnificent Rebel—Disney/Buena Vista
A Majority of One—Warner Bros.
Merrill's Marauders—Warner Bros.
Mondo Cane—Italian—Independent
Moon Pilot—Disney/Buena Vista
The Music Man—Warner Bros.
Mutiny on the Bounty—Metro-Goldwyn-
Mayer/Arcola

© Paramount Pictures.

1964 Sophia Loren in *The Fall of the Roman Empire*

My Geisha—Paramount
Night Creatures—Universal-International
The Phantom of the Opera—British—Universal-International
Pirates of Blood River—British—Independent
Rome Adventure—Warner Bros.
Der Rosenkavalier—British—Independent
Samar—Warner Bros.
Sergeants 3—United Artists
The Singer Not the Song—British—Warner Bros.
The Story of the Count of Monte Cristo—French—Warner Bros.
Tamahine—British—Independent
The Tartrars—Italian—Metro-Goldwyn-Mayer
The Waltz of the Toreadors—British—Rank
Who's Got the Action—Paramount
The Wonderful World of the Brothers Grimm—Pal/Cinerama/Metro-Goldwyn-Mayer
The World By Night No. 2—Warner Bros.

** Academy Award winner for Best Color Cinematography*

1963

The Best of Cinerama—Cinerama Releasing Corp.
The Birds—Hitchcock/International
Captain Sinbad—Metro-Goldwyn-Mayer
The Cardinal—Preminger/Columbia
Charade—Universal-International
Come Blow Your Horn—Paramount
Corps Profond—French—Independent
The Cracksman—British—Independent
The Crimson Blade—British—Independent
Critic's Choice—Warner Bros.
Diary of a Madman—United Artists
Doctor in Distress—British—Independent
Donovan's Reef—Ford/Paramount
The Fast Lady—British—Independent
55 Days at Peking—Bronston/Allied Artists
The Flying Clipper—German—Independent
For Love or Money—Universal-International
From Russia With Love—United Artists
From Saturday to Monday—Italian—Independent
Fun in Acapulco—Wallis/Paramount
Ghost at Noon—French/Italian—Independent
Gudrun—Danish—Independent
Hercules and the Captive Women—Italian—Independent
Imperial Venus—Italian/French—Independent
The Incredible Journey—Disney/Buena Vista
Irma La Douce—Mirisch/United Artists
Island of Love—Warner Bros.
It's a Mad Mad Mad Mad World—Kramer/United Artists
Jason and the Argonauts—British—Columbia
Love Is A Ball—United Artists
Mclintock!—Batjac/United Artists
MacBeth—Independent
Man's Paradise—Italian—Independent
Mary, Mary—Warner Bros.
Miracle of the White Stallions—Disney/Buena Vista
My Six Loves—Paramount
A New Kind of Love—Paramount
The Nutty Professor—Paramount
Palm Springs Weekend—Warner Bros.
Papa's Delicate Condition—Paramount
PT 109—Warner Bros.
The Raiders—Universal-International
Rampage—Warner Bros.
The Running Man—British—Columbia
Savage Sam—Disney/Buena Vista
Seige of the Saxons—British—Columbia
Showdown—Universal-International
Spencer Mountain—Warner Bros.
Summer Holiday—British—American International
Summer Magic—Disney/Buena Vista
The Sword in the Stone (animated)—Disney/Buena Vista
Three Lives of Thomasina—Disney/Buena Vista
The Threepenny Opera—German—Independent
Tommy the Toreador—British—7 Arts

Frank's Greatest Adventure—Independent
Games—Universal
The Girl and the General—Italian/French—Metro-Goldwyn-Mayer
The Gnome-Mobile—Disney/Buena Vista
The Graduate—Levine/Embassy
Guess Who's Coming to Dinner—Columbia
Gunfire in Abilene—Universal
Gunn—Paramount
Half a Sixpence—Paramount
The Happening—Horizon/Columbia
The Happiest Millionaire—Disney/Buena Vista
Hell on Wheels—Independent
The Hills Run Red—Italian—United Artists
The Hippie Revolt—Independent
The Hired Killer—Italian—Paramount
The Honey Pot (It Comes Up Murder)—British/Italian/U.S.—United Artists
Hostile Guns—Paramount
Hotel—Warner Bros.
House of 1,000 Dolls—American International
Hurry Sundown—Preminger/Paramount
I'll Never Forget What's 'is Name—British—Independent
It!—British—Warner Bros.
The Jokers—Universal
The Jungle Book (animated)—Disney/Buena Vista
Kes—British—United Artists

King's Pirate—Universal
Knives of the Avenger—Italian—Independent
The Last Safari—British—Paramount
Lightning Bolt—Italian/Spanish—Independent
The Long Duel—British—Rank
Luv—Columbia
Made in Italy—Italian/French—Independent
The Mikado—British—Warner Bros.
Misunderstood—French/Italian—Independent
Monkeys Go Home—Disney/Buena Vista
The Mummy's Shroud—British—Independent
The Naked Runner—Warner Bros.
Navajo Joe—Italian/Spanish—United Artists
Night of the Generals—Columbia
Oedipus Rex—Italian—Independent
Oh, Dad, Poor Dad, Mamma's Hung You in the Closet and I'm Feeling So Sad—Paramount
The 1,000,000 Eyes of Su-Murn—American International
Operation Kid Brother—United Artists
The President's Analyst—Paramount
Privilege—Universal
The Projected Man—British—Universal
Red Dragon—Italian/German/U.S.—Independent
Red Tomahawk—Paramount
Reflections in a Golden Eye—Warner Bros.
The Reluctant Astronaut—Universal
The Ride to Hangman's Tree—Universal

1967 Mary Tyler Moore, James Fox and Julie Andrews in *Thoroughly Modern Millie*

© Paramount Pictures.

1968 Olivia Hussey and Leonard Whiting in *Romeo and Juliet*

A Rose for Everyone—Italian—Independent
Rough Night in Jericho—Universal
The Savage Eye—Italian—Independent
The Spirit is Willing—Paramount
The Taming of the Shrew—Columbia
Tammy and the Millionaire—Universal
Thoroughly Modern Millie—Universal
The Tiger Makes Out—Columbia
Torture Garden—British—Columbia
To Each His Own—Italian—Independent
To Sir With Love—Columbia
Triple Cross—Warner Bros.
Up the Down Staircase—Warner Bros.
Valley of Mystery—Universal
The Viking Queen—British—Warner Bros.
The Viscount—Warner Bros.
Wait Until Dark—Warner Bros.
War—Italian Style—Italian—American International
The War Wagon—Batjac/Universal
Waterhold No. 3—Paramount
What Am I Bid?—Independent
Who's Minding the Mint?—Columbia
The Wild Rebels—Independent
Work is a 4-Letter Word—British—Universal
You Only Live Twice—United Artists
The Young Girls of Rochefort—French—Warner Bros.
The Young Warriors—Universal

**Academy Award winner for Best Cinematography (separate classifications for color and black-and-white were discontinued starting this year)*

1968

2001: A Space Odyssey—Warner Bros.
Ace High—Italian—Paramount
And There Came a Man—Italian/French—Independent
The Anniversary—British—Independent
Any Gun Can Play—Italian/Spanish—Independent
Anzio—French/Italian/Spanish—DeLaurentiis/Columbia
Arizona Bushwackers—Paramount
Assignment K—British—Columbia
The Ballad of Josie—Universal
Barbarella—French/Italian—Paramount
Battle Beneath the Earth—British—Metro-Goldwyn-Mayer
Benjamin—French—Independent
Better a Widow—Italian/French—Universal
The Big Gundown—Italian/Spanish—Independent
Birds Come to Die in Peru—French—Universal
The Birthday Party—British—Independent
Blackbeard's Ghost—Disney/Buena Vista
The Bliss of Mrs. Blossom—British—Paramount
Blue—Paramount
Boom!—U.S./British—Universal
Bullitt—Solar/Warner Bros./7 Arts
Bye Bye Braverman—Warner Bros./7 Arts
Candy—U.S./French/Italian—Cinerama Releasing Corp.
The Champagne Murders—French—Universal
Charlie Bubbles—British—Universal
Charly—Cinerama Releasing Corp.
Chitty Chitty Bang Bang—British—United Artists
Chubasco—Warner Bros./7 Arts
The Cobra—Italian/Spanish—Independent
Coogan's Bluff—Universal
Corruption—British—Columbia
Countdown—Warner Bros./7 Arts
The Counterfeit Killer—Universal
Counterpoint—Universal
Custer of the West—U.S./Spanish—Cinerama Releasing Corp.
The Dance of Death—British—Independent
A Dandy in Aspic—British—Columbia
Danger: Diabolik—Italian/French—Paramount
The Devil in Love—Italian—Warner Bros./7 Arts
The Devil Rides Out—British—Warner Bros.
The Devil's Bride—Twentieth Century-Fox
Did You Hear the One About the Traveling Saleslady?—Universal
Doctor Faustus—British/Italian—Columbia
Don't Just Stand There!—Universal
Don't Raise the River, Lower the Bridge—British—Columbia
The Double Man—British—Warner Bros./7 Arts
Dracula Has Risen from the Grave—British—Universal
Duffy—British—Columbia
Fever Heat—Paramount
Finian's Rainbow—Warner Bros./7 Arts

© 1975, renewed 2003 Columbia Picture Industries, Inc.

1975 Goldie Hawn in *Shampoo*

Star Dust—Italian—Independent
Stardust—British—Columbia
The Sugarland Express—Zanuck-Brown/Universal
Superdad—Disney/Buena Vista
Swallows and Amazona—British—Independent
Swept Away . . .—Italian—Independent
The Taking of Pelham One Two Three—United Artists
The Terminal Man—Warner Bros.
That Midnight Man—Universal
The Three Musketeers (The Queen's Diamonds)—British—Twentieth Century-Fox
Three Tough Guys—De Laurentiis/Paramount
Torso—Italian—Independent
Truck Stop Women—Independent
Uptown Saturday Night—First Artists/Warner Bros.
Venial Sin—Italian—Independent
Verdi—Independent
A Very Natural Thing—Independent
Willie Dynamite—Zanuck-Brown/Universal
Zandy's Bride—Warner Bros.

1975

Abduction—Independent
The Apple Dumpling Gang—Disney/Buena Vista
The Arena—Independent
At Long Last—Twentieth Century-Fox
Bigfoot: The Mysterious Monster—Independent
Black Christmas (Silent Night, Evil Night)—Canadian—Independent
A Boy and His Dog—Independent
Brother, Can You Spare A Dime? (sequences)—Independent

Children of Rage—Independent
Cleopatra Jones and the Casino of Gold—U.S./Hong Kong—Warner Bros.
Conduct Unbecoming—British Lion/Allied Artists
Coonskin—Independent
The Day of the Locust—Paramount
Dick Deadeye, or Dirty Done (animated)—British—Independent
Doc Savage . . . the Man of Bronze—Pal/Warner Bros.
Dog Day Afternoon—Warner Bros.
Drifter—Independent
The Drowning Pool—Warner Bros.
The Eiger Sanction—Universal
Escape to Witch Mountain—Buena Vista
Farewell, My Lovely—Avco Embassy
Fire in the Flesh—Independent
The Fortune—Columbia
The Four Musketeers (The Revenge of Milady)—Twentieth Century-Fox
Galileo—British—American Film Theater
Give 'em Hell, Harry!—Independent
The Great Waldo Pepper—Universal
Hedda—British—Independent
The Hindenburg—Universal
The Human Factor—Independent
Illustrious Corpses—Italian/French—United Artists
Inside Out—British/West German—Warner Bros.
Jacques Brel Is Alive and Well and Living in Paris—French/Canadian—American Film Theater
Janis (sequences)—Universal
Jaws—Zanuck-Brown/Universal
Journey Back to Oz (animated)—Independent
The Land That Time Forgot—British—American International
Th Last Days of Man on Earth—British—Independent
Let's Do It Again—First Artists/Warner Bros.
Lisztomania—Warner Bros.
Lord Shango—Independent
Love an Energy—Itlalian—Independent
The Maids—British—American Film Theater
Mandingo—DeLaurentiis/Paramount
Man at the Top—British—Independent
The Man Who Would Be King—Allied Artists/Columbia
Messiah of Evil—Independent
Midnight Pleasures—Italian—Independent
Mitchell—Allied Artists
Monty Python and the Holy Grail—British—EMI
Mr. Quip (The Old Curiosity Shop)—British—Independent
Night Moves—Warner Bros.
One of Our Dinosaurs Is Missing—Disney/Buena Vista
The Other Side of the Mountain—Universal
Out of Season—Independent
Paper Tiger—British—Independent
Permission to Kill—Euroopean—Avco Embassy
Posse—Bryna/Paramount
The Prisoner of Second Avenue—Warner Bros.

"... here in France and Italy, we gather that the best star Hollywood has in these markets is Technicolor. Many of the marquees we saw advertised their attractions by starting off with Technicolor, then the name of the picture and nary a mention of the cast names...."

W.R. WILKERSON, PUBLISHER

THE HOLLYWOOD REPORTER, JULY 1952

Rafferty and the Gold Dust Twins—Warner Bros.
The Reincarnation of Peter Proud—American International
Ride A Wild Pony—Disney/Buena Vista
Rollerball—United Artists
Rooster Cogburn—Wallis/Universal
Royal Flash—British—Twentieth Century-Fox
Salo or the 120 Days of Sodom—Italian—United Artists
Scent of Woman—Italian—Twentieth Century-Fox
Shampoo—Columbia
Sheila Levine Is Dead and Living In New York—Paramount
Sidecar Racers—Universal
Spanish Fly—British—EMI
The Spiral Staircase—British—Warner Bros.
The Strongest Man in the World—Disney/Buena Vista
That Lucky Touch—British—Rank
Those Were the Years—Italian—Independent
Three Days of the Condor—Paramount
The Ultimate Warrior—Warner Bros.
When the North Wind Blows—Independent
W.H.I.F.F.S—Brut
White, Yellow, Black—Italian/Spanish/French—Independent
The Yakuza—Warner Bros.

1976

Aces High—British—EMI/Cine Artists
Alfie Darling—British—EMI
Allegro non Troppo (sequences-animated)—Italian—Independent
All the President's Men—Warner Bros.
At the Earth's Core—British—Independent
The Bawdy Adventures of Tom Jones—British—Universal
Best of Walt Disney's True-Life Adventures (compilation)—Disney/Buena Vista
The Bingo Long Traveling All-Stars & Motor Kings—Universal
Buffalo Bill and the Indians, or Sitting Bull's History Lesson—Altman/DeLaurentiis
Bugsy Malone—British—Paramount
Car Wash—Universal
Carry on England—British—Rank/Independent
Casanova & Co.Austrian/Italian/French/German—Twentieth Century-Fox
The Context—Italian—United Artists
Crime and Passion—American International
Drive-In—Columbia
The Enforcer—Warner Bros.
Escape From the Dark—British—Disney/Buena Vista
Face to Face—Swedish—DeLaurentiis/Paramount
Family Plot—Hitchcock/Universal
Fellini's Casanova—Italian—Grimaldi/Universal
Freaky Friday—Disney/Buena Vista
Gable and Lombard—Universal
The Genius—Italian/French/German—Titanus
The Great Scout & Cathouse Thursday—American International

The Gumball Rally—First Artists/Warner Bros.
Gus—Disney/Buena Vista
How Funny Can Sex Be?—Italian—Independent
The Incredible Sarah—British—Independent
It Shouldn't Happen to a Vet—British—EMI
I Will, I Will . . .For Now—Twentieth Century-Fox
Jim, the World's Greatest—Universal
Julia—West German—Independent
The Last Tycoon—Paramount
Lipstick—De Laurentiis/Paramount
Mackintosh & T.J.—Independent
Massacre in Rome—Italian—Ponti/Independent
A Matter of Time—U.S./Italian—AIP
Midway—Mirisch/Universal
Moses—British/Italian—Avco Embassy
Mustang Country—Universal
The Next Man—Allied Artists
No Deposit No Return—Disney/Buena Vista
Obsession—Columbia
Ode to Billy Joe—Warner Bros.
Operation Daybreak—Warner Bros.
The Ritz—Warner Bros.
Robin and Marion—Columbia
Rocky—United Artists
The Sailor Who Fell From Grace with the Sea—British—Avco Embassy
Seven Beauties—Italian—Independent
Seven Nights in Japan—Anglo/French—Paramount
The Seven Per-Cent Solution—British—Universal
The Shaggy D.A.—Disney/Buena Vista
Shoot—Canadian—Avco Embassy
The Shootist—De Laurentiis/Paramount
Shout at the Devil—British—American International
The Slipper and the Rose—British—Universal
The Song Remains the Same—British—Warner Bros.
Sparkle—Warner Bros.
St. Ives—Warner Bros.
Survive!—U.S./Mexican—Independent
Swashbuckler—Universal
To the Devil—A Daughter—British/German—Independent
Treasure of Matecumbre—Disney/Buena Vista
Trial by Combat (Choice of Weapons)—British—Warner Bros.
Two-Minute Warning—Universal
W.C. Fields and Me—Universal
Winterhawk—Independent
Won Ton Ton, The Dog Who Saved Hollywood—Paramount

1977

Airport '77—Universal
The Amsterdam Kill—Hong Kong—Independent
Are You Being Served?—British—EMI
Bishop's Bedroom (La Stanza del Vescovo)—Italian—Independent
The Black Panther—British—Independent

1975 *Jaws*

A Bridge Too Far—British—United Artists
Candleshoe—Disney/Buena Vista
The Car—Universal
The Choirboys—Universal
Cross of Iron—British/West German—Avco
Embassy
Dynasty—Hong Kong—Independent
Equus—British—United Artists
Exorcist II: The Heretic—Warner Bros.
Greased Lightning—Warner Bros.
The Great Day (Una Giornata Speciale)—Italian—
Independent
The Great Gundown—Independent
Herbie goes to Monte Carlo—Disney/Buena Vista
Heroes—Universal
The Hound of the Baskervilles—British—
Independent
I'll Never Forget Whatshisname—British—
Universal
It's Alive—Warner Bros.
Jabberwocky—British—Columbia
Julia—Twentieth Century-Fox
The Last Remake of Beau Geste—Universal
Leopard in the Snow—British/Canadian—
Independent
MacArthur—Universal
March or Die—British—Columbia
Nasty Habits—Brut/Independent
New York, New York—United Artists
1900—Paramount
Oh, God!—Warner Bros.
One on One—Warner Bros.
Orca—Paramount
Outlaw Blues—Warner Bros.
The Pack—Warner Bros.
The People That Time Forgot—British—AIP
Pete's Dragon—Disney/Buena Vista
The Prince and the Pauper—British—Warner
Bros.
The Rescuers—Disney/Buena Vista
Rollercoaster—Universal
September 30, 1955—Universal
The Sentinel—Universal
The Sex Machine—Independent
Silver Bears—British—Columbia
Slap Shot—Universal
Smokey and the Bandit—Universal
Sorcerer—Universal
The Squeeze—British—Warner Bros.
Stand Up Virgin Soldiers—British—Warner Bros.
Stormtroopers (Sturmtruppen)—Italian—
Independent
Submission (Scandalo)—Italian—Independent
Suspiria—Italian—Twentieth Century-Fox
Sweeney—British—EMI
Tentacles—Italian—American International
Thieves—Brut/Paramount
Torso—Italian—Ponti/Independent
The Town That Dreaded Sundown—American
International
25 Years-Impressions—British—EMI
Twilight's Last Gleaming—Allied Artists

The Violation of Claudia—Independent
Viva Knievel!—Warner Bros.
Which Way Is Up?—Universal
The White Buffalo (Hunt to Kill)—DeLaurentiis
White Rock—British—Independent

1978

Alice, Sweet Alice (Communion)—Allied Artists
All Things Bright and Beautiful—Independent
Almost Summer—Motown/Universal
The Betsy—Allied Artists
Beyond and Back—Sunn Classic
The Big Fix—Universal
Bloodbrothers—Warner Bros.
Blue Collar—Universal
Born Again—Avco Embassy
The Boys in Company C—Columbia
The Brink's Job—DeLaurentiis/Universal
Caravans—Universal
The Cat From Outer Space—Disney/Buena Vista
The Class of Miss MacMichael—British—Brut
Comes a Horseman—United Artists
Crossed Swords—British—Warner Bros.
Death on the Nile—Paramount/EMI
The Deer Hunter—Universal/EMI
**The End of the World in Our Usual Bed in a Night
Full of Rain**—Warner Bros.
Fingers—Independent
F.I.S.T.—United Artists
FM—Universal
Force 10 From Navarone—American International
Gray Lady Down—Mirisch/Universal
The Greek Tycoon—Universal
Halloween—Independent
Hot Lead and Cold Feet—Disney/Buena Vista
House Calls—Universal
I Wanna Hold Your Hand—Spielberg/Universal
If Ever I See You Again—Columbia
Interiors—Universal—United Artists
Invasion of the Body Snatchers—United Artists
It Lives Again—Warner Bros.
Jaws 2—Zanuck-Brown/Universal
King of the Gypsies—DeLaurentiis/Paramount
Laserblast—Independent
Leopard in the Snow—British/Canadian—
Independent
Magic—Levine/Twentieth Century-Fox
Message from Space—United Artists
The Medusa Touch—British—Independent
Metamorphoses—Independent
Moment by Moment—Universal
Movie, Movie—Warner Bros.
National Lampoon's Animal House—Universal
Nunzio—Universal
Oliver's Story—Paramount
The Other Side of the Mountain—
Filmways/Universal
Paradise Alley—Universal
Return from Witch Mountain—Disney/Buena Vista
Revenge of the Pink Panther—United Artists

Same Time, Next Year—Universal
Sgt. Pepper's Lonely Heart's Club Band—Universal
Shalimar—Indian—United Artists
Silver Bears—Columbia/EMI
Skateboard—Universal
Slow Dancing in the Big City—United Artists
Straight Time—First Artists/Warner Bros.
Stevie—U.S./British—First Artists
Superman—U.S./British—Warner Bros.
The Swarm—Warner Bros.
Sweeney 2—British—EMI
Take All of Me—Independent
Uncle Joe Shannon—United Artists
Warlords of Atlantis—Columbia/EMI
Watership Down (animated)—Avco Embassy
Who'll Stop the Rain?—United Artists
The Wiz—Motown/Universal
The Wild Geese—British—Allied Artists

1979

Agatha—First Artists/Warner Bros.
All That Jazz—Columbia/Twentieth Century-Fox
All Things Bright and Beautiful—British—EMI
Americathon—Lorimar/United Artists

Apocalypse Now*—Coppola/United Artists
The Apple Dumpling Gang Rides Again—
Disney/Buena Vista
Ashanti—Swiss—Columbia
Being There—Lorimar/United Artists
The Bermuda Triangle—Sunn Classic
Beyond Death's Door—Sunn Classic
Beyond the Poseidon Adventure—Allen/Warner
Bros.
The Black Hole—Disney/Buena Vista
The Black Stallion—United Artists
Boulevard Nights—Warner Bros.
Buck Rogers—Universal
The Cat and the Canary—British—Independent
The Concorde-Airport '79—Universal
Cuba—United Artists
Dawn of the Dead—Independent
Dracula—Mirisch/Universal
The Electric Horseman—Columbia
The Fall of the House of Usher—Sunn Classic
Firepower—Independent
The Fish That Saved Pittsburgh—United Artists
French Postcards—Paramount
The Frisco Kid—Warner Bros.
Game of Death—Columbia
Going in Style—Warner Bros.

1979 Julie Andrews, Dudley Moore and Bo Derek
in *10*

© Orion Pictures

"Technicolor films are so much more popular than black-and-white that when a star tried to negotiate a deal with a producer making a movie abroad, and mentioned his $100,000 fee, the producer said, 'No. If it's a choice between spending it for a star or spending it for color, I'll take color!'"

LEONARD LYONS, NATIONALLY SYNDICATED

COLUMNIST, IN "THE LYON'S DEN"

Good Guys Wear Black—Columbia
The Great Santini—Orion/Warner Bros.
The Great Train Robbery—British—United Artists
Hair—United Artists
Hanover Street—British—Columbia
Head Over Heels—United Artists
Heart Beat—Orion/Warner Bros.
The Human Factor—British—Metro-Goldwyn-Mayer
Hurricane—DeLaurentiis/Paramount
The In-Laws—Warner Bros.
The Jerk—Universal
Jesus—Warner Bros.
Kramer vs. Kramer—Columbia
Last Embrace—United Artists
The Last Married Couple in America—Universal
The Legacy—Universal
The Legend of Sleepy Hollow—Sunn Classic
A Little Romance—Orion/Warner Bros.
Lost and Found—Columbia
The Main Event—First Artists/Warner Bros.
Moonraker—United Artists
More American Graffiti—Universal
1941—Universal/Columbia
The North Avenue Irregulars—Disney/Buena Vista
Old Boyfriends—Avco Embassy
Over the Edge—Orion/Warner Bros.
The Passage—United Artists
Phantasm—Avco Embassy
The Prisoner of Zenda—Mirisch/Universal
The Promise—Universal
Promises in the Dark—Orion/Warner Bros.
Rich Kids—Altman/United Artists
Rocky II—United Artists
Roller Boogie—United Artists
Running—Universal
The Seduction of Joe Tynan—Universal
Soldier of Orange—Dutch—Rank
Stories from a Flying Trunk—British—EMI
Summer Camp—Independent
Sunburn—Paramount
10—Orion/Warner Bros.
Tilt—Warner Bros.
Unidentified Flying Oddball (A Spaceman in King Arthur's Court)—Disney/Buena Vista
Walk Proud—Universal
The Wanderers—Orion/Warner Bros.
Yanks—Universal
Zombie Flesh Eaters (Island of the Living Dead)—Italian—Independent
Zulu Dawn—U.S./Dutch—Independent

** Academy Award winner for Best Cinematography*

1980

Any Which Way You Can—Warner Bros.
The Awakening—Orion/Warner Bros.
Altered States—Warner Bros.

The Big Brawl—Warner Bros.
The Big Red One—United Artists/Lorimar
The Black Stallion—Zoetrope/United Artists
The Blues Brothers—Universal
Breaking Glass—British—Independent
Bronco Billy—Warner Bros.
Caddyshack—Orion/Warner Bros.
Carny—United Artists
Cheech and Chong's Next Movie—Universal
Coal Miner's Daughter—Universal
Cruising—Lorimar/United Artists
Die Laughing—Warner Bros.
Divine Madness—Ladd/Warner Bros.
The Dogs of War—British—United Artists
Dressed to Kill—Filmways
ffolkes—British—Universal
The Fiendish Plot of Dr. Fu Manchu—Orion/Warner Bros.
The Final Countdown—Bryna/United Artists
The First Deadly Sin—Filmways
First Family—Warner Bros.
Flash Gordon—DeLaurentiis/Universal
Foxes—United Artists
Gilda Live—Warner Bros.
Gloria—Columbia
The Gong Show Movie—Universal
Hanger 18—Sunn Classic
Head Over Heels (Chilly Scenes of Winter)—British—United Artists
Heart Beat—Orion/Warner Bros.
Heaven's Gate—United Artists
Herbie Goes Bananas—Disney/Buena Vista
Honeysuckly Rose—Warner Bros.
The Idolmaker—United Artists
In God We Trust—Universal
In Search of Historic Jesus—Sunn Classic
Inside Moves—Independent
The Island—Zanuck-Brown/Universal
Just Tell Me What You Want—Warner Bros.
The Last Flight of Noah's Ark—Disney/Buena Vista
The Last Married Couple in America—Universal
Little Miss Marker—Universal
The Long Riders—United Artists
Melvin and Howard—Universal
Midnight Madness—Disney/Buena Vista
The Mirror Crack'd—British—EMI
Motel Hell—United Artists
Night Games—AvcoEmbassy
Night of the Juggler—Columbia
No Nukes—Warner Bros.
The Nude Bomb (The Return of Maxwell Smart)—Universal
Oh God! Book II—Warner Bros.
One-Trick Pony—Warner Bros.
Ordinary People—Paramount
Popeye—Paramount/Disney
Private Benjamin—Warner Bros.
Raging Bull—Chartoff-Winkler/United Artists
Resurrection—Universal
Roadie—United Artists
Second-Hand Hearts—Lorimar

The Shining—Kubrick/Warner Bros.
Simon—Orion/Warner Bros.
A Small Circle of Friends—United Artists
Smokey and the Bandit II—Universal
Somewhere in Time—Rastar/Universal
The Stunt Man—Twentieth Century-Fox
Superman II—Warner Bros.
Those Lips, Those Eyes—United Artists
Times Square—British—Stigwood/EMI
Tom Horn—First Artists/Warner Bros.
Tribute—Canadian—Carolco/Twentieth Century-Fox
Up the Academy—Warner Bros.
Urban Cowboy—Paramount
The Watcher in the Woods—British—Disney/Buena Vista
When Time Ran Out—Warner Bros.
Where the Buffalo Roam—Universal
The Wildcats of St. Trinian's—British—Independent
Windows—United Artists
Xanadu—Universal
Zombie—Italian——Independent
Zulu Dawn—U.S./Netherlands—Independent

1981

Absolution—British—Independent
All Night Long—Universal
An American Werewolf in London—British—Universal
Amy—Disney/Buena Vista
Arthur—Orion/Warner Bros.
Back Roads—Warner Bros.
Beyond the Reef—DeLaurentiis/Universal
Blow Out—Filmways
Body Heat—Warner Bros.
The Border—Universal/RKO
The Burning—Miramax
Bustin' Loose—Universal
The Cannonball Run—Twentieth Century-Fox
Caveman—United Artists
Comin' At Ya! (3D)—Italian—Independent
Condorman—British—Disney/Buena Vista
Continental Divide—Universal
Cutter's Way (Cutter and Bone)—United Artists
Dead and Buried—AvcoEmbassy
Death Hunt—Independent
The Devil and Max Devlin—Disney/Buena Vista
The Dogs of War—United Artists
Earthbound—Independent
Endless Love—Universal
Eureka—Metro-Goldwyn-Mayer/United Artists
Evil Under the Sun—Independent
Excalibur—Orion/Warner Bros.
Eye of the Needle—United Artists
Eyes of a Stranger—Warner Bros.
Eyewitness—Twentieth Century-Fox
The Fan—Stigwood/.Paramount
First Monday in October—Paramount
For Your Eyes Only—British—United Artists

Four Friends—British—Filmways
The Four Seasons—Universal
The Fox and the Hound—Disney/Buena Vista
The French Lieutenant's Woman—British—United Artists
The Funhouse—Universal
Ghost Story—Universal
The Gods Must Be Crazy—South African—Independent
The Great Muppet Caper—British—Universal
Halloween II—Universal
The Hand—Orion/Warner Bros.
Heartbeeps—Universal
Honkytonk Freeway—Universal
The Incredible Shrinking Woman—Universal
King of the Mountain—Polygram/Universal
Knightriders—Independent
Le Cage aux Folles II—Italian/French—United Artists
The Legend of the Lone Ranger—Universal
Looker—Ladd/Warner Bros.
The Man Who Saw Tomorrow—Warner Bros.
Memoirs of a Survivor—British—EMI
National Lampoon's Movie Madness (National Lampoon Goes to the Movies)—United Artists
Neighbors—Zanuck-Brown/Columbia
Night Crossing—British—Disney/Buena Vista
Nighthawks—Universal
Outland—Ladd/Warner Bros.
Prince of the City—Ladd/Warner Bros.
Raggedy Man—Universal
Ragtime—DeLaurentiis/Paramount
Reds*—Paramount
The Return of the Soldier—British—Independent
The Road Warrior (Mad Max 2)—Australian—Warner Bros.
Rollover—Orion/Warner Bros.
Sharky's Machine—Warner Bros.
S.O.B.—Edwards/Paramount/Lorimar
So Fine—British—Warner Bros.
Sphinx—Orion/Warner Bros.
Supersnooper (Super Fuzz)—Italian/U.S.—Columbia
Swamp Thing—United Artists
Tattoo—Levine/United Artists
Thief—United Artists
This Is Elvis—Wolper/Warner Bros.
Time Bandits—British—Independent
True Confessions—United Artists
Under the Rainbow—Warner Bros.
Wolfen—Orion/Warner Bros.
Zoot Suit—Universal

** Academy Award winner for Best Cinematography*

1982

Airplane II: The Sequel—Paramount
The Amateur—Canadian—Twentieth Century-Fox
Angel—Irish—Independent

1982 Ben Kingsley in *Gandhi*

Best Friends—Warner Bros.
The Best Little Whorehouse in Texas—Universal/RKO
Blade Runner—Warner Bros.
The Border—Universal
Brimstone and Treacle—British—Independent
Bugs Bunny's 3rd Movie: 1001 Rabbit Tales (animated)—Warner Bros.
Cat People—Universal
Conan the Barbarian—DeLaurentiis/Universal
Deathtrap—Warner Bros.
Death Valley—Universal
Diner—Metro-Goldwyn-Mayer
The Escape Artist—Zoetrope/Warner Bros.
E.T. The Extra-Terrestrial—Spielberg/Universal
Eureka—U.S./British—Metro-Goldwyn-Mayer/United Artists
Evil Under the Sun—British—Universal
Fast Times at Ridgemont High—Universal
Fighting Back—DeLaurentiis/Paramount
First Blood—Orion
Five Days One Summer—Warner Bros.
Francis—Universal

Friday the 13th Part 3 (3D)—Paramount
Gandhi*—British/Indian—Columbia
Halloween II—Universal
Hey, Good Lookin' (animated)—Bakshi/Warner Bros.
Honkytonk Man—Warner Bros.
Identification of a Woman—Italian—Independent
Independence Day—Warner Bros.
Jinxed!—Metro-Goldwyn-Mayer/United Artists
The Last Unicorn (animated)—Independent
A Little Sex—Universal
Midsummer Night's Sex Comedy—Warner Bros.
Missing—Polygram/Universal
Moonlighting—British—Independent
Night Shift—Ladd/Warner Bros.
One From the Heart—Zoetrope
Personal Best—Warner Bros.
Piranha II: The Spawning—Italian/U.S.—Columbia
The Plague Dogs (animated) —British/U.S.—Independent
Poltergeist—Metro-Goldwyn-Mayer/United Artists
Privileged—British—Universal
Return of the Soldier—British—Independent
Rocky III—United Artists
The Secret of NIMH (animated)—Metro-Goldwyn-Mayer/United Artists
Six Weeks—Universal
Soup for One—Warner Bros.
Star Trek: The Wrath of Kahn—Paramount
Still of the Night—Metro-Goldwyn-Mayer/United Artists
Tex—Disney/Buena Vista
The Thing—Universal
Too Far to Go—British—Independent
Tootsie—Columbia
The Toy—Rastar/Columbia
Trail of the Pink Panther—Metro-Goldwyn-Mayer/United Artists
Tron—Disney/Buena Vista
Venom—British—Independent
The Verdict—Zanuck-Brown/Twentieth Century-Fox
Victor/Victoria—British—Metro-Goldwyn-Mayer
The World According to Garp—Warner Bros.
Yes, Giorgio—Metro-Goldwyn-Mayer/United Artists

* Academy Award winner for Best Cinematography

1983

Bad Boys—Universal
The Black Stallion Returns—Zoetrope/Metro-Goldwyn-Mayer/United Artists
Blue Skies Again—Warner Bros.
Blue Thunder—Rastar/Columbia
Bullshot—British—Independent
Creepshow—Warner Bros.
Cross Creek—Universal
Cujo—Warner Bros.
Curse of the Pink Panther—Metro-Goldwyn-

The first custard pie ever

thrown in Technicolor

struck Alice Faye in a scene

in Twentieth Century-Fox's

HOLLYWOOD CAVALCADE—

and despite the competition

of war scares, the news was

blazoned to the ends of

the earth.

HOLLYWOOD TRADE PAPERS, JUNE 8, 1939

Mayer/United Artists
Daffy Duck's Movie: Fantastic Island (animated)—
Warner Bros.
Daniel—Independent
D.C. Cab—Universal
The Dead Zone—DeLaurentiis/Lorimar
Deal of the Century—Geffen/Warner Bros.
Doctor Detroit—Universal
Eddie Macon's Run—Universal
Educating Rita—British—Rank
The Entity—Twentieth Century-Fox
Going Berserk—Universal
Gorky Park—Orion
Halloween III: Season of the Witch—DeLaurentiis
Hammett—Orion/Warner Bros.
Hanna K.—Universal
High Road to China—Warner Bros.
Jaws 3-D—Universal
King of Comedy—Twentieth Century-Fox
Let's Spend the Night Together—Embassy
Local Hero—Warner Bros.
The Lonely Lady—Universal
Lovesick—Ladd/Warner Bros.
The Man With Two Brains—Warner Bros.
Merry Christmas, Mr. Lawrence—Universal
Mickey's Christmas Carol (animated)—
Disney/Buena Vista
Monty Python's The Meaning of Life—British—
Universal
National Lampoon's Vacation—Warner Bros.
Never Cry Wolf—Disney/Buena Vista
Never Say Never Again—British—Warner Bros.
Octopussy—United Artists
Of Unknown Origin—Warner Bros.
The Outsiders—Warner Bros.
The Pirates of Penzance—British—Universal
Private School—Universal
Psycho II—Universal
The Right Stuff—Ladd/Warner Bros.
Risky Business—Warner Bros.
Rumble Fish—Universal
Scarface—Universal
Second Thoughts—Universal
Silkwood—Nichols/ABC
Smokey and the Bandit II—Universal
Something Wicked This Way Comes—
Disney/Buena Vista
Star 80—Warner Bros.
The Sting II—Universal
Stroker Ace—Universal
Sudden Impact—Warner Bros.
Superman III—Warner Bros.
Table for Five—Warner Bros.
Tank—Universal
Tender Mercies—Universal
Trading Places—Paramount
Trenchcoat—Disney/Buena Vista
Twilight Zone: The Movie—Warner Bros.
Under Fire—Orion
Wagner—British/Hungarian/Austrian—
Independent
Wargames—Metro-Goldwyn-Mayer/United Artists

Yentl—Barwood/United Artists
Zelig—Warner Bros.

1984

All of Me—Universal
Amadeus—Foreman/Orion
American Dreamer—Warner Bros.
And the Ship Sails On—Italian/French—
Independent
Beverly Hills Cop—Paramount
Blame It on the Night—TriStar
The Bounty—British—DeLaurentiis/Orion
Cal—British—Warner Bros.
City Heat—Warner Bros.
Cloak and Dagger—Universal
Comfort and Joy—Universal
Conan the Destroyer—Universal
The Cotton Club—Orion
Crackers—Universal
Country—Touchstone/Buena Vista
The Dark Crystal—Universal
Dune—DeLaurentiis/Universal
Falling in Love—Paramount
Finders Keepers—Warner Bros.
Firestarter—Universal
Firstborn—Paramount
Friday the 13th Part 4: The Final Chapter—
Paramount
Garbo Talks—Metro-Goldwyn-Mayer/United
Artists
Grandview U.S.A.—Warner Bros.
Gremlins—Amblin/Warner Bros.
Greystoke: The Legend of Tarzan—Warner Bros.
Hard to Hold—Universal
Harry and Son—Orion
The Hit—British—Independent
The Hotel New Hampshire—Orion
Iceman—Universal
Irreconcilable Differences—Warner Bros.
The Killing Fields*—British—Warner Bros.
The Last Starfighter—Lorimar/Universal
The Little Drummer Girl—Warner Bros.
The Lonely Guy—Universal
Mass Appeal—Universal
Meatballs Part II—TriStar
Mike's Murder—Warner Bros.
The Muppets Take Manhattan—TriStar
The Natural—TriStar
The NeverEnding Story—British/West German—
Warner Bros.
Number One—British—Independent
Oh God, You Devil—Warner Bros.
Once Upon a Time in America—Avco
Embassy/Warner Bros.
A Passage to India—British—Lean/Columbia
Places in the Heart—TriStar
Police Academy—Warner Bros.
A Private Function—British—Independent
Protocol—Warner Bros.
Purple Hearts—Warner Bros.

Purple Rain—Warner Bros.
The Razor's Edge—Columbia
Repo Man—Universal
The River—Universal
The River Rat—Paramount
Scandalous—British—Independent
The Shooting Party—British—Independent
Sixteen Candles—Universal
Slaygroung—British—EMI
Splash!—Touchstone/Buena Vista
Star Trek III: The Search for Spock—Paramount
Stop Making Sense—Independent
Streets of Fire—Universal
Success Is the Best Revenge—British/French—
Independent
Swing Shift—Warner Bros.
Terror in the Aisles—Universal
Tightrope—Warner Bros.
Under the Volcano—Universal
The Wild Life—Universal
Windy City—Warner Bros.

*Academy Award winner for Best
Cinematography*

1985

After Hours—Warner Bros.
American Flyers—Warner Bros.
Baby—The Secret of the Lost Legend—

Touchstone/Buena Vista
Back to the Future—Universal
The Best of Times—Universal
Better Off Dead—Warner Bros.
The Black Cauldron (animated)—
Disney/Buena Vista
Brewster's Millions—Universal
Cat's Eye—Metro-Goldwyn-Mayer/United Artists
A Chorus Line—Columbia
Christopher Columbus—Warner Bros.
Creator—Universal
Dance With a Stranger—British—Independent
DreamChild—British—EMI
Eleni—Warner Bros.
The Emerald Forest—British—Embassy
Explorers—Paramount
Fandango—Amblin/Warner Bros.
Fletch—Universal
Friday the 13th Part 5: A New Beginning—
Paramount
The Goonies—Warner Bros.
Gotcha—Universal
Into the Night—Universal
Jewel of the Nile—Twentieth Century-Fox
King David—Paramount
Krush Groove—Warner Bros.
Ladyhawke—Warner Bros.
Lost in America—Geffen/Warner Bros.
Macaroni—Paramount
Mad Max Beyond Thunderdome—Australian—
Warner Bros.

1984 Judge Reinhold and Eddie Murphy in
Beverly Hills Cop

1985 Harrison Ford and Lukas Haas in *Witness*

In 1978, the ten top-grossing Technicolor pictures of all time: (1) JAWS, *(2)* THE GODFATHER, *(3)* THE STING, *(4)* GONE WITH THE WIND, *(5)* THE GRADUATE, *(6)* AMERICAN GRAFFITI, *(7)* AIRPORT, *(8)* THE TEN COMMAND-MENTS, *(9)* MARY POPPINS *and (10)* SMOKEY AND THE BANDIT.

© Paramount Pictures

Marie—DeLaurentiis
Mask—Universal
Miracles—Orion
Mishima (sequences)—Coppola-Lucas/Warner Bros.
My Science Project—Touchstone/Buena Vista
National Lampoon's European Vacation—Warner Bros.
Out of Africa*—Universal
Pale Rider—Warner Bros.
Pee Wee's Big Adventure—Warner Bros.
Perfect—Columbia
Plenty—Pressman/RKO
Police Academy 2: Their First Assignment—Ladd/Warner Bros.
Power—Lorimar
The Protector—Warner Bros.
Rambo: First Blood Part Two—TriStar
Restless Natives—British—Independent
The Return of the Soldier—Independent
Return to Oz—Disney/Buena Vista
Revolution—Warner Bros.
A Room With a View—British—Merchant-Ivory
Rustlers Rhapsody—Paramount
Sesame Street Presents: Follow That Bird—Warner Bros.
The Shooting Party—Independent
Silverado—Columbia
Silver Bullet—DeLaurentiis/Paramount
Spies Like Us—Warner Bros.
Stick—Universal
The Stuff—New World
Sweet Dreams—TriStar
Target—Zanuck-Brown/Warner Bros.
To Live and Die in L.A.—Metro-Goldwyn-Mayer/United Artists
Turtle Diary—British—Independent
Vision Quest—Warner Bros.
Weird Science—Universal

Wetherby—British—Independent
Wild Geese II—British—Universal
Witness—Paramount
The Year of the Dragon—DeLaurentiis/Metro-Goldwyn-Mayer/United Artists
Young Sherlock Holmes—Amblin

* Academy Award winner for Best Cinematography

1986

About Last Night—TriStar
An American Tale (animated)—Universal
The Best of times—Kings/Road/Universal
Biggies: Adventures in Time—British—Independent
Blue Velvet—DeLaurentiis
Brighton Beach Memoirs—Universal
Caravaggio—British—Independent
Choke Canyon—Independent
The Clan of the Cave Bear—Warner Bros.
Clockwise—British—EMI
Club Paradise—Warner Bros.
Cobra—Warner Bros.
Code Name: Wild Geese—New World
Crimes of the Heart—DeLaurentiis
Critical Condition—Paramount
Crossroads—Columbia
Deadly Friend—Warner Bros.
Down and Out in Beverly Hills—Touchstone/Buena Vista
Dream Lovers—Metro-Goldwyn-Mayer/United Artists
Dress Gray—Warner Bros.
Eat the Peach—Irish—Independent
Eight Million Ways to Die—TriStar
Ferris Bueller's Day Off—Paramount
Friday the 13th Part VI: Jason Lives—Paramount

The Golden Child—Paramount
The Great Mouse Detective (animated)—Disney/Buena Vista
Gung Ho—Paramount
Half Moon Street—RKO Radio/Twentieth Century-Fox
Hamburger . . . The Motion Picture—Independent
Hannah and Her Sisters—Orion
Heartbreak Ridge—Warner Bros.
Heartburn—Paramount
Highlander—U.S./British—EMI
Jake Speed—New World
King Kong Lives—DeLaurentiis
Labyrinth—TriStar
Lady Jane—British—Paramount
Legal Eagles—Universal
Link—British—Cannon/EMI
Little Shop of Horrors—Warner Bros.
A Man and a Woman: 20 Years Later—Warner Bros.
Manhunter—DeLaurentiis
Maximum Overdrive—DeLaurentiis
Mona Lisa—British—Independent
The Money Pit—Universal
The Mosquito Coast—Warner Bros.
Mr. Love—Warner Bros.
My Little Pony (animated)—Independent
No Retreat, No Surrender—New World
Nothing in Common—TriStar
One Crazy Summer—Warner Bros.
Police Academy 3: Back in Training—Warner Bros.
Power—Twentieth Century-Fox/Lorimar
Pretty in Pink—Paramount
Psycho III—Universal
Radioactive Dreams
Ratboy—Warner Bros.
Raw Deal—DeLaurentiis
'Round Midnight—Warner Bros.
Saving Grace—Columbia/Embassy
Shanghai Surprise—British—Independent
Short Circuit—TriStar

Stand By Me—Columbia
Star Trek IV: The Voyage Home—Paramount
Sweet Liberty—Universal
Tai-Pan—DeLaurentiis
Transformers: The Movie—DeLaurentiis
Trick or Treat—DeLaurentiis
True Stories—Warner Bros.
Under the Cherry Moon—Warner Bros.
Wildcats—Warner Bros.
Wise Guys—Metro-Goldwyn-Mayer/United Artists
Withnail and I—British—Independent

1987

Aladdin—Italian—Cannon
Amazon Women on the Moon (sequences)—Universal
Angel Heat—TriStar
Back to the Beach—Paramount
The Bedroom Window—DeLaurentiis
Bellman and True—British—Independent
The Belly of an Architect—British/Italian—Independent
Beverly Hills Cop II—Paramount
Body Slam—DeLaurentiis
Burglar—Warner Bros.
Campus Man—Paramount
Critical Condition—Paramount
Crystal Heart—Independent
Date With an Angel—DeLaurentiis
Dirty Dancing—Vestron
Eddie Murphy 'Raw'—Paramount
Empire of the Sun—Amblin/Warner Bros.
Evil Dead 2: Dead By Dawn—Independent
Extreme Prejudice—Carolco/TriStar
Fatal Attraction—Paramount
From the Hip—DeLaurentiis
Gaby—A True Story—TriStar
Hamburger Hill—Paramount/RKO Radio
Heat—Independent
Hellraiser—British—Cannon/New World
Hiding Out—DeLaurentiis
Hope and Glory—British—Columbia
Hotel Colonial—U.S./Italian—Orion
House II: The Second Story—New World
Innerspace—Warner Bros.
Ironweed—TriStar
Ishtar—Columbia
It's Alive III: Island of the Alive—Warner Bros.
The Killing Time—New World
The Kindred—Independent
King Kong Lives—DeLaurentiis
Knights and Emeralds—Warner Bros.
The Last Emperor*—British/Italian/Hong Kong—Columbia
Lethal Weapon—Warner Bros.
Like Father Like Son—TriStar
Lionheart—Orion
The Living Daylights—British—Metro-Goldwyn-Mayer/United Artists
The Lost Boys—Warner Bros.

1986 *Little Shop of Horrors*

1987 Alex Winter in *The Lost Boys*

Made in Heaven—Lorimar
Man on Fire—TriStar
Maurice—British—Merchant-Ivory
Midnight Crossing—Vestron
Million Dollar Mystery—DeLaurentiis
Moonstruck—Metro-Goldwyn-Mayer/United Artists
Nadine—TriStar
Near Dark—DeLaurentiis
Nuts—Warner Bros.
The Order of the Black Eagle—Independent
Orphans—Lorimar
Outrageous Fortune—Touchstone/Buena Vista
Overboard—Metro-Goldwyn-Mayer
Over the Top—Warner Bros.
Planes, Trains and Automobiles—Paramount
Police Academy 4: Citizens on Patrol—Warner Bros.
The Principal—TriStar
Rage of Honor—Independent
The Raggedy Rawney—British—Independent
Return to Salem's Lot—Warner Bros.
The Running Man—TriStar
Salome's Last Dance—British—Vestron
Secret of My Success—Universal
The Sicilian—Twentieth Century-Fox
Some Kind of Wonderful—Paramount
Souvenir—British—Independent
The Squeeze—TriStar
Summer School—Paramount
Superman IV: The Quest for Peace—Warner Bros.
Surrender—Warner Bros.
Suspect—TriStar

Touch and Go—TriStar
The Trouble With Spies—DeLaurentiis
The Unbearable Lightness of Being—Independent
The Untouchables—Paramount
Weeds—DeLaurentiis
White Water Summer—Columbia
Who's That Girl?—Warner Bros.
Wish You Were Here—British—Independent
The Witches of Eastwick—Warner Bros.

** Academy Award winner for Best Cinematography*

1988

Above the Law—Warner Bros.
The Accidental Tourist—Warner Bros.
The Accused—Paramount
Amsterdamned—Dutch—Vestron
Arthur 2: On the Rocks—Warner Bros.
Beaches—Touchstone/Buena Vista
Beethoven's Nephew—Independent
Beetlejuice—Warner Bros.
Big Top Pee-Wee—Paramount
Bill & Ted's Excellent Adventure—Independent
Bird—Warner Bros.
The Blob—TriStar
Bright Lights, Big City—Metro-Goldwyn-Mayer/United Artists
Caddyshack II—Warner Bros.
Casual Sex—Universal
Cat Chaser—Independent

© Disney Enterprises, Inc.

1991 Beast and Lefou share a dance in Disney's animated feature *Beauty and the Beast*

1990

Almost an Angel—Paramount
American Blue Note—Independent
Another 48 Hours —Paramount
Any Man's Death—Independent
Avalon—TriStar
Awakenings—Columbia
The Ballad of the Sad Cafe—U.S./British—Merchant-Ivory
The Belly of an Architect—British/Italian—Independent
Betsy's Wedding—Touchstone/Buena Vista
Blind Fury—TriStar
The Blood of Heroes (Salute of the Jugger)—Australian—New Line
Blue Steel—Vestron
The Bonfire of the Vanities—Warner Bros.
The Comfort of Strangers—U.S./Italian—Paramount
Crazy People—Paramount
Days of Thunder—Paramount
Def by Temptation—Independent
Desperate Hours—DeLaurentiis
Dick Tracy—Touchstone/Buena Vista
DuckTales: The Movie—Treasure of the Lost Lamp (animated)—Disney/Buena Vista
Ernest Goes to Jail—Touchstone/Buena Vista
The Field—Irish—Independent
Firebirds—Touchstone/Buena Vista
Flashback—Paramount
Flatliners—Columbia
Fools of Fortune—British—Polygram
The Freshman—TriStar
Funny About Love—Paramount
Ghost—Paramount
The Godfather Part III—Zoetrope/Paramount
Goodfellas—Warner Bros.
Graffiti Bridge—Warner Bros.
Graveyard Shift—Paramount
Green Card—Australian/French—Touchstone/Buena Vista

Gremlins 2: The New Batch—Amblin/Warner Bros.
The Guardian—UIP/Universal
The Handmaid's Tale—U.S./German—Cinecom
Hard to Kill—Warner Bros.
The Hunt for Red October—Paramount
I Love You to Death—TriStar
Impulse—Warner Bros.
Internal Affairs—Paramount
Jacob's Ladder—Carolco/TriStar
Joe versus the Volcano—Amblin/Warner Bros.
The Kill-Off—Independent
Look Who's Talking Too—TriStar
Loose Cannons—TriStar
Memphis Belle—British—Warner Bros.
Mountains of the Moon—TriStar
Mr. and Mrs. Bridge—Merchant-Ivory/Miramax
Mr. Destiny—Touchstone/Buena Vista
My Blue Heaven—Warner Bros.
Narrow Margin—Carolco/TriStar
Navy Seals—Orion
Nuns on the Run—British—Twentieth Century-Fox
The Nutcracker Prince (animated)—Canadian—Warner Bros.
Old Explorers—Independent
Postcards from the Edge—Columbia
Presumed Innocent—Warner Bros.
Pretty Woman—Touchstone/Buena Vista
Q & A—TriStar
Quick Change—Warner Bros.
The Reflecting Skin—British—Independent
The Rescuers Down Under (animated)—Disney/Buena Vista
Reversal of Fortune—Warner Bros.
The Rookie—Warner Bros.
The Russia House—Pathe/Metro-Goldwyn-Mayer/United Artists
The Sheltering Sky—British/Italian—Warner Bros.
Shipwrecked—Norweigian—Disney/Buena Vista
A Show of Force—Paramount
The Shrimp on the Barbie (Boyfriend from Hell)—Warner Bros.
Side Out—TriStar
Smack and Thistle—British—Independent
Space Avenger—Independent
Stella—Touchstone/Goldwyn/Buena Vista
Stephen King's IT—Lorimar/Warner Bros.
Strapless—British—Miramax
Taking Care of Business—Hollywood/Buena Vista
Tales from the Darkside: The Movie—Paramount
Three Men and a Little Lady—Touchstone/Buena Vista
Torrents of Spring—Italian/French—Independent
Total Recall—TriStar
The Two Jakes—Paramount
Welcome Home, Roxy Carmichael—Paramount
Where the Heart Is—Touchstone/Buena Vista
White Hunter, Black Heart—Warner Bros.

1991

The Addams Family—Paramount
All I Want For Christmas—Paramount
An American Tail: Fievil Goes West (animated)—Amblin/Universal
At Play in the Fields of the Lord—Universal
Barton Fink—Twentieth Century-Fox
Basic Instinct—Carolco
Beauty and the Beast—Disney/Buena Vista
Body Parts—Paramount
Born to Ride—Warner Bros.
Boyz N the Hood—Columbia
Bugsy—Columbia/TriStar
The Butcher's Wife—Paramount
Cape Fear—Universal
City Slickers—Columbia
The Commitments—Irish—Twentieth Century-Fox
Curly Sue—Warner Bros.
Dark Wind—Carolco
Dead Again—Paramount
Defending You Life—Geffen/Warner Bros.
Doc Hollywood—Warner Bros.
The Doctor—Touchstone/Buena Vista
Double X—British—Independent
Electric Moon—British—Independent
Falling from Grace—Columbia
Father of the Bride—Touchstone/Buena Vista
The Fisher King—Columbia/TriStar
Flight of the Intruder—Paramount
Frankie & Johnnny—Paramount
Guilty by Suspicion—Warner Bros.
He Said, She Said—Paramount
Hudson Hawk—Columbia/TriStar
The Inner Circle—Italian—Columbia/TriStar
K2: The Ultimate High—Paramount
L.A. Story—Carolco
The Last Boy Scout—Warner Bros.

The Marrying Man—Hollywood/Buena Vista
Naked Gun 2-1/2: The Smell of Fear—Paramount
Necessary Roughness—Paramount
New Jack City—Warner Bros.
Oscar—Touchstone/Buena Vista
Other People's Money—Warner Bros.
Out for Justice—Warner Bros.
Paradise—Touchstone/Buena Vista
Perfect Weapon—Paramount
The Power of One—Warner Bros.
The Prince of Tides—Columbia
Regarding Henry—Paramount
Return to the Blue Lagoon—Columbia/TriStar
Robin Hood : Prince of Thieves—Warner Bros.
Rocketeer—Disney/Buena Vista
Shattered—Metro-Goldwyn-Mayer
Silence of the Lambs—Rank/Orion
Soapdish—Paramount
Stepping Out—Paramount
Student Bodies—Paramount
Switch—Columbia/TriStar
Tales from the Darkside: The Movie—Columbia/TriStar
Teen Agent (If Looks Could Kill)—Warner Bros.
True Identity—Warner Bros.
V.I. Warshawski—Hollywood/Buena Vista
What About Bob?—Disney/Buena Vista
White Fang—Disney/Buena Vista
Wild Hearts Can't Be Broken—Disney/Buena Vista

1992

Aladdin (animated)—Disney/Buena Vista
Back in the USSR—Warner Bros.
Batman Returns—Warner Bros.
Blame It on the Bellboy—British—Hollywood/Warner Bros.
Bob Roberts—Paramount/Miramax/Polygram
The Bodyguard—Warner Bros.

© Warner Bros.

1989 *Batman*

City Slickers II - The Legend of Curly's Gold—Columbia

The Client—Warner Bros.

Clifford—Orion

Cobb—Warner Bros.

Color of Night—Hollywood/Buena Vista

Cops and Robbersons—TriStar

Crow—Warner Bros.

De Eso No Se Habla—U.S./Spanish—Sony

Disclosure—Warner Bros.

D2 the Mighty Ducks—Disney/Buena Vista

The Favor—Orion

Four Weddings and a Funeral—Gramercy

The Goofy Movie—Disney/Buena Vista

Guarding Tess—TriStar

Hans Christian Anderson's 'Thumbelina' (animated)—Warner Bros.

Holy Matrimony—Hollywood/Buena Vista

The House of the Spirits—Miramax

House of Cards—Independent

The Hudsucker Proxy—Warner Bros.

I'll Do Anything—Columbia

I Love Trouble—Touchstone/Buena Vista

Imaginary Crimes—Warner Bros.

The Inkwell—Touchstone/Buena Vista

Interview With the Vampire—Warner Bros.

In the Army Now—Hollywood/Buena Vista

Iron Will—Disney/Buena Vista

It Could Happen to You—TriStar

It's Pat—Touchstone/Buena Vista

The Jungle Book—Disney/Buena Vista

Just in Time—TriStar

Legends of the Fall*—TriStar

Leon—Columbia

The Lion King (animated)—Disney/Buena Vista

Little Big League—Columbia

Little Buddha—Miramax

Little Women—Columbia

The Lone Brave—Disney/Buena Vista

Love Affair—Warner Bros.

Low Down Dirty Shame—Hollywood/Buena Vista

Major League II—Warner Bros.

Mary Shelly's Frankenstein—TriStar

Maverick—Warner Bros.

Murder in the First—Wolper/Warner Bros.

My Father, the Hero—Touchstone/Buena Vista

My Girl 2—Columbia

My Posse Don't Do Homework—Hollywood/Buena Vista

The Myth of the White Wolf - The Further Adventures of White Fang—Disney/Buena Vista

Natural Born Killers—Warner Bros.

The Next Karate Kid—Columbia

North—Columbia

On Deadly Ground—Warner Bros.

A Perfect Season—Warner Bros.

Princess Caraboo—TriStar

A Pure Formality—French/U.S.—Sony

The Quick and the Dead—TriStar

Quiz Show—Hollywood/Buena Vista

1994 *The Lion King*

1994 *Black Beauty*

Rapa Nui—Warner Bros.
The Ref—Touchstone/Buena Vista
Renaissance Man—Touchstone/Buena Vista
Richie Rich—Warner Bros.
The Road to Wellville—Columbia
Roommates—Hollywood/Buena Vista
The Santa Clause—Hollywood/Buena Vista
Second Best—Warner Bros.
The Shawshank Redemption—Columbia
Silent Fall—Warner Bros.
The Slingshot—Sony
The Specialist—Warner Bros.
Star Trek: The Next Generation - The Movie—
Paramount
The Stars Fell on Henrietta—Warner Bros.
Tall Tale—Disney/Buena Vista
Terminal Velocity—Hollywood/Buena Vista
3 Ninjas Kick Back—TriStar
Threesome—Columbia/TriStar
The Tool Shed—Touchstone/Buena Vista
Trial by Jury—Warner Bros.
A Troll in Central Park (animated)—Warner Bros.
Twist of Fate—Touchstone/Buena Vista
War of the Buttons—Warner Bros.
When a Man Loves a Woman—Touchstone/Buena
Vista
With Honors Warner Bros.
Wolf—Columbia
Wyatt Earp—Warner Bros.

* *Academy Award winner for Best
Cinematography*

1995

Ace Ventura: When Nature Calls—Warner Bros.
Addicted to Love—Warner Bros./Miramax
Alaska—Columbia/Castle Rock
The Amazing Panda Adventure—Warner Bros.
The American President—Columbia/Castle Rock
Assassins—Warner Bros.
Bad Boys—Columbia
Batman Forever—Warner Bros.
Before Sunrise—Castle Rock/ Warner Home Video
Beyond Rangoon—Columbia/Castle Rock
Boys on the Side—Warner Bros.
The Bridges of Madison County—Warner Bros.
Casino—Universal Pictures
Copycat—Warner Bros.
Crimson Tide—Hollywood Pictures/Buena Vista
Cutthroat Island—Artisan Entertainment
Dangerous Minds—Hollywood Pictures/Buena
Vista
Dead Presidents—Hollywood Pictures/Buena Vista
Desperado—Columbia
Devil in a Blue Dress—TriStar
Die Hard With a Vengeance—Buena Vista/Cinergi
Dolores Claiborne—Castle Rock
Dracula: Dead and Loving It—Warner Home Video

Fair Game—Warner Bros.
Father of the Bride 2—Touchstone/Buena Vista
First Knight—Columbia
Funny Bones—British—Hollywood Pictures/Buena
Vista
A Goofy Movie (animated)—Disney/Buena Vista
Heat—Warner Bros.
Heavyweights—Disney/Buena Vista
Hideaway—TriStar
Jumanji—Columbia/TriStar
Jury Duty—TriStar
Last Summer in the Hamptons—Lions Gate Home
Entertainment
Little Big League—Rank/Castle Rock
A Little Princess—Warner Bros.
Mad Love—Buena Vista
The Man of the House—Disney/Buena Vista
Miami Rhapsody—Hollywood Pictures/Buena
Vista
Mr. Holland's Opus—Hollywood Pictures
Mr. Wrong – Touchstone/Buena Vista
Mixed Nuts – TriStar
Money Train – Columbia
The Net – Columbia
New Jersey Drive—Universal
Nixon—Walt Disney Home Video
Only You—Columbia TriStar
Othello—Columbia/Castle Rock
The Pebble and the Penguin (animated)—Warner
Bros.
Pocahontas (animated)—Disney/Buena Vista
Powder—Hollywood Pictures/Buena Vista
The Quick and the Dead—Columbia/TriStar
Roommates—Polygram/Buena Vista
The Run of the Country—British/Irish – Rank/Castle
Rock
The Scarlet Letter—Buena Vista Home
Entertainment
Sense and Sensibility—British/U.S—Columbia
Something to Talk About—Warner Bros.
The Stars Fell on Henrietta—Warner Bros.
Tall Tale—Disney/Buena Vista
The Tie That Binds—Disney
To Die For—Rank/Columbia
Toy Story (animated)—Disney/Buena Vista/Pixar
Under Siege 2: Dark Territory—Warner Bros.
Unstrung Heroes—Hollywood Pictures/Buena
Vista
While You Were Sleeping—Hollywood
Pictures/Buena Vista

1996

The Associate—Buena Vista
Barb Wire—Gramercy Pictures
Before and After—Hollywood Pictures/Buena Vista
Bottle Rocket—Columbia
Box of Moonlight—Vidmark/Trimark
Boys—Buena Vista

© Disney Enterprises, Inc. / Pixar Animation Studios

1998 *A Bug's Life*

The Cable Guy—Columbia
Carpool—Warner Bros.
Celtic Pride—Hollywood Pictures/Buena Vista
City Hall—Columbia/Castle Rock
The Craft—Columbia
D3: Mighty Ducks—Disney/Buena Vista
Diabolique—Warner Bros.
Driftwood—Irish/British – Blue Dolphin Film Distribution
Eddie—Hollywood Pictures/Buena Vista
Eraser—Warner Bros.
Executive Decision—Warner Bros.
Extreme Measures—British/U.S.—Columbia/Castle Rock
The Fan—TriStar
Fly Away Home—Columbia
Get on the Bus—Columbia
Ghosts of Mississippi – Castle Rock
The Glimmer Man – Warner Bros.
Hamlet – Columbia/Castle Rock
High School High – Sony/TriStar
Homeward Bound II: Lost In San Francisco – Disney/Buena Vista
The Hunchback of Notre Dame (animated)—Disney/Buena Vista
Jack – Hollywood Pictures/Buena Vista
James and the Giant Peach (animated)—Disney/Buena Vista
Jerry Maguire—Columbia /TriStar
Jude—British—Gramercy Pictures
The Juror—Columbia
Kazaam—Touchstone/Buena Vista
Last Dance—Touchstone/Buena Vista
Little Indian, Big City—Touchstone/Buena Vista
Mars Attacks!—Warner Bros.
Mary Reilly—TriStar
Michael—Rank/Castle Rock
Michael Collins—Warner Bros.
The Mirror Has Two Faces—Columbia/TriStar
Mrs. Winterbourne—TriStar
Multiplicity—Columbia
Muppet Treasure Island—Disney/Buena Vista

101 Dalmatians—Disney/Buena Vista
The People vs. Larry Flint—Columbia/TriStar
The Portrait of a Lady—U.S./British – Gramercy Pictures
The Preacher's Wife—Touchstone/Buena Vista
Ransom—Touchstone/ Buena Vista
The Rich Man's Wife—Hollywood Pictures/Buena Vista
Roald Dahl's Matilda—Columbia/TriStar
The Rock—Hollywood Pictures/Buena Vista
Sleepers—Warner Bros.
Solo—U.S./Mexican—Orpheus Films
Space Jam—Warner Bros.
Spy Hard—Hollywood Pictures/Buena Vista
The Stendhal Syndrome—Italian—Cine 2000/TromoTeam Video
Stonewall—British—BBC/Strand Releasing
Striptease—Rank/Castle Rock
Suburbia—Castle Rock/Sony Entertainment
The Sunchaser—Warner Bros.
Surviving Picasso—U.S./British—Warner Bros.
This is the Sea—U.S./British/Irish—Paramount
A Time to Kill—Warner Bros.
Tin Cup—Warner Bros.
Tom and Huck—Disney/Buena Vista
Twister—Warner Bros./Universal
Two Much—Spanish/U.S.—Buena Vista/Touchstone
When We Were Kings—Universal Pictures
White Squall—Hollywood Pictures/Buena Vista

1997

Air Force One—Columbia
Amistad—DreamWorks
Absolute Power—Columbia/Castle Rock
Air Bud—Disney/Buena Vista
Apt Pupil—U.S./French—Columbia/TriStar
The Blackout—Trimark
The Borrowers—British—Polygram/Universal Pictures

The Boxer—British/Irish/U.S.—Universal

Bring Me the Head of Mavis Davis—British—Trinity Home Entertainment

Buddy—Columbia

The Butcher Boy—Irish/U.S.—Warner Bros.

Con Air—Touchstone/Buena Vista

Conspiracy Theory—Warner Bros.

Contact—Warner Bros.

Dad Savage—British—Polygram

Devil's Advocate—Warner Bros.

The Devil's Own—Columbia

Donnie Brasco—Mandalay Entertainment/TriStar Pictures

Double Team—Columbia

Excess Baggage—Columbia

Father's Day—Warner Bros.

The Fifth Element—Columbia

Fire Down Below—Warner Bros.

Flubber—Disney/Buena Vista

Fools Rush In—Columbia

For Richer or for Poorer—Universal

The Game—Polygram Entertainment

Gattaca—Columbia/TriStar

G.I. Jane—Hollywood Pictures/Buena Vista

Girl's Night—British/U.S.—Granada Films

International/Showtime Networks Inc.

Gone Fishin'—Hollywood Pictures/Buena Vista

Gross Pointe Blank—Hollywood Pictures/Buena Vista

Hercules (animated)—Disney/Buena Vista

I Know What You Did Last Summer—Columbia Pictures/Sony Pictures

Incognito—Warner Bros.

Jungle 2 Jungle—Disney/Buena Vista

Kundun—Touchstone/Buena Vista

LA Confidential—Warner Bros.

Leo Tolstoy's Anna Karenina—Warner Bros.

Life is Beautiful—Italian—Buena Vista

Mad City—Warner Bros.

The Man Who Knew Too Little—Warner Bros.

Men In Black—Columbia

Men with Guns—Columbia TriStar Home Entertainment

Metro—Touchstone/Buena Vista

Midnight in the Garden of Good and Evil—Warner Bros.

Mojo—British—BBC/Channel Four Films

Mouse Hunt—DreamWorks

Murder at 1600—Warner Bros.

My Best Friend's Wedding—Columbia/TriStar

1997 Kim Basinger in *L.A. Confidential*.

1997 Will Smith in *Men in Black*

BELOW: 1998 *The Prince of Egypt,*

Nothing to Lose—Touchstone/Buena Vista
Office Killer—Buena Vista Home Video
The Peacemaker—DreamWorks
The Postman—Warner Bros.
Prefontaine—Hollywood Pictures/Buena Vista
Rocketman—Disney/Buena Vista
Romy and Michelle's Highschool Reunion—Buena Vista
Rosewood—Warner Bros.
Selena—Warner Bros.
Seven Years in Tibet—Mandalay Entertainment/Sony Pictures
The Slab Boys—British—Skreba Films
The Spanish Prisoner—Sony Pictures Classics
Spiceworld the Movie—British—Columbia Pictures
Starship Troopers—Touchstone/TriStar
That Darn Cat—Disney/Buena Vista
'Til There Was You—Paramount
Titanic—Paramount/20th Century Fox
Truth or Consequences, N.M.—Columbia/TriStar
Twin Town—British—Polygram Filmed Entertainment/Gramercy Pictures
U Turn—TriStar

1998

All the Little Animals—British—BBC/Lions Gate
Antz (animated)—DreamWorks
Aprile—Italian/French—Bac Films/Europafilm AS
Armageddon—Touchstone/Buena Vista
Beloved—Touchstone/Buena Vista
Besieged—Italian—Fine Line Entertainment
The Big Lebowski—Polygram Entertainment/Gramercy Pictures
A Bug's Life (animated)—Disney/Pixar
City of Angels—U.S./German—Warner Bros.
Dangerous Beauty—Warner Bros.
Deep Rising—Hollywood Pictures/Buena Vista
Desperate Measures—Mandalay Entertainment/TriStar Pictures

Enemy of the State—Touchstone/Buena Vista
Fallen—Warner Bros.
Goodbye, Lover—U.S./German—Warner Bros.
He Got Game—Touchstone/Buena Vista
Heart—British—Granada Film Productions
Holy Man—Touchstone/Buena Vista
The Horse Whisperer—Touchstone/Buena Vista
I'll Be Home For Christmas—Disney/Buena Vista
Jack Frost—Warner Bros.
Krippendorf's Tribe—Touchstone/Buena Vista
The Last Days of Disco—Warner Bros./Castle Rock
Lethal Weapon 4—Warner Bros.
Mafia—Touchstone/Buena Vista
Meet the Deedles—Disney/Buena Vista
Les Miserables—Warner Bros.
Mulan (animated)—Disney/Buena Vista
My Giant—Columbia/Castle Rock
The Negotiator—Warner Bros.
Palmetto—U.S./German—Warner Bros./Castle Rock
Paulie—DreamWorks
A Perfect Murder—Warner Bros.
Practical Magic—Warner Bros.
The Proposition—Polygram Filmed Entertainment
Quest for Camelot (animated)—Warner Bros.
The Prince of Egypt—DreamWorks
Safe Men—October Films
Saving Private Ryan*—Paramount
Side Streets—Cargo Films
Simon Birch—Hollywood Pictures/Buena Vista
Six Days, Seven Nights—Touchstone/Buena Vista
Small Soldiers—DreamWorks/UIP
Soldier—Warner Bros.
Sour Grapes—Columbia/Castle Rock
Tarzan and the Lost City—Warner Bros.
The Thin Red Line—Twentieth Century Fox/Fox 2000
US Marshalls—Warner Bros.
The Waterboy—Touchstone/Buena Vista
Without Limits—Warner Bros.
You've Got Mail—Warner Bros.
Zero Effect—Warner Bros./Castle Rock

**Academy Award winner for Best Cinematography*

1999

Agnes Brown—Irish—October Films/USA Films
American Beauty*—DreamWorks
Analyze This—Warner Bros.
Angela's Ashes—Universal/Paramount
Any Given Sunday—Warner Bros.
Chill Factor—Warner Bros.
The Clandestine Marriage—British—BBC/UIP
The Cradle will Rock—Touchstone/Buena Vista
Deep Blue Sea—Warner Bros.
Deuce Bigalow: Male Gigolo—Touchstone/Buena Vista
Doug's 1st Movie (animated)—Disney/Buena Vista
Forces of Nature—DreamWorks
Galaxy Quest—DreamWorks

1999 Mena Suvari in
American Beauty

The Green Mile—Warner Bros. /Castle Rock

The Haunting—DreamWorks

House on Haunted Hill—Warner Bros.

In Dreams—DreamWorks

The Insider—Touchstone/Buena Vista

Inspector Gadget—Disney/Buena Vista

Instinct—Touchstone/ Buena Vista

The Iron Giant (animated)—Warner Bros.

Janice Beard 45 WPM—British—Empire Pictures Inc.

Jesus' Son—U.S./Canadian—Jesus' Son Productions/Lions Gate

Liberty Heights—Warner Bros.

The Love Letter—DreamWorks

Mad Cows—British—Sagittaire Films

The Match—U.S./British/Irish—Gramercy Pictures

The Matrix—U.S./Australian—Warner Bros.

Message in a Bottle—Warner Bros.

My Favorite Martian—Disney/Buena Vista

Mystery, Alaska—Hollywood Pictures/Buena Vista

New World Disorder—British—The Carousel

Picture Company S.A.

One More Kiss—British—MOB Films Productions/Alibi Film International

The Other Sister—Touchstone/Buena Vista

Passion, The Story of Percy Grainger—Australian/U.S—Beyond Films/Motion International

A Room for Romeo Brass—British—October Films/USA Films

Runaway Bride—Paramount/Touchstone

The Sixth Sense—Hollywood Pictures/Buena Vista

Summer of Sam—Touchstone/Buena Vista

Tarzan (animated)—Disney/Buena Vista

The 13th Warrior—Touchstone/Buena Vista

Three Kings—Warner Bros.

Three to Tango—Warner Bros.

Toy Story 2—Disney/Pixar

The Trench—British/French—Somme Productions

True Crime—Warner Bros.

Wild Wild West—Warner Bros.

Academy Award winner for Best Cinematography

1999 Mena Suvari in
American Beauty

The Green Mile—Warner Bros. /Castle Rock

The Haunting—DreamWorks

House on Haunted Hill—Warner Bros.

In Dreams—DreamWorks

The Insider—Touchstone/Buena Vista

Inspector Gadget—Disney/Buena Vista

Instinct—Touchstone/ Buena Vista

The Iron Giant (animated)—Warner Bros.

Janice Beard 45 WPM—British—Empire Pictures Inc.

Jesus' Son—U.S./Canadian—Jesus' Son Productions/Lions Gate

Liberty Heights—Warner Bros.

The Love Letter—DreamWorks

Mad Cows—British—Sagittaire Films

The Match—U.S./British/Irish—Gramercy Pictures

The Matrix—U.S./Australian—Warner Bros.

Message in a Bottle—Warner Bros.

My Favorite Martian—Disney/Buena Vista

Mystery, Alaska—Hollywood Pictures/Buena Vista

New World Disorder—British—The Carousel

Picture Company S.A.

One More Kiss—British—MOB Films Productions/Alibi Film International

The Other Sister—Touchstone/Buena Vista

Passion, The Story of Percy Grainger—Australian/U.S—Beyond Films/Motion International

A Room for Romeo Brass—British—October Films/USA Films

Runaway Bride—Paramount/Touchstone

The Sixth Sense—Hollywood Pictures/Buena Vista

Summer of Sam—Touchstone/Buena Vista

Tarzan (animated)—Disney/Buena Vista

The 13th Warrior—Touchstone/Buena Vista

Three Kings—Warner Bros.

Three to Tango—Warner Bros.

Toy Story 2—Disney/Pixar

The Trench—British/French—Somme Productions

True Crime—Warner Bros.

Wild Wild West—Warner Bros.

**Academy Award winner for Best Cinematography*

© Miramax Film Corp.

2001 Renee Zellweger stars in *Bridget Jones's Diary*

PREVIOUS SPREAD: **2000** Russell Crowe in *Gladiator*

Miss Congeniality—Warner Bros./Castle Rock
Mission to Mars—Touchstone/Buena Vista
Nurse Betty—Gramercy Pictures/USA Films
102 Dalmatians—Disney/Buena Vista
Pay It Forward—Warner Bros.
The Perfect Storm—Warner Bros.
Proof of Life—Warner Bros./Castle Rock
Ready to Rumble—Warner Bros.
Recess: School's Out—Disney/Buena Vista
Red Planet—Warner Bros.
Remember the Titans—Disney/Buena Vista
The Replacements—Warner Bros.
The Road to El Dorado (animated)—DreamWorks
Road Trip—DreamWorks
Romeo Must Die—Warner Bros.
Shanghai Noon—U.S/Hong Kong—
Touchstone/Buena Vista
Small Time Crooks—DreamWorks
Space Cowboys—Warner Bros.
The Tigger Movie (animated)—Disney/Buena Vista
Unbreakable—Touchstone/Buena Vista
Under Suspicion—Revelations
Entertainment/Columbia TriStar Entertainment
Up at the Villa—Universal/UIP
Whipped—Destination Films

2001

The Affair of the Necklace—Warner Bros.
Atlantis : The Lost Empire (animated)—
Disney/Buena Vista
Bridget Jones Diary—Universal
Cats and Dogs—Warner Bros.
Charlotte Gray—British/Australian—Warner Bros.
Crazy/Beautiful—Touchstone/Buena Vista
The Curse of the Jade Scorpion—DreamWorks
Double Whammy—U.S./German—Lions Gate Films
Inc.
Exit Wounds—Warner Bros.
Gerry—Pathe
Gosford Park—U.S./British/ - Chicago Films/USA
Films
Hannibal—Universal
Harry Potter and the Sorcerer's Stone—Warner
Bros.
Hearts in Atlantis—Warner Bros./Castle Rock
High Heels and Low Life—British/U.S.—
Touchstone/Buena Vista
The Importance of Being Ernest—U.S./British—
Miramax/Buena Vista
Jump Tomorrow—British/U.S.—Eureka Films/IFC
Films
Just Visiting—U.S./French—Hollywood
Pictures/Buena Vista
Juwanna Mann—Warner Bros.
K-Pax—Universal
Lantana—Australian/German—A-Film Distribution
The Last Castle—DreamWorks/UIP
Long Time Dead—British—Universal Focus
The Lord of the Rings: The Fellowship of the
Ring—New Line Cinema

2000

Almost Famous—DreamWorks
Beautiful Creatures—British—Universal
Best in Show—Warner Bros./Castle Rock
Chicken Run (animated)—U.S./British—
DreamWorks
Coyote Ugly—Touchstone/Buena Vista
The Crew—Touchstone/ Buena Vista
Dinner Rush—Access Motion Picture Group
Dinosaur (animated)—Disney/Buena Vista
Duets—Hollywood Pictures/Buena Vista
The Emperor's New Groove (animated)—
Disney/Buena Vista
Essex Boys—British—Granada Film
Productions/Buena Vista Home Video
Gangster No. 1—British/German—BSkyB/IFC Films
Gladiator—DreamWorks/Universal
Gone in 60 Seconds—Touchstone/Buena Vista
Gossip—U.S./Australian—Warner Bros.
Gun Shy—Hollywood Pictures/Buena Vista
High Fidelity—Touchstone/Buena Vista
It was an Accident—British/French—Pathe
The Legend of Bagger Vance—Twentieth Century
Fox/DreamWorks

© Miracle Productions

2002 *Harry Potter and the Chamber of Secrets*

Made—Artisan Entertainment
The Martins—British—Icon Entertainment International/Medusa Distribuzione
The Mexican—DreamWorks
Mike Bassett: England Manager—British—Hallmark Entertainment
Monsters Inc. (animated)—Disney/Buena Vista
The Musketeer—Universal/Miramax
Ocean's Eleven—Warner Bros.
Osmosis Jones—Warner Bros.
Pearl Harbor—Touchstone/Buena Vista
The Princess Diaries—Disney/Buena Vista
Rock Star—Warner Bros.
The Royal Tenenbaums—Touchstone/Buena Vista
Shrek - DreamWorks
See Spot Run—U.S./Australian—Warner Bros.
Spirited Away—Buena Vista International
Sweet November—Warner Bros.
Thirteen Ghosts—Warner Bros.
Training Day—Warner Bros.
Valentine—U.S./Australian—Warner Bros.

2002

Adventures of Pluto Nash—U.S./Australian—Warner Bros./Castle Rock
Analyze That—U.S./Australian—Warner Bros.
Before You Go—British—Arkangel Productions/Capitol
Blood Work—Warner Bros.
Catch Me If You Can—DreamWorks

Club Le Monde—British—2M Films/ScreenProjex
Collateral Damage—Warner Bros.
The Count of Monte Cristo—U.S./British/Irish—Touchstone/Buena Vista
Dirty Pretty Things—British—Miramax/Buena Vista
Divine Secrets of the Ya-Ya Sisterhood—Warner Bros.
Eight Legged Freaks—Warner Bros.
Far From Heaven—Focus Features
Feardotcom—U.S./British/German—Warner Bros.
Gangs of New York—Miramax
Ghost Ship—U.S./Australian—Warner Bros.
Harry Potter and the Chamber of Secrets—Warner Bros.
Hope Springs—British/U.S.—Touchstone Buena Vista
The Hot Chick—Touchstone/Buena Vista
Juwanna Mann—Warner Bros.
The Kid Stays in the Picture—MCA/Universal Pictures
Lilo & Stitch (animated)—Disney/Buena Vista
The Lord of the Rings: The Two Towers—New Line Cinema
Miranda—British/German—Feelgood Films/Channel Four Films
Moonlight Mile—Touchstone/Buena Vista
Murder by Numbers—Warner Bros./Castle Rock
My Little Eye—British/French/U.S.—Universal Pictures/Focus Features
Possession—U.S./British/U.S.—Focus Features
Queen of the Damned—U.S./Australian—Warner Bros.
Reign of Fire—Touchstone/Buena Vista

1982

Gandhi (British/Italian), winner for Best Cinematography—by Billy Williams and Ronnie Taylor

1984

The Killing Fields, winner for Best Cinematography—by Chris Menges

1985

Out of Africa, winner for Best Cinematography—by David Watkin

1987

The Last Emperor (Italian/British/Hong Kong), winner for Best Cinematography—by Vittorio Storaro

1989

Glory, winner for Best Cinematography—by Freddie Francis

1992

A River Runs Through It, winner for Best Cinematography—by Philippe Rousselot

1994

Legends of the Fall, winner for Best Cinematography—by John Toll

1997

Titanic, winner for Best Cinematography—by Russell Carpenter

1998

Saving Private Ryan, winner for Best Cinematography—by Janusz Kaminsky

1999

American Beauty, winner for Best Cinematography—by Conrad L. Hall

2002

The Road to Perdition, winner for Best Cinematography—by Conrad L. Hall

2004

The Aviator, winner for Best Cinematography—by Robert Richardson

TECHNICOLOR MILESTONES

Color Positive Release Prints
(1955-today)

1 Color positive release prints are typically manufactured from color internegatives or "duplicate negatives," although on occasion several prints may be manufactured from the original camera negative film.

2 Color positive rawstock, like the color negative and color intermediate rawstocks, is an integral color film made up of three basic dye forming layers coated on to a flexible support.

3 Color positive stock is normally contact printed: that is, it is exposed by modulated light that passes through the color negative printing element while it is in intimate contact with the color positive.

4 The exposed color positive rawstock is then developed, creating a visible image from the latent image exposed during the printing step.

5 Composite prints with printed-in optical soundtracks are normally manufactured for bulk release. A separate exposure of the area reserved for the optical soundtrack on the rawstock is made in a continuous fashion on the same printer that prints the picture information, at a second station with a second light source. At this time the color positive stock is in intimate contact with a black-and-white soundtrack negative, which serves as the printing element for the sound information.

*Note: Most motion pictures today use an optical sound track. This was not the case during the 1950s when stereophonic sound systems were used to a high degree in conjunction with the then new wide screen processes, particularly CinemaScope and VistaVision.

Warner Bros. was the first studio to experiment with stereophonic sound in two pre-World War II pictures, Four Wives (1939) and Santa Fe Trail (1940). The system, called Vitasound, was not successful as few theater owners were willing to spend the money to install special sound equipment.

In late 1940, Walt Disney introduced Fantasound with his Technicolor Fantasia. It was generally well received but, again, exposure was limited to a handful of major theaters during its roadshow run.

It wasn't until 1952, with the release of This Is Cinerama, that stereophonic sound—and magnetic sound tracks—began to receive wide attention. Over the following few years, films featuring stereophonic sound became immensely popular with movie audiences.

Following a low period during the 1960s, Universal successfully featured Sensurround with Earthquake (1974), Midway (1976) and Rollercoaster (1977). Renewed interest in multichannel sound has been spearheaded by the Dolby system and, in the 1990s, by Sony (SDDS: Sony Dynamic Digital Sound) and the Digital Theater Systems process (DTS). Unlike competitors Dolby and Sony, DTS records sound tracks on CD-ROMs.

Color Negative

Color Positive Release Print

RIGHT: **Technician removes rolls of color negative film from dryer**

TECHNICOLOR MILESTONES

1915

Technicolor Motion Picture Corp. established by Dr. Herbert T. Kalmus (November 19)

1916

"Technicolor Process Number One," a two-component additive system, developed for Technicolor by Kalmus, Comstock & Westcott, Inc.

1917

The Gulf Between, a one-reel film, produced in Jacksonville, Forida; serviced in the first Technicolor laboratory, a railway car

1922

"Technicolor Process Number Two," a two-component subtractive system, developed

Technicolor, Inc. formed

First feature film, The Toll of the Sea

1923

Technicolor's first Hollywood laboratory established

1924

Cytherea filmed with artificially lit interiors; Technicolor's first experience in photographing an interior set on a dark stage

1925

Douglas Fairbanks' The Black Pirate filmed in Technicolor

1926

"Technicolor Process Number Three," a two-component subtractive imbition process, developed

1928

First Technicolor picture with music and sound effects, The Viking

1929

First Technicolor all-talking picture, On With The Show

1930

Technicolor's main Hollywood plant completed

1931

Dr. Troland issued patents for his Monopack process (applied for in 1921)

1932

"Technicolor Process Number Four," a three-component imbition process, developed

First film in Technicolor three-component process, Flowers and Trees, produced in animaton by Walt Disney

Print output for year totalled 5.5 million feet

1934

First live-action three-color picture, La Cucaracha

1935

First full-length three-color feature, Becky Sharp

1936

Technicolor, Ltd. organized in London

1937

First Technicolor feature filmed in England, Wings of the Morning

Technicolor entered non-theatrical film field

Snow White and the Seven Dwarfs, Disney's first full-length animated feature, premiered (first general release; 1938)

1938

Developed a continuous developing machine for processing three-strip negative

1939

Gone With the Wind released

Introduced three-strip negative three times the speed of previous negatives for use in Technicolor cameras

Print activity in Hollywood plant increased to 130 million feet

1940

Special award presented to Technicolor for three-color process by the Academy of Motion Picture Arts and Sciences

1941

Technicolor Monopack process introduced with aerial shots in *Dive Bomber* (remained in use for special purposes until 1952)

1944

Optical printer introduced by Technicolor which enabled fades, dissolves and special effects to be printed in color

Thunderhead, Son of Flicka, first all-Monopack Technicolor feature

1948

Technichrome, a special purpose product, introduced for photography of the Olympic Games held in England

Record expansion for print output—up from 130 million feet in 1939 to 320 million feet

1950

Technicolor introduced a three-strip photographic system using uncorrected incandescent illumination and with a substantially lower light level

1953

Developed and built a contact printer with additive color for use in wide screen processes

1954

With lenses from Superscope and Panavision, set up printers for first making anamorphic prints from flat negatives and flat prints from Cinemascope negatives

Technicolor cameras used for the last time on an American-made film (*Foxfire*)

1955

"Technicolor process number Five," a method of achieving improved definition of imbibition prints working from new Eastman color negative, introduced

Technicolor Italiana launched in Rome

Developed Technicolor-Technirama, a multi-purpose photography and print system that provided flexibility in the preparation of negatives and a wide choice of high quality color release prints suited to large screen exhibition in 35mm or 70mm sizes or smaller audience requirements in 16mm. First used on *Night Passage* (1957)

1956-57

Development of the wet printing process to permit making high quality reduced grain, dirt-free prints from 35mm and 16mm color-reversal films. First full feature wet printed: *Pal Joey*

1956-58

With the introduction of Todd-AO and Camera 65, developed and manufactured optical printers for handling 65mm negatives and printing enlargement to 70mm or reduction to 35mm—anamorphic or flat—and 16mm anamorphic

1960

Introduced Super Technirama 70

Technicolor's founder, Dr. Herbert T. Kalmus, retired

1961

Made Cinemiracle extractions (three panel) from Camera 65 and Technirama. Location shots for *How the West Was Won* were filmed in 65mm then converted to Cinerama to be compatible with the three-camera studio cinematography

Introduced an integrated transfer process in which the sound track is printed and the picture image is colored in a continuous operation

Introduced a predetermined distance counter which electronically programmed effects and light changes during the printing of matrices

Introduced auto-selective printing, allowing dissolves and fades from original negatives without the cost and quality loss of using internegatives and using an assembled original negative for printing many versions

1963

Introduced Techniscope as well as a new system for printing 35mm negatives in 70mm release prints for road show potential

Dr. Kalmus died on July 11 at age 81

1963-64

Built optical printers for making 70mm "rectified" prints from 65mm Ultra-Panavision negatives for Cinerama to be shown on a curved screen. First pictures were *It's A Mad, Mad, Mad, Mad World* and *The Greatest Story Ever Told*

2004

Technicolor inaugurates newly expanded Guadalajara DVD manufacturing facility as world's largest

Technicolor acquires Command Post – expanding its digital content solutions business in Canada

Technicolor broadens its European film and post production operations with acquisitions of Madrid Film Group, the largest film and post production operation in Spain, and International Recording, a Rome-based sound services company

Technicolor builds Tokyo broadcast playout facilities for Disney and acquires Corinthian Television Facilities in London, UK— introducing its new broadcast playout services offering

Technicolor acquires The Moving Picture Company (MPC) expanding its worldwide postproduction service

2005

Technicolor launches its Electronic Content Distribution Services division, dedicated to providing digital cinema services and securely managed content distribution to the home. It also announces its new Network Services Division dedicated to providing broadcast playout and cinema advertising services

Technicolor Digital Cinema launches SkyArc, the world's largest digital distribution network for cinema advertising

THE TECHNICOLOR TECHNIQUE

For ten years, beginning in 1915, Dr. Kalmus divided his energies between Technicolor and other Kalmus, Comstock & Westcott clients. In 1925, he made a decision to break away from the engineering firm and devote full time to the color company. With Dr. Kalmus went Dr. Leonard Troland and Joseph Arthur Ball.

While Dr. Daniel Comstock was responsible for the majority of patents issued on the two-color process, it was Mr. Ball, one of Dr. Comstock's stu-

BELOW: **Early diagram of the Technicolor three-color camera**

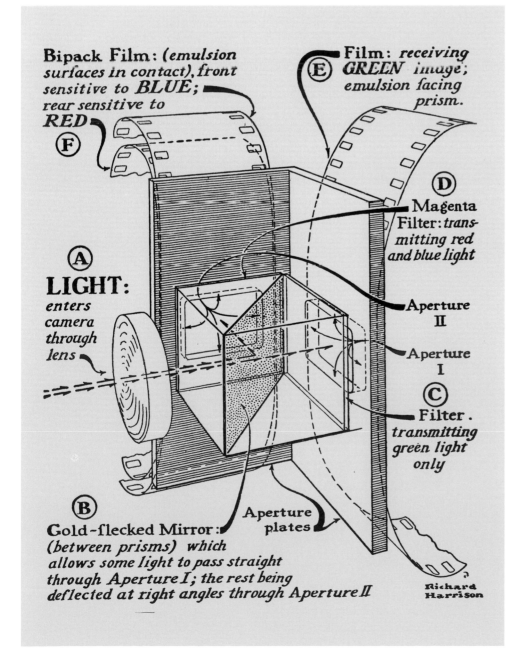

Bipack Film: (emulsion surfaces in contact), front sensitive to **BLUE**; rear sensitive to **RED**
(F)

(A) **LIGHT**: enters camera through lens

Film: receiving (E) GREEN image; emulsion facing prism.

(D) Magenta Filter: transmitting red and blue light

Aperture II

Aperture I

(C) Filter. transmitting green light only

(B) Gold-flecked Mirror: (between prisms) which allows some light to pass straight through Aperture I; the rest being deflected at right angles through Aperture II

Aperture plates

Richard Harrison

dents at M.I.T. who is credited with the unique method of making prints which grew into Technicolor's three-component system. And, together with Henry Prouch, a German mechanic, and George Alfred Mitchell, the originator of the famous Mitchell camera, he designed and built three of the original new Technicolor three-strip cameras. By May, 1932, the entire three-color "package" was ready to make its debut.

Color printing procedures begin with white light. Optically speaking, white light consists of three primary colors: red, blue and green. This is one way of saying that when proper amounts of red, blue and green are subtracted from white light, any color visible to the human eye will be reproduced.

The Camera
(1932-1955)

The Technicolor three-strip camera exposed three separate black-and-white negatives simultaneously through a single lens. Immediately behind this lens was a beam-splitter made by two prisms of optical glass which were gold coated (later silver flecked) to produce a slight mirrored effect. The purpose of the beam-splitter was to reflect part of the light to an aperture to the left. The remaining light passed directly through to a normally positioned aperture.

The ray of light that passed directly through the prism reached a green filter that allowed only green light (or a green image) to reach the negative behind it. The reflected beam of light was directed to a standard bi-pack containing two negatives. The front film carried a red-orange dye which absorbed the blue light and filtered out the red rays. These rays passed through to register on the rear film of the pair.

Using this camera, suppose one takes a picture of a red balloon on green grass against a blue sky. Since the balloon reflects only red light, it must register on the red negative. In the same way, the green grass sends its reflected light to the green negative and the blue sky leaves its impression on the blue negative. Although it is necessary to identify the negatives by color, it must be remembered that they were not actually colored. The red negative, for instance, had no capacity for turning red when the light hit it. It was simply a black-and-white

record of the red element and offered an orthodox photograph of the red portions in the camera's field. The three negatives also embodied the intensity of the light that struck them.

The next step was to preserve these values in a special positive that would absorb and print the dyes.

Three-Strip Release Prints
Inhibition to Dye Transfer
(1932-1955)

The exposed film from the Technicolor three-strip camera, when developed, produced negatives that were silver in color. Held up to the light, however, they appeared the same as black-and-white negatives. These strips of negative were then run through a matrix printer, a device in which special matrix film was exposed to light coming through a negative.

In photography, matrix means what it does in other forms of printing: a relief image from which multiple copies are made. In effect, the matrices were the "plates" from which the films were developed. Because the original negatives were used so infrequently—only to make new sets of matrices

when necessary—they remained in excellent condition.

The matrix positive, a special gelatin-coated film, was capable of absorbing (or imbibing) and printing dyes. Through a special chemical process, the gelatin on it was hardened in proportion to the light that hit when exposed to the original negative. Using the red image as an example, wherever the object photographed was the reddest, the hardening of the gelatin was thinnest. That was because the red light blackened the negative and therefore kept the light from the gelatin on the matrix. When the red matrix was washed, the soft gelatin flushed away. The remaining hard gelatin formed a relief of the red record. In this relief, the red portions of the scene were represented by valleys; the blue and green portion by hills.

While the matrices were being made, a special dye-receptive blank film was prepared. If the customer wanted prints with optical sound tracks,* the silver sound record was incorporated in the blank film at this stage. If the customer's prints were to carry magnetic sound tracks,* the silver sound record was omitted and the magnetic tracks were applied after the dye transfer.

Each matrix was dyed on a dye transfer machine with its complementary, or opposite, color. The red

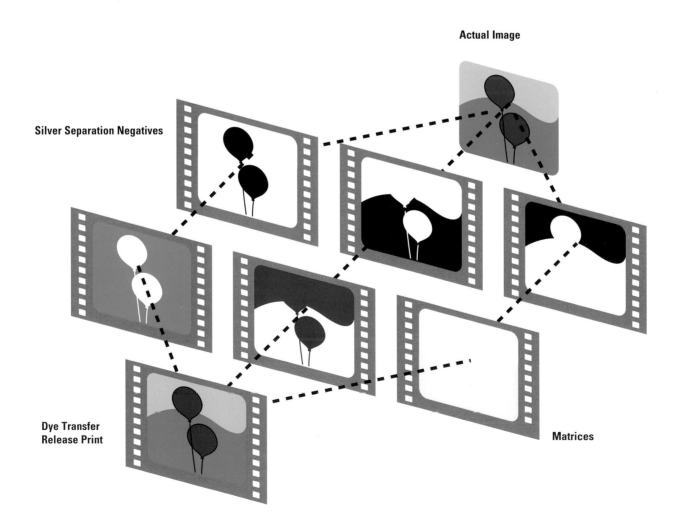

Actual Image

Silver Separation Negatives

**Dye Transfer
Release Print**

Matrices

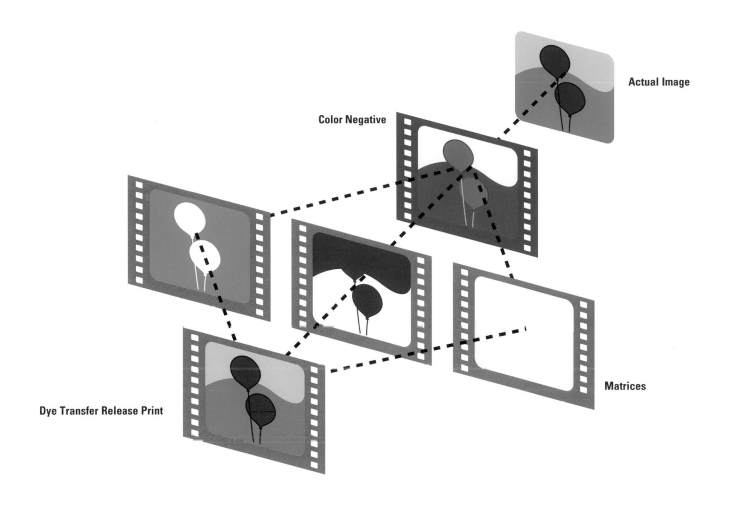

Actual Image

Color Negative

Matrices

Dye Transfer Release Print

matrix was brought into contact with a blue-green dye called cyan (blue-green being complementary to red). The green matrix was dyed with a magenta dye (complementary to green) and the blue matrix was dyed with a yellow dye (complementary to blue).

Again, using the red record as an example, when the red matrix was brought into contact with the blue-green dye, the dye was imbibed only in proportion to the thickness of the matrix. Therefore, the hills on the matrix, which act like type in printing, got a great deal of dye and the valleys got little or none. Since the red balloon was a valley on the red matrix, the spot where the balloon registered did not get any blue-green color. Conversely, the low spots on the red matrix were high spots on the other two matrices. So on the blue-green matrices, the places where the balloon did not register became hills. Because of that, in those spots, they absorbed ample amounts of yellow and magenta dyes.

When each of the three matrices had been processed through the dye transfer machine, the once blank film contained all the colors necessary for excellent reproduction of the color scene and was ready for delivery to exhibitors for projection. Where yellow dye was present, blue light was subtracted from the projector's white light source. Similarly, red was subtracted where cyan was present and green where magenta occurred. Absence of all dyes resulted in white light on the screen. The

presence of all dyes in sufficient quantities created an absence of light, or a black image.

■

Beginning in the early 1950s, Technicolor began processing dye transfer prints from the then recently introduced Eastman and Ansco color negatives. The printing process—working with red, blue and green matrices—was essentially the same as for the three-strip process, which used three separate negatives exposed by the Technicolor camera. The main difference was in step number one. Instead of working from three negatives, matrices were made from a single strip of color negative which contained three emulsion layers—one for each of the three primary colors—superimposed on a cellulose acetate base. These three emulsion layers were differently sensitive to different colors of light. This means that the photo-sensitive silver halide particles in the separate emulsions were exposed by different colors of light. Generally, color negative films had a filter layer between the top two emulsions. Where the color sensitivity was not complete, this filter aided in separating unwanted colors from a particular emulsion.

Color Negative

Color Positive Release Print

Color Positive Release Prints
(1955-today)

1 Color positive release prints are typically manufactured from color internegatives or "duplicate negatives," although on occasion several prints may be manufactured from the original camera negative film.

2 Color positive rawstock, like the color negative and color intermediate rawstocks, is an integral color film made up of three basic dye forming layers coated on to a flexible support.

3 Color positive stock is normally contact printed: that is, it is exposed by modulated light that passes through the color negative printing element while it is in intimate contact with the color positive.

4 The exposed color positive rawstock is then developed, creating a visible image from the latent image exposed during the printing step.

5 Composite prints with printed-in optical soundtracks are normally manufactured for bulk release. A separate exposure of the area reserved for the optical soundtrack on the rawstock is made in a continuous fashion on the same printer that prints the picture information, at a second station with a second light source. At this time the color positive stock is in intimate contact with a black-and-white soundtrack negative, which serves as the printing element for the sound information.

*Note: Most motion pictures today use an optical sound track. This was not the case during the 1950s when stereophonic sound systems were used to a high degree in conjunction with the then new wide screen processes, particularly CinemaScope and VistaVision.

Warner Bros. was the first studio to experiment with stereophonic sound in two pre-World War II pictures, Four Wives *(1939)* and Santa Fe Trail *(1940)*. The system, called Vitasound, was not successful as few theater owners were willing to spend the money to install special sound equipment.

In late 1940, Walt Disney introduced Fantasound with his Technicolor Fantasia. *It was generally well received but, again, exposure was limited to a handful of major theaters during its roadshow run.*

It wasn't until 1952, with the release of This Is Cinerama, *that stereophonic sound—and magnetic sound tracks—began to receive wide attention. Over the following few years, films featuring stereophonic sound became immensely popular with movie audiences.*

Following a low period during the 1960s, Universal successfully featured Sensurround with Earthquake *(1974),* Midway *(1976) and* Rollercoaster *(1977). Renewed interest in multichannel sound has been spearheaded by the Dolby system and, in the 1990s, by Sony (SDDS: Sony Dynamic Digital Sound) and the Digital Theater Systems process (DTS). Unlike competitors Dolby and Sony, DTS records sound tracks on CD-ROMs.*

RIGHT: **Technician removes rolls of color negative film from dryer**

THOMSON—YESTERDAY AND TODAY

*T*homson, a global company based in France, has a long history of innovation and industry leadership and has brought entertainment and information to millions of customers around the world. Following its acquisition of Technicolor in 2001, Thomson began to reposition itself from a leading provider of consumer electronics products under the Thomson, RCA and GE brands to become the preferred partner to the media and entertainment industries. A leader in digital technologies, Thomson maintains its legacy of innovation by supporting extensive research and development activities. Included in its diverse patent portfolio are color television, mp3, MPEG digital compression, and many others.

Maintaining a leadership position in break-through technologies is nothing new for Thomson. The company—named after founder Elihu Thomson—was built on a tradition of innovation and evolved from a company that was one of the leading providers of electricity in the 19th century.

"There is scarcely a day passing on which some new use for electricity is not discovered. It seems destined to become at some future time the means of obtaining light, heat, and mechanical force," wrote high school student Elihu Thomson. He was predicting the future of the electric art and his calling as one of America's most prolific inventors. In a career that spanned five decades, Thomson was granted 696 U.S. patents on inventions as varied as arc lights, generators, electric welding machines, and x-ray tubes. But it was the recording wattmeter, a practical method of measuring the amount of electricity used by a home or business that brought fame and opportunity.

From modest beginnings with fellow high school science professor Edwin Houston, Thomson built one of the leading electrical companies of the nineteenth century—Thomson-Houston. His first important invention was the 3-coil dynamo, which, with its automatic regulator and other novel features, was the basis of the successful electric lighting system produced by the company. His experiments with alternating current (AC), although disputed as dangerous by direct current (DC) promoter Thomas Edison, led to the adoption of alternating current technology as the U.S. standard. Six months before Thomas Edison opened his first power station in New York, Elihu Thomson's system was lighting streets in Kansas City, Missouri.

The Thomson-Houston Electric Company also found early success at global

marketing, establishing subsidiary companies in Europe and South America. In 1892, the merger of Thomson-Houston and Edison General electric companies formed General Electric. Thomson's inventive work was of such importance it has gone into extensive use in lighting, railways, and power transmission. He was also the inventor of the electric air drill as we know it today, and a pioneer in high frequency work, upon which wireless methods are based.

In 1893, the Compagnie Francaise Thomson-Houston (CFTH) was formed in Paris, a sister company to GE in the United States. It is from this company that the modern Thomson Group has evolved. Like its American counterpart, the French Thomson manufactured a variety of electrical, and later electronic, products. As part of its growth plan in the 1980's, it acquired General Electric's RCA and GE consumer electronics business and further developed its television and consumer products business on a global basis.

However, the acquisition of Technicolor in 2001 signaled a change in the Group's strategic direction. With the purchase of Grass Valley Group in 2002, Thomson expanded into the professional broadcast equipment market with a complete line of cameras, switchers and video processing equipment. Over the years Thomson made a number of smaller acquisitions and in parallel divested itself of its television activities.

Today, Thomson is the largest single provider of services, systems and technology to the media and entertainment industries worldwide, enabling its clients to optimize their performance in a changing business environment.

Thomson is a wholly public company and is traded on the New York Stock Exchange and the French CAC 40. Through its Services Division where Technicolor resides, Thomson is the number one provider of worldwide media services and the number two provider of postproduction services worldwide. Its Systems & Equipment Division—comprising Grass Valley, Access Platforms and Gateways, and its Connectivity business—is the industry leader in HD broadcast equipment; studio/electronic field production cameras, video servers, intelligent video digital recorders and routers, DSL modems and satellite set top boxes. It is ranked number two worldwide in cable modems and is a leader in IP set-top boxes, mp3 players and telephony products. Its Technology Division comprises nine research laboratories around the globe employing hundreds of research engineers and intellectual property and licensing experts. It has a portfolio of 45,000 patents and focuses on developing technology solutions for the media and entertainment industries including compression, security, digital cinema and content management tools.

BIBLIOGRAPHY

Most of the research for *Glorious Technicolor* was extracted from the archives of Technicolor, Inc., personal memos and correspondence between company principals, technicians and industry executives, as well as interviews with primary sources who have worked with the company either in processing or film production.
Also examined were the journals and publications prepared by Technicolor personnel, including:

An Outline of the History of the Beginning of the Technicolor Development in Boston—1914-1925 by Dr. Daniel F. Comstock (date unknown)

The Technicolor Process of Three-Color Photography by James A. Ball (1935)

Color Consciousness by Natalie Kalmus (1935)

Technicolor Adventures in Cinemaland by Dr. Herbert T. Kalmus (1938)

Mobile Photography by the Technicolor Method by George Cave (1939)

Technicolor Cinematography by Winton Hoch (1942)

Technicolor Today by Dr. Herbert T. Kalmus (1952)

Technicolor News & Views (house organ, various issues)

The following books were particularly helpful either in giving an overview of the motion picture industry, past or present, or in substantiating details relating to specific motion picture productions:

Eames, John D. *The MGM Story.* New York; Crown, 1975.

Film Daily Year Book. New York: Arno Press.

Finch, Christopher. *The Art of Walt Disney.* New York: Abrams, 1973

Friedman, Joseph S. *History of Color Photography.* Boston: American Photographic Publishing Co., 1944.

Griffith, Richard, and Mayer, Arthur. *The Movies.* New York: Simon & Schuster, 1957.

Harmetz, Aljean. *The Making of the Wizard of Oz.* New York: Knopf, 1977.

Huntley, John. *British Technicolor Films.* London: Skelton Robinson, 1949.

International Motion Picture Almanac. New York: Quigley Publications.

Jacobs, Lewis. *The Rise of the American Film.* New York: Harcourt, Brace, 1939.

Kalmus, Herbert T., and Kalmus, Eleanore King Kalmus, *Mr. Technicolor.* Abscecon: MagicImage Filmbooks, 1993.

LeRoy, Mervyn, and Kleiner, Dick. *Take One.* New York: Hawthorn Books, 1974.

Limbacher, James L. *Four Aspects of the Film.* New York: Brussel and Brussel, 1968.

Manvell, Roger. *Love Goddesses of the Movies.* New York: Crescent Books, 1975.

The New York Times Directory of the Film. New York: Arno Press/Random House, 1971.

The New York Times Film Reviews, 1913-1970. New York: Arno Press/Quadrangle, 1971.

Osborne, Robert. *60 Years of the Oscar.* New York: Abbeville, 1989.

Parish, James Robert, and Bowers, Ronald L. *The Golden Era: The MGM Stock Company.* New Rochelle: Arlington House, 1973.

Powdermaker, Hortense. *Hollywood, the Dream Factory.* Boston: Little, Brown, 1950.

Pratt, William, and Bridges, Herb. *Scarlett Fever.* New York: Collier Macmillian, 1977.

Rhode, Eric. *A History of the Cinema.* New York: Hill and Wang, 1976.

Rosten, Leo. *Hollywood.* New York: Harcourt Brace, 1941.

Schickel, Richard. *The Disney Version.* New York: Simon & Schuster, 1968.

Stine, Whitney, and Davis, Bette. *Mother Goddam.* New York: Hawthorn Books, 1974.

Taylor, Deems. *A Pictorial History of the Movies.* New York: Simon and Schuster, 1943.

Taylor, John Russell. *The Hollywood Musical.* New York: McGraw-Hill, 1971.
Trent, Paul. *Those Fabulous Movie Years: The 30s.* Barre: Barre Publishing, 1975.

Variety Movie Guide. New York: Prentice Hall, 1992.

Walker, John (editor). *Halliwell's Film Guide.* New York: Harper-Perennial, 1994.

Willis, John. *Screen World,* Vols. 38-42. New York: Crown 1987-1991.

Wilson, Arthur (editor). *The Warner Bros. Golden Anniversary Book.* New York: Dell/Film and Venture Corp., 1973.

Among the periodicals consulted were: *American Cinematographer, Business Screen, Daily Variety, Film Facts, Films in Review, Fortune, Hollywood Citizen News, Hollywood Reporter, Journal of the SMPTE, Motion Picture Daily, Motion Picture Herald, Motion Picture News, Moving Picture World, The Photographic Journal, Popular Mechanics, Saturday Evening Post, Stage, Views & Reviews and Village Voice.*

PHOTO CREDITS

INDEX